Arts in Society

Reyner Banham
Paul Barker
John Berger
Angela Carter
Albert Hunt
Paul Mayersberg
Dennis Potter
E. P. Thompson
Michael Thompson
Andrew Weiner
Michael Wood

Fontana Communications Series

EDITED BY RAYMOND WILLIAMS

This is a new series which will bring together original studies
of a wide range of cultural practice. Its area of interest
will include the arts, the modern media and popular
culture and entertainment. It will be especially concerned
with new methods and approaches in this increasingly
important and developing field, and will include studies
of contemporary language and cultural concepts in relation
to modern society.

Already published:
KEYWORDS by Raymond Williams

Forthcoming:
IMAGE – MUSIC – TEXT by Roland Barthes
Essays selected and translated by Stephen Heath

THE STATE. COMMUNICATION AND THE PEOPLE
by James Curran and Jean Seaton

Arts in Society

edited by Paul Barker

A *New Society* Collection

Fontana/Collins

First published in Fontana 1977

This collection copyright © *New Society* 1977
Introduction copyright © Paul Barker 1977

Made and printed in Great Britain by
William Collins Sons & Co. Ltd, Glasgow

Contents

Introduction: Dreaming together – how to 'read' the mass arts

Paul Barker

Nobody lives in the present – except perhaps painters, scientists and engineers. All these try to see the world as it is, if only (in the case of engineers) to remake it now. Everyone else lives in a mishmash of future and past. The present is simply where hope and experience meet: a mixture of pain and dreams.

To understand the imagery of mass culture, we must recognize that it is no exception to this. Even where there is a surface show of 'reality' (most famously in Norman Rockwell's covers for the *Saturday Evening Post*), the purpose is to convey a dream or a nostalgia; or both. This rule is very, very seldom violated; and such anomalies seem to require rather special political and social circumstances. (The heyday of *Picture Post* may be an example.)

In general, the mass media have the quality of permanent adolescence, teetering between childhood's past and adulthood's future. Adolescence may be dying out as a social fact. (In his *Centuries of Childhood*, Philippe Ariès forecasts an increasingly direct transit from the infant to the adult state.) But it lives on as the frame of mind of the mass media. They deliver a youth that many people never really had. Anyone who lived in the London of the Swinging Sixties will know the difference between media portrayal and reality. The title itself was a journalistic creation – the result of a special feature in *Time*.

What are the attributes of mass culture? In 1957 Richard Hamilton listed them thus:

Popular (designed for mass audience) Witty
Transient (short-term solution) Sexy
Expendable (easily forgotten) Gimmicky
Low cost Glamorous
Mass produced Big business
Young (aimed at youth)

The technologies with which it is most associated are: cheap printing, on fabric or on paper, and especially in colour; photography, whether still or moving, whether TV or cinema; and the manufacture of plastics. Plastics are the mass material *par excellence*. They are what the cast iron of the Palm House and the Crystal Palace was merely aspiring to. They have all the ingredients that Hamilton listed – especially when wrapped round a girl on a *Penthouse* spread (or a Lamb's Navy Rum ad), or their male imitations in *Playgirl* or *Viva*. Here is one early dithyramb on the subject:

Despite its Greek pastoral names (polystyrene, phenoplastic, polyvinyl, polyethylene), plastic is essentially alchemy. There has just been a plastics exhibition in Paris. People form a long queue to get into the stand to see the archetype of a magical operation take place: the transformation of matter. A dream machine, all tuby and rectangular . . . effortlessly converts a heap of greenish crystals into bright, fluted trays to put on a dressing table! On the one hand, crudy, earthy matter; on the other, the finished, human object; and between these two, nothing; nothing but a distance travelled, semi-supervised by a man in a cap, himself partway between a god and a robot.* (Roland Barthes, *Mythologies*)

The most evident example of mass culture in full blast at the moment is pornography. Poland supplies it to the Soviet Union. Yugoslavia supplies it to both Comecon and the EEC. America supplies it to everyone. London (doing what Japan has done with motorbikes and cars) is selling successfully in the American markets products that began as sheer imitation. The real innovator – Denmark – has been taken over (as usual) by the big men. The porno industry is more flourishing, as

* 'Robot' is the only word most languages have ever borrowed from Czech, via Karel Capek. In the context of mass culture it is an ironically apt source. Czechoslovakia, for most people, is the artefact of news stories, from Sudetenland and Munich, to Slansky and Jan Palach. It's not a 'real' place which can perhaps be visited, but a place where headlines are enacted. Its best-known writing is Kafka's literature of dreams. And the most famous interpreter of dreams since Joseph was born in Moravia, at what is now called Freudova Ulice instead of, as formerly, Schlossergasse.

I write, than the vehicle industry; and it was well ahead of Saab/Volvo in deciding to organize its production teams in groups. In 1975 the French government decreed a 50 per cent tax on hardcore films; the state car firm (Renault) was more in need of a 50 per cent cut. Frank Lloyd Wright said that, to see the future, we should keep our eyes on the little filling station. Was that because, among the mints and the children's comics and the Kleenex, he knew that it would be selling *Lui*?

Pornography is only the most recent confirmation that mass art – like French classical drama – largely proceeds by stereotypes. It trades in what is accepted, in what is acceptable. The taboos change – sometimes suddenly; but there always *are* taboos. In England it is now all right to be overtly obscene but not to be overtly racialist. Previously, the reverse was true.

Individual items of mass culture are transient. But the delivery systems have a long half-life. In studying mass arts a great deal of attention is paid to the popular press (it is easier to catch and hold than radio or television). But in all countries this is a dying form, mostly notable for its death throes. It has outlived its former function and – like that earlier mass-delivery system, railways – is reduced to soliciting, and often getting, public subsidy.

The varieties of press that do flourish are periodicals of one sort or another, and regional papers. In France, for example, the Paris daily press has the difficulties that are common everywhere. But papers with (by French standards) big circulations, though seldom read by foreigners, do well: *Ouest-France*, *Le Progrès* (Lyons), *Le Dauphiné Libéré*, *Sud-Ouest*. So do news magazines, women's magazines, sex magazines.

What does best, in fact, is that which is closest to gossip. Provincial papers in any country are especial monuments to the appeal of *faits divers*. One glossary defines these as 'unimportant news items'. But these apparent fillers are among the most important contents of newspapers. The more provincial a newspaper is, the more it is likely to be full of them. (Even among London dailies, much of the success of the *Daily Telegraph* is due to the array of *faits divers* it stuffs into the bottoms of columns. It is a more interesting paper, most days,

if you fold it and read only the bottom halves of the pages.)
Main news stories are more or less untrue. They are based
on partial information or guesswork, and are what makes
yesterday's newspaper so dead. What you read with fascina-
tion when you find an old newspaper in the lining of a cup-
board are the small items about people's lives, the court
reports, the minor scandals.

This is what novelists read the papers for, too. The old
News of the World, which consisted of little else, was the
favourite newspaper of both Joyce Cary and George Orwell.
The storylines of *Crime and Punishment* and *Le Rouge et le
Noir* both had their origin in a *fait divers*. As it happens,
what Michael Wood says about Stendhal, in his book on that
novelist, could apply to mass culture: 'There are no master
images, as in Henry James or Ibsen; there are no webs of
metaphor, as in George Eliot or Claudel. Nothing is hidden,
the art lies on the surface.'

Many writers (of both left and right) who try to find in
mass culture the kind of master image that does not exist,
arrive from a background of literary criticism. They are more
at home with Henry James, in fact, than with *News at Ten*.
You often have a feeling that they see the mass media as
having, somehow, *let them down*.

Except in a very flexible version, like that of Walter
Benjamin, a Marxist approach can also be a hindrance.* It is
notoriously difficult to relate the 'high art' of a period to its
social structure. You tend to emerge with such banalities as
'the novel is a bourgeois form' – without any means to explain
why, therefore, it reached one of its high points in Russia.
It is just as hard to relate mass culture *directly* to society as
a whole. (Advertising would seem the easiest to link to the
industrial base. But as an epigraph to his *Madison Avenue
USA*, Martin Mayer quotes an advertising text-book which
says: 'The student must avoid the error so frequently made

* Benjamin committed suicide trying to escape from the Nazis. Much
of his writing was essays or articles. There is a collection of some of
these, with an introduction by Hannah Arendt, under the title, *Illumina-
tions*. The essay most relevant to the present book is 'The work of art
in the age of mechanical reproduction'.

of assuming a simple cause-and-effect relationship between advertising and change in the consumption of a brand or product.' Why firms advertise, and why they advertise as they do, is a study in itself.)

Of course, without an industrial revolution there would be no masses in the modern sense; hence no art for or from them. Among other things, factories produce 'leisure' – which mass art, mass culture, can fill.

To come to grips with the fluidity of this, the best studies take one specific item or process and look at it in detail, though seldom at great length: Barthes's *Mythologies*, Orwell's essays, Benjamin again. Attempts to build more elaborate structures often collapse. They risk missing the point of mass art: its surface. Its secret depth is that it has no secret depth.

It is important *not* to read into the content, or apparent content, of mass culture a statement about those who are *using* that product. Not all the working people who read Horatio Bottomley's rabid *John Bull* were like that themselves. Nor do girls who read *Honey* live like *Honey* girls. I once heard E. P. Thompson use the phrase, 'stubbornness of being', to try to put this across. In other words, people are tougher than that. It is not media that use people but people that use media.

Mass art is openly available. It can be 'read' – interpreted – by anyone. A good definition of mass art would be that which anyone can have a view on, and that view be as valid as anyone else's. About other arts, the non-knowledgeable still have to clutch at some escape-phrase like 'I don't know much about it, but . . .' Mass art is what everyone knows about. It is 'mass' not in the sense that the 'mass of the people' are involved, but in the sense that everyone, of whatever social class, is. Everyone will have at least looked at the odd issue of *Bild* (if they are German), the *Sun* (if English), *France-Dimanche* (if French); and will have an opinion about these papers. Similarly with a Ford Cortina, a new man-made fibre, a Day-Glo sticker, a ready-to-wear suit, *Jaws*. This universality, very different from that of Shakespeare or Tolstoy, is of course what makes these arts interesting to examine; it is their strength; it should not be held against them.

Even in the making, a mass-cultural object is *never* a one-person production. Better call it a process than an object. Any substitution of a notional single author is misleading. This is the cardinal sin of the *Cahiers du Cinéma* concern with the director as supposed *auteur* of Hollywood big-studio films. Here, more accurately, is a cameraman talking:

I very much enjoyed making *The Song of Bernadette*. At the beginning of the picture, in Bernadette's home, when she comes in and stands there for a minute, you see a little glow on the wall, hardly noticeable, just like you would use to make a head stand away from an object behind it, but more intensified. I had this spotlight glow to the very end of the picture. And here is a perfect example of how little directors control things like this. When we looked at three cut reels, Henry King said, 'Do you notice something?' And I said, 'What?' And he said, 'Every time she appears there's something glowing at the back of her head.' I don't know whether he thought this was something spiritual that had crept into the picture from heaven! . . . You could do these things. You could add things for the picture on your own . . . (Charles Higham, *Hollywood Cameramen*)

Newspapers, magazines, cars, advertisements, television programmes, top twenty records: all are put together in this same way.

In much of western Europe now, a ten-year-old has great-grandparents who read the early cheap press, sat to have their likeness taken, listened to player-pianos. His grandparents went to the pictures, bought shellac records, listened to the wireless, danced the Charleston, thought Lindbergh a hero. His parents watched television, bought Quant and Biba style dresses, read paperbacks, drove around by car. What is *his* experience? What will his children's be? Even in the mass world of dreams, the biggest influence – or biggest filter of influence – is the family. For better or worse, and no better has so far been invented. (Most 'communes', as has been pointed out, are simply groups of couples living together.) But this ten-year-old's family is almost as saturated in mass culture as an American boy's would be. This will be most nearly true if the ten-year-old is English, a member of a nation urbanized

for more than a century. It will be least true if he is Spanish or Italian, where the scramble to get off the land continues. The more we are enveloped in mass media, the more we all become actors. How many people in England, for example, now know *no one* who has appeared on television, in whatever capacity? A programme like *Candid Camera* entirely depends on this willing theatricality. So do the increasing number of cheap studio-shows with participant audiences.

Simply because the mass media *are* mass, their techniques inevitably fit any particular group rather poorly. But many who say they oppose these techniques use them in their turn. An 'underground' press grew up, especially in America, in the 1960s. But its language was as sensational as what it attacked. 'Freaking the overground press has developed into something of an art within the movement. Characters like Abbie Hoffman and Jerry Rubin have misinformed and disrupted everything from documentaries to talk shows with varying degrees of sophistication. The whole Yippie operation at the 1968 Chicago convention was a matter of hype and super-hype.'* The underground and Richard Nixon had in common a belief in the power of manipulation.

In recent European history, the obvious comparison is with the Situationists, whose slogans appeared on the walls of Paris (also in 1968). Now any outsiders who want to protest effectively follow in those footsteps. Even the solidest trade unions have learned theatrical techniques. So have social reformers. The sixties and seventies have seen a rise in volunteer movements of one sort or another. But they are not of the nineteenth-century kind. They are often, crucially, pressure groups, using the techniques of publicity to influence central government. They depend on (are almost a part of) the mass media, and cannot achieve their aims either without them or without central government's ultimate help. This produces characteristic distortions. In its (obviously reasonable) wish to press the case of people in bad housing as well as those without a roof to lie under, Shelter has defined 'homeless' as covering both. It is more theatrical.

* Roger Lewis, *Outlaws of America: the underground press and its context.*

On the whole, the mass media handle politics poorly but
sex well (though it depends what you mean by 'well'). More
aspects of life have become sexualized than have become
politicized. The 'underground' put across its sexual message
better than its political one. The mass media are Reich-and-
water, not Marx-and-water.

This will continue to be true unless western Europe starts
to look to Russia or China for its model, instead of to
nineteenth-century England and twentieth-century America.
If, say, western Europe became communist, mass communica-
tions would change markedly. At the moment, mass com-
munications veer between the libertarian model of the press
(publish everything you can, whatever the consequence) and
the social-responsibility model (publish most things, but shy
away from reporting that which is 'socially harmful'). Report-
ing on race and rape show the resultant tensions. But the
one-party model (despite Poland's sideline in porn) is a means
of putting over the mass line; communication serves the party.
Urie Bronfenbrenner's *Two Worlds of Childhood* underlines
how different are the messages received by American and
Soviet children. In the USSR, it is not dreams that are
communicated but *a* dream. (Outside the official media, of
course, whether *Pravda*, the *People's Daily*, *Al Ahram* or *Ya*,
gossip is unassuaged and flourishes.)

The mass media are great inflaters of fashion* – including,
as education and half-education have spread, intellectual or
semi-intellectual ones. A disc jockey or a fur designer will try
to make the right noises about, for example, ecology. Mass
art is extremely *verbal*. Thus, television is largely parasitic
on newspapers – though they also feed from the hand that
they feed. The mass art of advertising (of which all other
genres are a special case?) has never got far away from
The Word.

This blur of purveyed opinion creates a haze it is hard to
see through. Much of it consists of mumbo-jumbo against
what is nonetheless going forward. As early as 1818, Francis

* In its heyday, cinema was more a part of the fashion trade than of
the art business.

Klingender* notes Mary Shelley's *Frankenstein* – a mass stereotype if ever there was one – as evidence for a 'mood of despondency which sprang from the unexpected frustration of the hopes placed in science and political reform'. And the painter, John Martin, plunged into nostalgia for the sublimity of Nineveh and Babylon: 'Into the solemn visions of antiquity we look without demanding the clear daylight of truth. Seen through the mist of ages, the *great* becomes *gigantic*, the wonderful swells into the *sublime*.'†

In Martin's painting, Marc Isambard Brunel's Thames Tunnel was used as an image of Hell. Now, presumably, he would have been a TV producer, deploring Birmingham's Aston Expressway.

One cumulative effect of mass communication nowadays is that, though transient in intention, it more and more puts itself on record. So the music, manners and modes of the past are instantly and synchronously to hand in a way they have never been before. Revivals of styles can go with ever-gathering speed. The cycle, rubbish-camp-acceptable-antique, has now become almost totally telescoped. Mass communication is like the memories in a mind half-asleep. Or like your mind when drowning? In everything, the mass media are flatteners and foreshorteners, like zoom-lens photography. Every high street with the same advertised brands; every newscast with the same news; every singer with the same tune. Even what is local becomes merely another candidate for mass consumption: good for a joke by Eddie Waring on *It's a Knockout*.

Sometimes it seems that sheer saturation is having its own rolling-back effect, and that the mass media are being turned to more individual uses. But all the talk about smallness has accompanied, step by step, the actual arrival of *larger* units – in administration, business, entertainment, everything. (In Britain, the much-heralded local radio stations are about as diverse as tinned peas bought in Manchester and tinned peas bought in London.) The essential shape of mass communication is not a late-night *Open Door* programme or a radio

* Francis Klingender, *Art and the Industrial Revolution*.
† Quoted in Klingender.

phone-in sex-advice half-hour, but the newspaper serialization of the book of the film of the TV show of the singer who wears those *fantastic* clothes . . .

The mass arts have become a natural resource. They provide images and feelings and sometimes words, which you can take off the peg and try on for fit. (Not all slogans persuade; not all designs sell.) These then become part of the cinema of the brain's internal fictions. An everlasting picture-show. [1976]

A note on the text

All the pieces in this book, except the Introduction, have previously appeared in *New Society*. Most were printed in the section from which the book takes its title, *Arts in Society*. Each week this takes a single theme and tackles it at essay length.

In the ten years I have run this feature, I have been very fortunate in the contributors who have helped in it. From the resulting stock of seven or eight hundred articles (allowing for material on the arts published in other parts of the magazine, too), I could have included in this book *something* on just about every conceivable aspect of the mass arts and of the arts seen socially. But after much hesitation, I decided to weave together articles by a number of our main regular voices during this time, with a very small admixture of 'irregulars'. It seemed to me that by reading the same person in different contexts, a better interplay of argument emerged. In a field where much discussion is of a pretty low quality, this is perhaps more use than trying to be too 'comprehensive'.

So, in a sense, there are obvious gaps in what this book covers. I hope it nonetheless stands up as a whole – as a coherent way of looking at these arts. The coherence is not ideological or stylistic. What all these authors share is a respect for the object actually under scrutiny; a high level of intelligence; and a low level of bullshit. They also respect ordinary people – the people because of whom the popular arts are popular.

Many of the pieces I have *not* included, of course, also had these attributes. I trust that those contributors not represented here will forgive me, and that no reader of *New Society* misses an article he particularly valued. I hope, too, that I shall be forgiven the self-indulgence of including an article of my own here and there, where it seemed to fit. (I make no claims for *their* quality . . .)

All carry their date of first publication, because this is some-

times relevant. Marc Bolan, John Lennon and Trevor Griffiths, for example, are not now where they were when Andrew Weiner, Michael Wood and Albert Hunt wrote about them. But such pieces still stand in their own right.

One or two of the contributions on painting and on theatre may need a special footnote.

I wanted to include something on the 'high arts' seen socially. Francis Bacon and Richard Hamilton, for example, are scarcely mass art. But both draw on mass stereotypes, and depend strongly on photography; and both are discussed here from a very non-arty, a very 'social' point of view.

Similarly, you could argue that no modern theatre apart from the Raymond Revuebar or the *Black and White Minstrel Show* is mass art. But at least the Half Moon Theatre has been working at that problem; and Trevor Griffiths feels the need to justify himself in terms of an *eventual* popular impact.

A last word on the two 'parting shots' which end the book. I simply find them both very enjoyable. I had originally sketched out a more solemn conclusion. But jokes are a serious form of discourse, too; and writing about mass culture should have at least some of the qualities Richard Hamilton (see my Introduction) attributes to that culture itself. Wit is one of these.

In any event, E. P. Thompson's social historical look at one not-so-mass paper, *The Times*, could be imitated for other papers in other contexts. And as for D. H. Lawrence, he is surely by now almost as much a mass novelist as Jacqueline Suzann. When Players cigarettes recently made a books offer to their customers, one of the discount-rate but 'handsomely bound' John Player Classics was *Sons and Lovers*.

PAUL BARKER

Styles

You can't go home again

Michael Wood

Nostal'gia, n. Homesickness as a disease. Except that home, in all our contemporary nostalgias, is invariably a place in the past, *is* the past. And the disease, if it is a disease, has suddenly become universal.

Of course it was always universal, in one sense. Most cultures dream of golden ages and gardens of Eden, and even so-called primitives dream of an even more primitive past, the original, unspoiled season described in so many myths. Most old folks can remember a time when beer was cheaper (well, even young folks can remember that), and people had more respect, and the corporation had not ploughed up those fields at the end of the street for council housing. Most of us remember odd patches of our lives with especial affection, sometimes patches that were not in themselves particularly pleasant – they provoke a sort of tenderness just because they are fragments of our past, pieces of ourselves. *These You Have Loved*, *Those Were the Days* and *Old-Time Music Hall* have long been standard fare at the BBC. Mary Hopkins used to sing – and still sings, on scattered jukeboxes in France and America – a song actually called *Those were the days*, and Anthony Newley, more recently, waxed lyrical about *The good old bad old days*. If Jerome Kern wrote *Yesterdays* (and he did), John Lennon and Paul McCartney wrote *Yesterday*. The Beatles, in fact, who seemed so full of the future, were also full of nostalgia: 'There are places I'll remember all my life,' they shouted; and 'No no, you're wrong, when I was a boy everything was right . . .'

We can probably take all this as the normal state of affairs. No tense is perfect, in spite of what grammarians say, especially not the present. We are always dissatisfied enough to be ready for some form of flight into the past, a package tour to one of our preferred Arcadias. Marxism often looks

less like a plan for an imaginable future than like a yearning
for a lost human innocence and generosity. De Gaulle's whole
career was based on an implicit appeal to Joan of Arc and
Louis Quatorze (not to mention Vercingetorix and Charle-
magne), and Teddy Kennedy's whole non-career is predicated
on a nostalgia for his dead brothers. Nostalgia speaks to a
sense of loss, and it's hard to think of a time in public or in
private life when we have not lost something.

But then it is the loss (real or imagined) that counts. All
flights into the past (or into the future for that matter) are
boarded in the present. You need to get old before you can
start talking about how things were when you were young.
You have to experience change before you can compare the
old days and the new. And on the level of myth, you have
to suffer from the absence of Eden before you can invent it,
you can't pick up the halves of a divided self before the
division has taken place. The true paradises, as Proust says, are
lost paradises. Nostalgia looks to the past, but it belongs to
the present. Whatever its object or its content, it is a way of
behaving *now*.

And that is what is so interesting about our particular *now*,
about our forlorn 1970s. For if ordinary, run-of-the-windmill
nostalgia expresses a sense of loss and dissatisfaction, what are
we to make of the rampant, ubiquitous, unashamed nostalgia
which leers at us these days whichever way we turn? We don't
seem to care which piece of the past we get, or how we get
it: Henry VIII, Elizabeth I, *Dad's Army*, *The Onedin Line*,
Upstairs, Downstairs, Lord Peter Wimsey, *The Forsyte Saga*,
The Pallisers, *The World at War* – all trade on nostalgia in
some way, and that is to speak only of television. If we
happen not to like one or two of those items, we love several
of the others, and the Ghost of Christmas Past wins, whatever
we do. At the cinema, if we don't fall for *Gatsby*, there's
always *That's Entertainment* (*that's* entertainment?). Fellini
remembers Fellini in *Amarcord*, and Bertolucci is making a
film called *1900*. Among people who still read books, the
growing taste for biography is probably a variety of nostalgia
for an older form of novel, for the kinds of truth novels used
to offer to tell us. There are a great many styles of dress and

styles of make-up that function principally by means of a recall of an older period.

Most striking of all, the world of popular music has simply become haunted by the fifties; literally haunted by the resurrection of Bill Haley and what appears to be the eternal, youthful middle age of Chuck Berry, and synthetically haunted by the countless new combos who either dress like fifties groups or sing like them or both. To see the movie *Let the Good Times Roll* is to experience something like double vision. Here is a film based on a 1970s concert given by 1950s stars like Little Richard and Bo Diddley, and time seems both to pass and not to pass. The non-musical historical clips in the picture – photographs of the young Nixon, a moment from Brando's *The Wild One*, shots of fifties teenagers all ribbons and sneakers and brilliantine – make the 1950s seem a thousand years away, an age of very strange costumes and hairdos and notions about charm. The clips showing the performers, on the other hand, suggest nothing has changed, except the waistlines and hairlines of the performers themselves. Their music and their dress are uncannily close to what we are hearing and seeing now. Turn on your television and you will see Alvin Stardust, who looks just like Elvis Presley got up as a ghost, and sings the way he looks.

Such abandonment to the visions of yesterday – the phrase is the title of Jeffrey Richards's book about imperialist movies, a work of nostalgia disguised as a piece of history – suggests a vast despair about today, and plainly today is not the best of times. But nostalgia is not really a response to danger or disaster or rising prices – when those elements strike you're too busy and too angry to be nostalgic. When the cost of meat goes up again, when the bombs begin to appear in your neighbourhood, you may well wish you lived back in the old cheaper, quieter days; but you wish a lot of other things first. What nostalgia mainly suggests about the present is not that it is catastrophic or frightening, but that it is undistinguished, unexciting, blank. There is no life in it, no hope, no future (the important thing about the present is what sort of future it has). It is a time going nowhere, a time that leaves nothing for our imaginations to do except plunge into the past.

Well, we can embroider on the present a little, if we insist
on being serious. What is really behind all that talk of the
need for moderation in British politics, of the need for a brave
new middle party, is the sense of a fine old car running out of
petrol. We are so sunk in moderation that we try to make
a virtue out of it. We *invent* a friendly garage which just
happens to be placed where the car looks like stopping. The
American silent majority – if there ever was one – was based
on a similar, and similarly faint-hearted fantasy: the hope that
your coughing and spluttering car will not need any major
repairs. All these lame visions do is help us to see why
nostalgia is having such a run.

Nostalgia points to the death of dreams, to a depleted
graveyard where only shadows of what you once believed
remain. English Tories don't really believe in free enterprise
any more than English Socialists really believe in nationaliza-
tion; and this might be seen as progress if it were not clearly
experienced as a loss of faith and energy. Americans don't
really believe in America; and again, this would be a welcome
sign of maturity, if it were not plainly a moral disaster. We
have lost all our old gods, and have not yet invented new ones.
The trouble is, the new ones are not likely to appear just
because we need them. Or perhaps they will appear when we
need them *enough*; but that doesn't seem to be yet, the car
has to rattle on for a few more sad miles. It is also possible,
of course, that no new gods will appear at all, that the car
will just stop for good. We could find ourselves camping out
indefinitely in our current landscape. In the meantime, though,
we have our memories of our hours of greatness, a clear
contrast to our present disarray.

This is the obvious attraction of the series of television
plays about Henry VIII, and of all the programmes about the
Second World War. We were *confident* in the sixteenth cen-
tury – profligate, masterful, domineering. Those were the days.
And we were brave during the war, we stuck together and we
kept going, and we *won*. And there were proper enemies then,
too. None of your invisible IRA, using unforgivable tactics,
in a cause you half-suspect may be right, but real Germans,
monocled, heel-clicking monsters. The reappearance of these

sinister Huns in shows like *Colditz* has provoked a certain amount of stir among decent-minded people; but what such Germans are in such contexts are simply figments of an English dream of an old glory. The constant recourse to the 1950s in current pop music has the same source, I think: those were the great days, the 'golden age of rock 'n' roll', as the lyric of a recent song literally has it.

But some of our other nostalgias are more subtle and more complicated. There is what we can call the Last Days of Pompeii nostalgia, for example. The film, *That's Entertainment*, is ostensibly a celebration of the heroic era at MGM, but its real theme is the *end* of MGM, signified by the auction of famous, familiar properties when the studio was sold. We see all the triumphs, that is, across our awareness of the studio's disappearance, and the effect is something like that of one of those sob stories where everyone except the heroine knows the heroine's done for. The same is true, I think, of *The Forsyte Saga* and *The Pallisers*, and in the comic rather than the elegiac mood of *Upstairs, Downstairs*. These are worlds and styles we shall not see again, and we are conscious of their demise even as we gloat over their re-creation.

The Onedin Line plays out the paradox even more clearly. It is not just that sailing ships are obsolete (they don't make 'em like that any more), and therefore available for nostalgia. It is rather that such obsolescence lends a special pathos to every sailing ship we see on the screen, because we see its death written into its very life. Similarly, Don McLean's song *American pie* has identified a certain America as ending with the death of Buddy Holly, 'the day the music died'. Rock 'n' roll itself, that expression of youth and energy and sexuality, had gone with the wind, and we were invited to look back at it with eyes of weary mourning. This is nostalgia, then, which enjoys doom as it sorrows over it, which looks to the past for a music or a style or a set of achievements which make the present look poor; but then which consoles itself for the invidious comparison by the reflection that nothing lasts forever. It is a nostalgia for the great, final, dwindling days of something that has vanished.

Conversely, there is a nostalgia for the early days of what

we have (whatever it is we have), a Beginning of the End nostalgia. Losey's film *The Go-Between*, for example, and Visconti's *Death in Venice*, take us back to the turn of the century, to a glossier, more graceful time, a place of formal manners and fulsome costumes. But then they find there the germs of all our current discontents. 'The past is a foreign country,' Losey says, quoting from L. P. Hartley's novel. 'They do things differently there.'

Well, they do and they don't. This is a past which is far enough away to seem exotic and yet near enough to belong, unmistakably, to us. The charm of such evocations is that they picture us as poised on the brink of what we were to become. Nothing really seems irrevocable. This is the time before things turned out the way they did, the time when they might have gone the other way (the equivalent time in American nostalgias is the perfect, static time of westerns, the moment *just before* civilization set in and cleaned up that wild but vivid country). It presents not a choice but at least a temporary illusion of freedom from what historically happened. It is a nostalgia for an edge of an era, reflects a desire to get out of modernity without leaving it altogether. This is very common in recent movies, whatever their setting and period (*Far from the Madding Crowd*, the remakes of *Jane Eyre* and *Wuthering Heights*, Visconti's ghastly *Ludwig*), and I think it has something to do with the current revival of interest (if there is a revival of interest) in people like Gissing and Wells and Bennett.

They were men who lived among the origins of what was to be our world, and we return to their lives (if not to their works) with a dim or sometimes anxious curiosity about what it was like to be around when the twentieth century had played so few of its now familiar marked cards. We don't expect to learn how to live from them, or how things could have been different. We do hope, I think, to breathe the fresh air of a past which is not quite a foreign country. Hardy wrote (in *Tess of the D'Urbervilles*) of the 'ache of modernity', and, seen from here, that ache has the appeal of a vital clue to some ill-defined puzzle. We are all positively arthritic with the ache of modernity, and it would be a form of rejuvenation

to find out what the ache felt like when it was just beginning.

The music of Scott Joplin plays a similar tune. In it we hear both the drawing-rooms of the nineteenth century and the honky-tonks of a slightly later time. We can enjoy all kinds of combinations and emphases in these slender, complicated, melancholy pieces: the drawing-room perks up because of its association with the honky-tonk; the honky-tonk gets a bit of tone, a *tradition*, from the drawing-room; there is a new land between the drawing-room and the honky-tonk, a transitional musical territory which foreshadows our own day, which is also (some say) a time of transition, and not just in music. But whatever our enjoyment, we get it from the same place, from the same excursion into a past which is partly the present.

I imagine there are all sorts of other nostalgias, each with their different relation to the past, but these will do for a start. The more so since it is, after a while, not so much the profusion of our current nostalgias that comes to seem so striking, as their *frankness*. A few years back, it seems to me (can this be the beginning of a nostalgia for a time when we weren't so nostalgic?), we were a lot more sheepish or ironic about our trips down memory lane. We may have kept a place in our hearts for the songs we sang when we were young, but we didn't expect to find them in the hit parade again, and if we had found them there, we shouldn't really have known what to do except smirk a bit. The Temperance Seven were our idea of nostalgia, and what an edgy, jokey look back in bashfulness that was. Today's nostalgia seems entirely unapologetic, a sort of gleeful wallowing in what's gone, and there is some kind of moral progress there: open nostalgia is one step nearer to a confession of what's up with the present.

It may be useful to compare this new state of our sensibility with the set of tastes that went, not so long ago, under the name of 'camp' (Susan Sontag's *Notes on Camp* appeared in 1964). Camp was, among many other things, nostalgic. But it was, like the rest of us, furtively nostalgic, it kept glancing over its shoulder to see if it was being followed by agents of the present. An old movie might be good because it was bad,

but that wouldn't stop you from judging a new movie to be
good because it was good (or bad because it was bad). You
would queue up for hours to see the terrible wartime serial
version of *Batman and Robin* ('Take that, you filthy Jap'),
but you would also queue up for hours to see a new Bergman
film. Now, it seems to me, it takes a real effort to go to see
a new film at all, and most new films are simulations of old
films anyway, costume dramas of the twenties and thirties, like
Gatsby and *Paper Moon*.

Or to follow the same development along the line of a
single instance: *Casablanca*, which used to be a great camp
romantic movie, loved for its exquisite mushiness, is now
frequently taken to be a great movie *tout court*, a misty work
of art from the forgotten past, something like *The Great Train
Robbery* or Garbo's *Camille*. This has a lot to do simply
with the passing of time, of course, but it also has to do with
our conversion of irony into plain regret. Television shows like
Star Trek and *The Avengers* mark the same movement. They
used to seem silly and innocent (*Star Trek*), brittle and stylish
(*The Avengers*), and we watched them with pleased condescen-
sion, enjoying a joke with (presumably) their producers. But
now we watch them (if we can see them again, and in
America, where television is like the mind of a drowning man,
you can always see everything again) with nostalgia. Whatever
happened to innocence and style, and how could two shows
be so self-possessed, so certain of their effects and their
audiences? 'They don't make them like that any more.' The
phrase itself, which used to serve as a parody of nostalgia,
has lost its edge, and now seems to mean just what it says.
We have heard the chimes at midnight, Master Shallow.

In the 1960s, then, in or out of camp, we were fairly
surreptitious and ambivalent about the pleasure we took in
the past, because we didn't want to relinquish our hold on the
present, on whatever it meant to be modern. Now that the
present seems so full of woe, and being modern seems to
mean some sort of vast technological treason against the
planet, we have simply let go; we have taken the plunge and
named the nostalgia that used to be so wary of speaking its
name. For this is where everything points: the profusion and

frankness of our nostalgia, the taste for the Great Days of England, for the Last Days of Pompeii and for the Beginning of the End, and for much else littered about the unreconstructed past. It all suggests not merely a sense of loss and a time in trouble, but a general abdication, an actual desertion from the present.

It would be useful, of course, if we could distinguish between genuine, substantial expressions of nostalgia and casual and calculating exploitations of it, but we probably can't. Even exploitations, like *The Pallisers*, and the hoo-ha connected with *Gatsby*, and the innumerable books of soft-focus memoirs by film stars and social layabouts, all become a part of the expression. Nostalgia is now a climate, not a set of particular intentions.

Its origins or early signs are another business, though. *Bonnie and Clyde*, for example, released in 1967, was accused of glamorizing violence, which it certainly did. But it also glamorized *the past*, and was a direct precursor of, say, *The Sting*. *The Forsyte Saga*, first shown in 1967, was early enough to be antiquarian rather than nostalgic, but it paved a lot of the way. The Beatles, not more than ordinarily nostalgic themselves, were clearly precursors of the new nostalgia, and are now objects of nostalgia in their own rite.

These origins and sequels all point to an element of charade in our nostalgia, an element of dressing up, a sense of style as a variety of disguise. Redford and Newman in *The Sting* don't really look like hustlers in old Chicago, any more than Faye Dunaway and Warren Beatty in *Bonnie and Clyde* looked like gangsters on the run. They all look like modern people, our own contemporaries rigged out in quaint fancy dress, and this is perhaps the point. These are trips to the past, allusions to it, implications of the past in the present. A girl who borrows her grandmother's shawl and garnets doesn't want to look like her grandmother, she wants to look like an up-to-date girl fashionably arrayed in a memory. The 1920s make-up doesn't revive the Jazz Age, it allows an echo of the Jazz Age to play across a 1970s face. We should probably distinguish, then, between the nostalgia provoked by an old photograph, say, and the nostalgia provoked by a

movie that looks like an old photograph. In the one case, a piece of the past is experienced as lost; in the other, a general sense of loss makes us look around for a piece of the past that will suit our present feelings. We haven't lost it because we have only just made it up. In any event, as long as we spend so much energy and imagination on these versions of what we never had, we can hardly hope to do anything with what we *do* have. But then, if we had any hopes for what we have, we shouldn't spend so much time rummaging among these old disguises; and the wheel comes full circle and starts another spin.

This, I think, is where I had better get off. I feel a distinct need to riffle through my cigarette-card collection before I get my pumps out for my old-time dancing class. No harm in a bit of nostalgia, after all. Home is where the heart is, and homesickness cannot really be all that serious a disease. Except that there is the difference I suggested earlier between occasional nostalgia and constant, omnivorous nostalgia; the sort of difference there is, for example, between the seasonal migration of many birds and the terminal, one-way excursions of lemmings. [1974]

Notes for a theory of sixties style

Angela Carter

Velvet is back, skin anti-skin, mimic nakedness. Like leather and suede, only more subtly, velvet simulates the flesh it conceals, a profoundly tactile fabric. Last winter's satin invited the stroke, a slithering touch, this winter's velvet invites a more sinuous caress. But the women who buy little brown velvet dresses will probably do so in a state of unknowing, unaware they're dressing up for parts in our daily theatre of fact; unaware, too, how mysterious that theatre is.

For the nature of apparel is very complex. Clothes are so many things at once. Our social shells; the system of signals

with which we broadcast our intentions; often the projections of our fantasy selves (a fat old woman in a bikini); the formal uniform of our life roles (the businessman's suit, the teacher's tweed jacket with leather patches and ritual accessory of pipe in breast pocket); sometimes simple economic announcements of income or wealth (real jewellery – especially inherited real jewellery, which throws in a bonus of class as well – or mink). Clothes are our weapons, our challenges, our visible insults.

And more. For we think our dress expresses ourselves but in fact it expresses our environment and, like advertising, pop music, pulp fiction and second-feature films, it does so almost at a subliminal, emotionally charged, instinctual, non-intellectual level. The businessmen, the fashion writers, the designers and models, the shopkeepers, the buyers, the window dressers live in the same cloud of unknowing as us all; they think they mould the public taste but really they're blind puppets of a capricious goddess, goddess of mirrors, weather-cocks and barometers, whom the Elizabethans called Muta-bility. She is inscrutable but logical.

The inscrutable but imperative logic of change has forced fashion in the sixties through the barriers of space and time. Clothes today sometimes seem arbitrary and bizarre; neverthe-less, the startling dandyism of the newly emancipated young reveals a kind of logic of whizzing entropy. Mutability is having a field day.

Let us take the following example. A young girl, invited to a party, left to herself (no mother to guide her), might well select the following ensemble: a Mexican cotton wedding dress (though she's not a bride, probably no virgin, either – thus at one swoop turning a garment which in its original environment is an infinitely potent symbol into a piece of decoration); her grandmother's button boots (once designed to show off the small feet and moneyed leisure of an Edwardian middle class who didn't need to work and rarely had to walk); her mother's fox fur (bought to demonstrate her father's status); and her old school beret dug out of the loft because she saw Faye Dunaway in *Bonnie and Clyde* (and a typical role-definition garment changes gear).

All these eclectic fragments, robbed of their symbolic con-

tent, fall together to form a new whole, a dramatization of the individual, a personal style. And fashion today (real fashion, what real people wear) is a question of style, no longer a question of items in harmony. 'What to wear with what' is no longer a burning question; in the 1960s, everything is worn all at once.

Style means the presentation of the self as a three-dimensional art object, to be wondered at and handled. And this involves a new attitude to the self which is thus adorned. The gaudy rags of the flower children, the element of fancy dress even in 'serious' clothes (the military look, the thirties revival), extravagant and stylized face-painting, wigs, hairpieces, amongst men the extraordinary recrudescence of the decorative moustache (and, indeed, the concept of the decorative man), fake tattooing – all these are in the nature of disguises.

Disguise entails duplicity. One passes oneself off as another, who may or may not exist – as Jean Harlow or Lucy in the Sky with Diamonds or Al Capone or Sergeant Pepper. Though the disguise is worn as play and not intended to deceive, it does nevertheless give a relaxation from one's own personality and the discovery of maybe unsuspected new selves. One feels free to behave more freely. This holiday from the persistent self is the perpetual lure of fancy dress. Rosalind in disguise in the Forest of Arden could pretend to be a boy pretending to be a seductress, satisfying innumerable atavistic desires in the audience of the play. And we are beginning to realize once again what everybody always used to know, that all human contact is profoundly ambiguous. And the style of the sixties expresses this knowledge.

The *Bonnie and Clyde* clothes and the guru robes certainly don't indicate a cult of violence or a massive swing to transcendental meditation (although *Rave* magazine did feature a 'Raver's Guide' to the latter subject in the November issue); rather, this rainbow proliferation of all kinds of fancy dress shows a new freedom many people fear, especially those with something to lose when the frozen, repressive, role-playing world properly starts to melt.

Consider a typical hippy, consider a typical Chinese Red

Guard. One is a beautiful explosion of sexually ambiguous silks and beads, the other a sternly garbed piece of masculine aggression, proclaiming by his clothes the gift of his individual self to the puritan ethic of his group. The first sports the crazy patchwork uniform of a society where social and sexual groupings are willy-nilly disintegrating, the second is part of a dynamically happening society where all the individuals are clenched together like a fist. One is a fragment of a kaleidoscope, the other a body blow. One is opening out like a rose, the other forging straight ahead.

Of course, one does not have to go so far afield as China to see this dichotomy of aim. If you put the boy in the djellibah next to a middle-aged police constable, each will think of the other: 'The enemies are amongst us.' For the boy in the djellibah will be a very young boy, and the class battle in Britain (once sartorially symbolized by Keir Hardie's cloth cap) is redefining itself as the battle of the generations.

The Rolling Stones drugs case was an elegant confrontation of sartorial symbolism in generation warfare: the judge, in ritually potent robes and wig, invoking the doom of his age and class upon the beautiful children in frills and sunset colours, who dared to question the infallibility he represents as icon of the law and father figure.

The Rolling Stones' audience appeal has always been anti-parent, anti-authority, and they have always used sartorial weapons – from relatively staid beginnings (long hair and grime) to the famous *Daily Mirror* centre spread in super-drag. They are masters of the style of calculated affront. And it never fails to work. The clothing of pure affront, sported to bug the squares (as the Hell's Angels say), will always succeed in bugging the squares no matter how often they are warned, 'He only does it to annoy'.

The Hell's Angels and the other Californian motor-cycle gangs deck themselves with iron crosses, Nazi helmets, necklets and earrings, they grow their hair to their shoulders and dye their beards green, red and purple, they cultivate halitosis and body odour. Perfect dandies of beastliness, they incarnate the American nightmare. Better your sister marry a Negro than

A.S. B

have the Oakland chapter of Hell's Angels drop in on her for coffee.

But this outlaw dress represents a real dissociation from society. It is a very serious joke and, in their Neanderthal way, the Hell's Angels are obeying Camus's law – that the dandy is always a rebel, that he challenges society because he challenges mortality. The motor-cycle gangs challenge mortality face to face, doing 100 m.p.h. on a California freeway in Levis and swastikas, no crash helmet but a wideawake hat, only a veneer of denim between the man and his death. 'The human being who is condemned to die is, at least, magnificent before he disappears and his magnificence is his justification.'

In the decade of Vietnam, in the century of Hiroshima and Buchenwald, we are as perpetually aware of mortality as any generation ever was. It is small wonder that so many people are taking the dandy's way of asking unanswerable questions. The pursuit of magnificence starts as play and ends as nihilism or metaphysics or a new examination of the nature of goals.

In the pursuit of magnificence, nothing is sacred. Hitherto sacrosanct imagery is desecrated. When Pete Townshend of The Who first put on his jacket carved out of the Union Jack, he turned our national symbol into an abstraction far more effectively than did Jasper Johns when he copied the Old Glory out in paint and hung it on his wall. Whether or not Pete Townshend fully realized the nature of his abstraction is not the question; he was impelled to it by the pressures of the times.

Similarly, fabrics and objects hitherto possessing strong malignant fetishistic qualities have either been cleansed of their deviational overtones and used for their intrinsic textural charm, or else worn in the camp style with a humorous acknowledgement of those overtones. Rubber, leather, fur, objects such as fishnet stockings and tall boots are fetishes which the purity of style has rendered innocent, as sex becomes more relaxed and the norm more subtle.

Iconic clothing has been secularized, too. Witness the cult of the military uniform. A guardsman in a dress uniform is ostensibly an icon of aggression; his coat is red as the blood he hopes to shed. Seen on a coat-hanger, with no man inside

it, the uniform loses all its blustering significance and, to the innocent eye seduced by decorative colour and tactile braid, it is as abstract in symbolic information as a parasol to an Eskimo. It becomes simply magnificent. However, once on the back of the innocent, it reverts to an aggressive role: to old soldiers (that is, most men in this country over 40) the secularized military uniform gives far too much information, all of it painful. He sees a rape of his ideals, is threatened by a terrible weapon of affront.

A good deal of iconic clothing has become secularized simply through disuse. It no longer has any symbolic content for the stylists and is not decorative enough to be used in play. Mutability has rendered it obsolescent. The cabaret singer in her sequin sheath which shrieks 'Look at me but don't touch me, I'm armour-plated' survives as an image of passive female sexuality, the *princesse lointaine* (or, rather, the *putain lointaine*) only in the womblike unreality of the nightclub or on the fantasy projection of the television screen. The tulle and taffeta bride in her crackling virginal carapace, clasping numinous lilies, the supreme icon of woman as a sexual thing and nothing else whatever, survives as part of the potlatch culture at either end of the social scale – where the pressures to make weddings of their daughters displays of conspicuous consumption are fiercest.

On the whole, though, girls have been emancipated from the stiff forms of iconic sexuality. Thanks to social change, to contraception, to equal pay for equal work, there is no need for this iconography any more; both men and women's clothes today say, 'Look at me and touch me if I want you.' Velvet is back, skin anti-skin, mimic nakedness. [1967]

An anatomy of rubbish

Michael Thompson

I am at present working on a theory of communication, not of 'messages' but of 'things'. Marriage can be reduced to a system of communication of women between groups of men. Economics can be seen as a communication system in which the various goods are transmitted according to certain (often very complex and specific) rules. Traffic can be studied as a communication system in which vehicles are communicated between the different road junctions.

Such an approach – which treats women and groups of men as essentially the same as buses and roundabouts – does not need to take account of human attributes such as motivation, love, expectation . . . It separates marriage from morality, and economics from the assumptions of rational behaviour. It treats phenomena like marriage and the circulation of goods as if they were just a part of the environment. Nonetheless, an important distinction must be made between two kinds of communicable things:

1. Things which remain exactly the same, not wearing out, or breaking, or being eaten, as they are passed from one communicator to another. Once such a 'communiqué' has been introduced into a communication system, it can pass through a theoretically *infinite* number of transmissions. Communiqués of this type we can call 'durable'.

2. Things which have only a limited life-expectancy. Items of food seldom pass through many hands before they are eaten. Tools, pots, pans, clothes, likewise get broken or wear out. Such a communiqué, introduced into a communication system, will pass through a *finite* number of transmissions and then cease to exist. Communiqués of this type we can call 'transient'.

Different types of communicable things can be arranged

along a continuum, running from extremely transient to durable:

Transient
pole

Durable
pole

| Food | Tools | Clothing | Jewellery |

But this is too easy. The difference between the transient and the durable, in many cultures, is not truly one of degree but of kind. It is the difference between a finite number and infinity. One of the best-known examples is in the Trobriand Islands, off south-east New Guinea. There, the 'durable' goods (shell ornaments and necklaces) are associated with a highly ceremonial, magical and prestige-ridden sequence of transmissions; while the 'transient' goods (foodstuffs, pigs, tooth-dye) are transmitted in a mundane, matter-of-fact manner. The distinction is a commonplace among anthropologists and Paul Bohannan has used it to distinguish between 'spheres of exchange'.

Our own society makes the distinction, too – though in a more complicated way. Certainly we see some things as durable, some as transient. But something transient can *become* durable: 'junk' can become 'antique'. How?

Take the motor car as a first example. With few exceptions (Rolls-Royces, Ferraris), a car is transient in nature. One buys it shining and new; gradually it becomes battered, rusty and worn out. As this process takes place, so the trade-in value decreases. The ordinary motor car is not only transient by nature, it is also accepted and treated by us as transient. Yet some very old cars – which might be expected to be 'worthless' by now – are fantastically valuable. Enthusiasts will pay £1,000 for a Red-Label Bentley in appalling condition, and then devote an enormous amount of time and money to restoring it to its former glory. The owner will never allow it to return to the dilapidated condition in which he bought it.

In case you might want to argue that a Red-Label Bentley is somehow exceptional (like Rolls-Royces and Ferraris), let

me add that old Austin Sevens and interwar MG sports cars, which were practically worthless not long ago, are now highly prized. So long as they are well maintained, they can only increase in value.

There are other examples of this process. Take antiques. Chippendale chairs are transient in nature. The battered state of many of those that survive shows that their first owners regarded them as such. The present owners, by contrast, have spent a lot of effort on restoring them and treat them with the utmost care and delicacy.

Take houses. These are rather interesting, being communicated not in physical space but in sociological space. The houses stay in the same place and only the owners change. The Georgian and early Victorian houses in Islington were built speculatively in north London for the middle-class market. They must originally have been seen as functional and good value for money. In other words, they were transient, and as the years passed their value dropped (helped by the railways which made it possible to live in fashionable Victorian suburbs). Eventually, after the First World War, they became almost worthless. They became tenements, housing one lower-class family per floor; and the rents did not even cover the cost of essential repairs. Islington became one huge slum — acres and acres of almost worthless transient houses. But then, about ten or fifteen years ago, Georgian houses were suddenly all the rage, and adventurous middle-class people started to buy these slum houses and to restore them, at considerable expense. Now, many of the squares are almost entirely restored, and are subject to preservation orders. The houses are unlikely ever to be allowed to fall into disrepair, for the very sound reason that a house which ten years ago cost £750 can now be sold for £18,000 (Noel Road, overlooking the Regent's Canal). These Islington houses have become 'durable'.

A preservation order is confirmation that a house has become durable; but acquisition by the National Trust (or by a museum in the case of a movable communiqué) is the final crystallization of durability – complete withdrawal from the field of communication. Thus, in the Trobriand Islands a very few of the shell valuables are so fine, and have such illustrious

histories, that they are no longer exchanged but are permanently displayed in the villages, and so provide the New Guinea equivalent to the Tate Gallery.

A tremendous sense of shock was caused by the recent Florence floods. There was a great response, both in practical assistance and in funds, to the subsequent appeal. Both the shock and the response were on a scale quite out of proportion to the loss of life and limb, the criterion by which we normally measure such disasters. This extreme response relates to the appalling jolt delivered to our conceptual categories by the news that some supremely durable objects of the western world (the art treasures of the Renaissance) had, overnight, become supremely transient.

It is extraordinarily difficult for people to transfer something from one category to another. Mary Douglas (in her book, *Purity and Danger*) has shown the tremendous lengths that are necessary (pollution avoidances or taboo behaviour) to keep our categories distinct and watertight in the face of nature's constant tendency to break down these differences. To transfer things wantonly leads to a rapid breakdown of distinctions. There are practical difficulties also: it is just not reasonable to expect that when you go to bed you have in your garage a transient and practically worthless Hispano-Suiza, and that when you wake up in the morning it is a durable and extremely valuable Hispano-Suiza. That sort of thing happens in fairy tales but not in real life. (This is probably the most important feature of fairy tales: the reckless crossing of categorical boundaries – for example, low-class animal to high-class human in the case of the frog transformed into a prince.) The direct transition from 'transient' to 'durable' (as shown in the diagram below) is not possible.

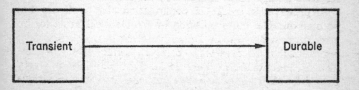

One way around the problem is for us to create a special intermediate category where the 'thing' can rest unnoticed until its association with the transient category has disappeared. Once this has happened, then it can be 'discovered' and transferred without much difficulty to the 'durable' category. All the things in this intermediate category would have to be almost worthless, because anything valuable could scarcely be forgotten. One can represent the process thus:

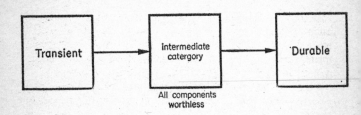

This is, in fact, the mechanism actually used. The middle category we call 'rubbish'. Once a car has become more and more battered, and less and less valuable, and more and more 'out of date' (an expression only used in reference to transient things), it becomes material that is good only for scrap or the junkyard.

The people who buy, sell, do up and use these vehicles also fall within the 'rubbish' category. Students and unmarried young men are really neither one thing nor the other. They are not dependent like children, yet not responsible like 'grown-ups'. All the cars at present being restored and done up and made into 'durable' cars, have passed through this 'rubbish' category and have then been discovered and upgraded.

A car passes from the 'transient' category to the 'rubbish' category because of the combined effects of obsolescence (the result of technological evolution) and of dilapidation (the result of its being accepted and treated as transient). A car passes from the 'rubbish' category to the 'durable' category by the process of restoration (requiring time, money and faith on the part of the owner). Obsolescence and dilapidation proceed

rather slowly; 'discovery' and restoration tend to be faster. We can represent the mechanism of transformation thus:

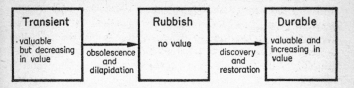

This explanation is entirely structural. The sequence, transient/rubbish/durable, is spread out in time, but I haven't given explanations of the causal type: 'Such and such happened and gave rise to such and such six weeks later.' Why should such a transformation take place at all?

I think it started with the industrial revolution. Leslie White, the American culturologist, said: 'Culture advances as the energy harnessed per capita per annum increases, or as the efficiency of control of the energy increases, or both.' A graph showing the energy harnessed in the western world, per capita per year, must look like this:

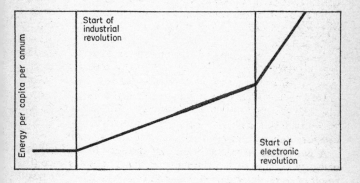

The change in gradient at the start of the industrial revolution is due to the sudden increase in energy harnessed (machines as extensions of human muscles). The change in gradient at the start of the electronic revolution is largely due

to increases in efficiency in controlling the energy (computers as extensions of the nervous system).

With the industrial revolution, the pre-industrial way of life became an art form. The collection of antiques and an interest in rural customs became popular at this time. Such activities were in line with the high regard for property and for knowledge (both at that time scarce resources). This was the transformation. Once started, it acquired increasing momentum, but the rubbish always had to be pre-1830 rubbish (no post-1830 items are allowed even now in the London Antique Dealers' Fair).

However, what is happening now is not an exact replica of what happened with antiques at the start of the industrial revolution. The speed-up of the electronic revolution is killing the process off.

Things are passing through the transient/rubbish/durable sequence at an ever-quickening rate. Two years ago I was coming to like St Pancras station, now St Pancras is as established as a Nash terrace. Then I had to sharpen my taste for 1930s seaside bungalows and tiled pubs. One year it was Victorian clothes; next year it was the co-respondent shoes and double-breasted suits of the 1930s. Now, old WRAC overcoats of the 1940s are being bought up. Very soon, everything will have passed through the transformation. The entire mechanism will then cease to exist as quickly as we acquired it at the start of the industrial revolution.

The essential feature of 'camp' taste is that things are lifted out of the rubbish category 'before their time'.

The whole outrageous attraction of 'camp' lies in the individual's quest for rubbish to discover and make durable, and in the confusion it causes to the conceptual categories of those who have not caught up with you. It is an ephemeral pleasure, because the transient/rubbish/durable transformations, which are its matrix, will soon no longer exist. [1969]

Arts 1
Photography and Painting

No more portraits

John Berger

It seems to me unlikely that any important portraits will ever be painted again. Portraits, that is to say, within the sense of portraiture as we now understand it. I can imagine multi-medium memento-sets devoted to the characters of particular individuals. But these will have nothing to do with the works now in the National Portrait Gallery.

I see no reason to lament the passing of the portrait – the talent once involved in portrait painting can be used in some other way to serve a more urgent, modern function. It is, however, worth while enquiring why the painted portrait has become outdated; it may help us to understand more clearly our historical situation.

The beginning of the decline of the painted portrait coincided roughly speaking with the rise of photography, and so the earliest answer to our question – which was already being asked towards the end of the nineteenth century – was that the photographer had taken the place of the portrait painter. Photography was more accurate, quicker and far cheaper; it offered the opportunity of portraiture to the whole of society: previously such an opportunity had been the privilege of a very small elite.

To counter the clear logic of this argument, painters and their patrons invented a number of mysterious, metaphysical qualities with which to prove that what the painted portrait offered was incomparable. Only a man, not a machine (the camera), could interpret the soul of a sitter. An artist dealt with the sitter's destiny: the camera with mere light and shade. An artist judged: a photographer recorded. Etcetera, etcetera.

All this was doubly untrue. First, it denies the interpretative role of the photographer, which is considerable. Secondly, it claims for painted portraits a psychological insight which

99 per cent of them totally lack. If one is considering por-
traiture as a genre, it is no good thinking of a few extra-
ordinary pictures but rather of the endless portraits of the
local nobility and dignitaries in countless provincial museums
and town halls. Even the average Renaissance portrait—
although suggesting considerable presence – has very little
psychological content. We are surprised by ancient Roman or
Egyptian portraits, not because of their *insight*, but because
they show us very vividly how little the human face has
changed. It is a myth that the portrait painter was a revealer
of souls. Is there a qualitative difference between the way
Velasquez painted a face and the way he painted a bottom?
The comparatively few portraits that reveal true psychological
penetration (certain Raphaels, Rembrandts, Davids, Goyas)
suggest personal, obsessional interests on the part of the artist
which simply cannot be accommodated within the *professional*
role of the portrait painter. Such pictures have the same kind
of intensity as self-portraits. They are in fact works of self-
discovery.

Ask yourself the following hypothetical question. Suppose
that there is somebody in the second half of the nineteenth
century in whom you are interested but of whose face you
have never seen a picture. Would you rather find a painting
or a photograph of this person? And the question posed like
that is already highly favourable to painting, since the logical
question should be: would you rather find a painting or a
whole album of photographs?

Until the invention of photography, the painted (or sculp-
tural) portrait was the only means of recording and presenting
the likeness of a person. Photography took over this role
from painting and at the same time raised our standards for
judging how much an informative likeness should include.

This is not to say that photographs are *in all ways* superior
to painted portraits. They are more informative, more psycho-
logically revealing, and in general more accurate. But they
are less tensely unified. Unity in a work of art is achieved as
a result of the limitations of the medium. Every element has
to be transformed in order to have its proper place within
these limitations. In photography the transformation is to a

considerable extent mechanical. In a painting each trans-
formation is largely the result of a conscious decision by the
artist. Thus the unity of a painting is permeated by a far
higher degree of intention. The total effect of a painting (as
distinct from its truthfulness) is less arbitrary than that of
a photograph; its construction is more intensely socialized
because it is dependent on a greater number of human
decisions. A photographic portrait may be more revealing and
more accurate about the likeness and character of the sitter;
but it is likely to be less persuasive, less (in the very strict
sense of the word) conclusive. For example, if the portraitist's
intention is to flatter or idealize, he will be able to do so far
more convincingly with a painting than with a photograph.

From this fact we gain an insight into the actual function
of portrait painting in its heyday: a function we tend to
ignore if we concentrate on the small number of exceptional
'unprofessional' portraits by Raphael, Rembrandt, David,
Goya, etcetera. The function of portrait painting was to
underwrite and idealize a chosen social role of the sitter.
It was not to present him as 'an individual' but, rather, as an
individual monarch, bishop, landowner, merchant, and so on.
Each role has its accepted qualities and its acceptable limit
of discrepancy. (A monarch or a pope could be far more
idiosyncratic than a mere gentleman or courtier.) The role
was emphasized by pose, gesture, clothes and background. The
fact that neither the sitter nor the successful professional
painter was much involved with the painting of these parts is
not to be entirely explained as a matter of saving time: they
were thought of and were meant to be read as the accepted
attributes of a given social stereotype.

The hack painters never went much beyond the stereotype;
the good professionals (Memlinck, Cranach, Titian, Rubens,
Van Dyck, Velasquez, Hals, Philippe de Champaigne) painted
individual men, but they were nevertheless men whose
character and facial expressions were seen and judged in the
exclusive light of an ordained social role. The portrait must
fit like a handmade pair of shoes, but the type of shoe was
never in question.

The satisfaction of having one's portrait painted was the

satisfaction of being personally recognized and *confirmed in one's position*: it had nothing to do with the modern lonely desire to be recognized 'for what one really is'.

If one were going to mark the moment when the decline of portraiture became inevitable, by citing the work of a particular artist, I would choose the two or three extraordinary portraits of lunatics by Géricault, painted in the first period of romantic disillusion and defiance which followed the defeat of Napoleon and the shoddy triumph of the French bourgeoisie. The paintings were neither morally anecdotal nor symbolic: they were straight portraits, traditionally painted. Yet their sitters had no social role and were presumed to be incapable of fulfilling any. In other pictures Géricault painted severed human heads and limbs as found in the dissecting theatre. His outlook was bitterly critical: to choose to paint dispossessed lunatics was a comment on men of property and power: but it was also an assertion that the essential spirit of man was independent of the role into which society forced him. Géricault found society so negative that, although sane himself, he found the isolation of the mad as and perhaps more meaningful than the social honour accorded to the successful. He was the first and, in a sense, the last profoundly anti-social portraitist. The term contains an impossible contradiction.

After Géricault, professional portraiture degenerated into servile and crass personal flattery, cynically undertaken. It was no longer possible to believe in the value of the social roles chosen or allotted. Sincere artists painted a number of 'intimate' portraits of their friends or models (Corot, Courbet, Degas, Cézanne, Van Gogh), but in these the social role of the sitter is reduced *to that of being painted*. The implied social value is either that of personal friendship (proximity) or that of being seen in such a way (being 'treated') by an original artist. In either case the sitter, somewhat like an arranged still life, becomes subservient to the painter. Finally it is not his personality or his role which impress us but the artist's vision.

Toulouse-Lautrec was the one important latter-day exception to this general tendency. He painted a number of portraits

of tarts and cabaret personalities. As we survey them, they survey us. A social reciprocity is established through the painter's mediation. We are presented with neither a disguise — as with official portraiture – nor with mere creatures of the artist's vision. His portraits are the only late-nineteenth-century ones which are persuasive and conclusive in the sense that we have defined. They are the only painted portraits in whose social evidence we can believe. They suggest – not the artist's studio – but 'the world of Toulouse-Lautrec': that is to say a specific and complex social milieu. Why was Lautrec such an exception? Because in his eccentric and obverse manner he believed in the social roles of his sitters. He painted the cabaret performers because he admired their performances: he painted the tarts because he recognized the usefulness of their trade.

Increasingly for over a century fewer and fewer people in capitalist society have been able to believe in the social value of the social roles offered. This is the second answer to our original question about the decline of the painted portrait.

The second answer suggests, however, that given a more confident and coherent society, portrait-painting might revive. And this seems unlikely. To understand why, we must consider the third answer.

The measures, the scale-range of modern life, have changed the nature of individual identity. Confronted with another person today, we are aware, through this person, of forces operating in directions which were unimaginable before the turn of the century and which have only become clear relatively recently. It is hard to define this change briefly. An analogy may help.

We hear a lot about the crisis of the modern novel. What this involves, fundamentally, is a change in the mode of narration. It is scarcely any longer possible to tell a straight story sequentially unfolding in time. And this is because we are too aware of what is continually traversing the storyline laterally. That is to say, instead of being aware of a point as an infinitely small part of a straight line, we are aware of it as an infinitely small part of an infinite number of lines, as the centre of a star of lines. Such awareness is the result of our

constantly having to take into account the simultaneity and extension of events and possibilities.

There are many reasons why this should be so: the range of modern means of communication: the scale of modern power: the degree of personal political responsibility that must be accepted for events all over the world: the fact that the world has become indivisible: the unevenness of economic development within that world: the scale of the exploitation. All these play a part. Prophecy now involves a geographical rather than historical projection; it is space not time that hides consequences from us. To prophesy today it is only necessary to know men as they are throughout the whole world in all their inequality. Any contemporary narrative which ignores the urgency of this dimension is incomplete and acquires the over-simplified character of a fable.

Something similar but less direct applies to the painted portrait. We can no longer accept that the identity of a man can be adequately established by preserving and fixing what he looks like from a single viewpoint in one place. (One might argue that the same limitation applies to the still photograph, but as we have seen, we are not led to expect a photograph to be as conclusive as a painting.) Our terms of recognition have changed since the heyday of portrait painting. We may still rely on 'likeness' to identify a person, but no longer to explain or place him. To concentrate upon 'likeness' is to isolate falsely. It is to assume that the outermost surface *contains* the man or object: whereas we are highly conscious of the fact that nothing can contain itself.

There are a few cubist portraits of about 1911 in which Picasso and Braque were obviously conscious of the same fact, but in these 'portraits' it is impossible to identify the sitter and so they cease to be what we call portraits.

It seems that the demands of a modern vision are incompatible with the singularity of viewpoint which is the prerequisite for a static-painted 'likeness'. The incompatibility is connected with a more general crisis concerning the meaning of individuality. Individuality can no longer be contained within the terms of manifest personality traits. In a world of transition and revolution individuality has become a problem

of historical and social relations, such as cannot be revealed by the mere characterizations of an already established social stereotype. Every mode of individuality now relates to the whole world.

The reasons that I have given for the decline and disappearance of the painted portrait have implications which reach further than the portrait. A whole function of painting is in question. And perhaps more than that. [1967]

Sight and sex

John Berger

The interest in drawing or painting nude or semi-nude figures is profoundly sexual: likewise the appreciation of the finished product. The assertion that all plastic art has a sexual basis is liable to confuse the issue. The interest I am talking about is direct and in most cases quite conscious. Titian knew perfectly well why he enjoyed painting nymphs: just as the homosexual painters of the Renaissance knew why they were interested in the subject of St Sebastian: the subject which allowed them to paint a young, nude man in ecstasy.

It is this which makes it possible to compare Rubens's painting of his wife with a fur round her shoulders with a typical but prettier than average photograph from a number of *Beauties of the Month* (a booklet of nude and semi-nude photographs of the type available in any city in Britain). Both painting and photograph were intended to appeal to the viewer's imaginative sexual pleasure in a woman's body.

There are important differences. A wife from the Flemish *haute bourgeoisie* of the seventeenth century was a very different person from a free-roaming young woman in London today: physically different and aspiring to a different physical ideal. A comparison of their hands reveals this dramatically.

There are also differences of purpose. One picture was made largely for the artist's personal satisfaction; the other largely

for an impersonal market. Nevertheless the comparison is possible because of their common appeal and because our sexual imagination, unless distressingly inhibited, should be able to transcend the historical changes of taste involved. I want to make the comparison, not in order to prove the obvious – which is that the photograph here is rather less than a work of art – but because I believe the comparison may throw some light on the problem of sexual imagery.

There are surprisingly few paintings in European art of entirely disclosed nude women. The foci of sexual interest – the sexual parts themselves and the breasts – are usually disguised or under-emphasized. Inconsequential draperies fall between women's legs; or their hands, while drawing attention to their sex, hide it. Until comparatively recently, women were invariably painted without pubic hair. Similarly, although breasts were more openly displayed, their nipples were modestly diminished in size and emphasis.

To explain this in terms of moral injunctions would be to project a late-nineteenth-century puritanism backwards into the past. To explain it in terms of aesthetics might be historically more accurate. A Renaissance painter would probably have justified his practice in terms of what seemed and did not seem beautiful. Yet aesthetics are a consequence rather than a cause. And although the producers of *Beauties of the Month* and other such booklets can hardly be accused of aestheticism, they obey the same rule. The models (except in one or two other series from abroad) are shaved: the ratio of half-disguised or half-dressed figures to naked ones is about four to one. Is this simply the result of the very indirect influence of pictorial convention?

It is a truism that figures undressing are more provocative than naked ones. Clearly the viewer's expectations are an important factor: imagine a strip club where the girls begin naked and end up fully clothed. (Only poets and lovers would perhaps attend, remembering the experience of lying in bed and watching her dress.) Yet why should it be the preliminary expectations that appeal most? Why is the ensuing nakedness an anti-climax by comparison?

To answer this question we must turn to the sexual function

of nakedness in reality, rather than on a stage or in a picture. Clothes encumber contact and movement. But it would seem that nakedness has a positive visual value in its own right: we want to *see* her naked: she delivers to us the sight of herself and we seize upon it – often quite regardless of whether we are seeing her for the first time or the hundredth. What does this sight of her mean to us, how does it, at that instant of total disclosure, affect our desire?

I may be wrong, and professional psychologists may correct me, but it seems to me that her nakedness acts as a confirmation and provokes a very strong sense of relieved happiness. She is a woman like any other: we are overwhelmed by the marvellous simplicity of the familiar mechanism.

We did not, of course, consciously expect her to be otherwise: unconscious homosexual, sado-masochistic or other desires may have led us to suppress more fantastic expectations: but our 'relief' can be explained without recourse to the unconscious.

We did not expect her to be otherwise, but the urgency and complexity of our feelings bred a sense of uniqueness which the sight of her, *as she is*, then dispels. She is more like any other woman than she is different. In this lies the warm and friendly – as opposed to cold and impersonal – anonymity of nakedness.

The relief of being reminded that women have sexual characteristics in common can obviously be explained by an Oedipus relationship to the mother: it is the relief of being reminded that all women are really like the first one. But what concerns me more now is the attempt to define that element of banality in the instant of total disclosure: an element that exists only because we need it.

Up to that instant she is more or less mysterious. The etiquettes of modesty are not only puritan or sentimental: they recognize the loss of mystery as real. And the explanation is largely a visual one. The focus of interest shifts from her eyes, her mouth, her shoulders, her hands – all of which are capable of such subtleties of expression that her personality, perceived through them, remains manifold – it shifts from these to her sexual parts, whose formation suggests an

utterly compelling but single process. She is reduced or elevated – whichever you prefer – to her primary category: she is *female*. Our relief is the relief of finding the reality to whose exigencies all our earlier fantasies are now subject. (There may be a danger by now of the woman seeming to be a mere object; let me therefore add that her reactions to male nakedness are surely somewhat similar, although she is likely to appraise more specifically because a man's sexual capacity is clearer to the eye.)

I said that we needed the banality which we find in the first instant of disclosure. And I have explained how – crudely speaking – it brings us back to reality. But it does more than that. This reality, by promising the familiar, proverbial mechanism of sex, offers at the same time the opportunity of mutual subjective identification: the opportunity of what I term in my essay on Picasso the 'shared subjectivity of sex'.

Thus it is from the instant of disclosure onwards that we and she can become mysterious as a single unit. Her loss of mystery occurs simultaneously with the offering of the means for creating a shared mystery. The sequence is: subjective → objective → subjective to the power of two.

How much has this to do with seeing? Could not the same process take place in the dark? It could; but this only substitutes a rather narrowly-ranged sense of touch for the far freer and more comprehensive sense of sight. Indeed, the sense of sight is so free – that is to say so susceptible to the imagination it feeds – that the process I have described, although normally occurring as part of an overt sexual relationship, can also take place metaphorically.

When I was drawing a lot from models and teaching Life Drawing, the first sight of the model just undressed always had an equivalent effect on me. Prior to that moment she was the creature of her own temperament. Suddenly she became proverbial. Later as one drew her, relying alternately upon analysis and empathy, her particular idiosyncratic existence and one's own imagination became – for the duration of the drawing – inseparable.

We can now understand the difficulty of presenting an image

of emphatic and total nakedness. The image will tend to strike us as banal. And, taken out of context and sequence, this banality, instead of serving as a bridge between two intense imaginative states, will tend merely to emphasize itself.

Let us now return to the comparison of the two pictures. Neither of the models is entirely naked. Yet our conclusions are relevant; for having analysed nakedness at its most extreme as a factor of sexual experience, we can now see how any degree of nakedness is part of a process which naturally continues past the point of total disclosure. Some may object that this is only a needlessly complicated way of saying: if you see her undressed, you want to fuck her. But crass over-simplification about such matters is an evasion.

Both pictures are intended to imply development in time.

We are meant to presume that the next thing the girl in the photograph will do is to take her panties off. The fact that they are almost transparent suggests that she will do this soon. She wears them for our benefit (see what I have said above) rather than for her own. Rubens's wife is in the act of turning, her fur about to slip off her shoulders. Clearly she cannot remain as she is for more than a second. In a superficial sense her image is more instantaneous than the photograph's.

But, in a more profound sense, the painting 'contains' time and its experience. It is easy to imagine that a moment before the woman pulled the fur round her shoulders, she was entirely naked. The consecutive stages up to and away from the instant of total disclosure have been transcended. She can belong to any or all of them simultaneously. This is not the case with the girl in the photograph. Everything about her – her expression, her pose, her relationship with the viewer and the nature of the medium as used here – makes it certain that she can only be about to undress further.

Something similar happens in terms of form. In the photograph she confronts us as a matter of fact. Our own or anybody else's possible pleasure in this fact is a totally separate issue. It is not that we are disinterested, but that the image offered us is disinterested. It is as though we saw her through the *eyes* of a eunuch while our sexual interest remained normal. Hence her so peculiar tangibility. She is there and

yet she is not there: this contradiction being the result, not of the naturalism of the picture, but of its lack of subjectivity. One might describe this lack – projecting it back on to her – by saying that her body looks as though it is numb.

In the Rubens the woman's body, far from looking numb, looks extremely susceptible and vulnerable: which, by the same conversion as we have just made, means that she confronts us as experience.

Why do we have such an impression? There are superficial literary reasons: her dishevelled hair, the expression of her eyes revealing how sex liberates into temporary timelessness, the extreme paleness of her skin. But the profound reason is a formal and visual one. Her appearance has been literally broken by the painter's subjectivity. Beneath the fur that she holds across herself, the upper part of her body and her legs can never meet. There is a displacement sideways of about nine inches: her thighs, in order to join on to her hips, are at least nine inches too far to the left.

I doubt whether Rubens planned this: just as I doubt whether most viewers consciously notice it. In itself it is unimportant. What matters is what it permits. It permits the body to become impossibly dynamic. Its coherence is no longer within itself but within the wishes of the viewer. More precisely, it permits the upper and lower halves of the body to rotate separately and in opposite directions round the sexual centre which is hidden: the torso turning to the right, the legs to the left. At the same time this hidden sexual centre is connected by means of the dark fur coat to all the surrounding darkness in the picture, so that she is turning both *around* and *within* the dark which has been made a metaphor for her sex.

Apart from the necessity of transcending the single moment and of admitting subjectivity, there is one further element which is essential for any great sexual image of the nude. This is the element of banality. In one form or another this has to exist because, as we saw, it is what transforms the voyeur into the lover. Different painters – Giorgione in the *Tempesta*, Rembrandt, Watteau, Courbet – have introduced it in different ways: Rubens introduces it here by means of his

compulsive painting of the soft fatness of flesh.

I don't want to suggest as a conclusion that there cannot be good nude photographs. There are even great ones, and on another occasion I hope to discuss some of these. Nor do I want to suggest that *Beauties of the Month* and other such booklets are despicable or harmful. I myself am more interested in looking at them than at any of the usual picture books of photographs such as you can buy at W. H. Smith's.

All I have wanted to show is that the seeing of a nude – in art and in reality – is a rather more complex and *synthetic* process than aesthetes, censors, glamour publicists and other puritans would have us believe. [1966]

Painting as language

Michael Wood

People were laughing a lot at the Tate when I saw the Lichtenstein exhibition, pointing out things that pleased them, grinning to themselves. There was nothing malicious in this, no scorn, no incomprehension; nothing philistine about it. It was a joke shared with the artist. People got the point.

Roy Lichtenstein's work is extremely good-humoured, easy to take, easy to look at, full of quotes to pick up and enjoy. The rocking sea of his kinetic seascapes has a mechanical lurch, it is a parody of more romantic escapes into so-called nature. *Compositions* II is a giant exercise book labelled Compositions, a gag, a *trompe-l'œil* which deceives no one. There are allusions to Art Nouveau, to Action Painting, to Cubism, and of course to the comic books. The allusions are like quotations in jazz, they are meant to amuse us. But Lichtenstein's humour goes beyond this pleasantness, and we shouldn't stay too long with the obvious jokes. There is nothing mild or trivial about Lichtenstein's work. It is rooted in humour, but the humour is not a mood, and not an idiom. It is a way of looking at the world.

Humour is a play of possibilities. It juggles with opposites, and this is exactly how Lichtenstein works. Lurching horizons, plastic seas, cartoons of emotional crisis, a statue of an explosion. There are ironies, they smile at art's inadequacy. Rauschenberg has said that he tries to act in the gap between art and life. Lichtenstein paints the gap.

When he talks about his work, Lichtenstein talks a good deal about humour. 'Well, there is something humorous about doing a sunset in a solidified way, especially the rays, because a sunset has little or no specific form . . .' 'Taking an outline and calling it Madame Cézanne is in itself humorous, particularly the idea of diagramming a Cézanne when Cézanne himself said, "The outline escaped me . . ."'

Humour in this sense is simplification, it is the primary colours of most of the paintings, the heavy outlines round the unshaded comic-book faces, the dotted skies or seas, the golfball staring geometrically out from a blank background. It is simplification aware of how much it is simplifying, aware of what it's losing. Lichtenstein consciously resists 'good painting', better mimesis, realism, for it would reduce the contrast, the conflict between the subject and the style. 'At that time I was interested in anything I could use as a subject that was emotionally strong – usually love, war, or something that was highly charged and emotional subject matter. Also, I wanted the subject matter to be opposite to the removed and deliberate painting techniques. Cartooning itself usually consists of very highly charged subject matter carried out in standard, obvious, and removed techniques.'

This is the principle behind all the comic-book paintings. Guns blaze, planes explode, lovers quarrel, girls weep and drown, all in the same flat, beautiful, post-Disney idiom. The irony reflects both the banality of our passions, of our wars, and the poverty of our means of depiction.

So far, so good. This is the ironic, the humorous basis for the paintings. And most of the paintings don't go beyond this. They are stylish, witty, ironic in this sense. They juggle subject and style. We watch the juggling, we register a kind of tension. But good ironies always resolve themselves into something else, into a kind of truth beyond the play of contradic-

tions, and Lichtenstein's best paintings do just this. Their truth, of course, is the feeling they give you, which is hard to describe. It is a sense of glamour and abstraction, but shadows of discomfort run across it.

Lichtenstein's paintings, even the quietest, are full of action, of suspended movement. His most frequent design is a curve, a wave. The famous golfball is a circle full of crescents. The cover of the exercise book of *Compositions* II is a field of writhing flakes. Everything moves, or threatens to move. Waves, water, hair, horizons, brush strokes, even a ball of twine. Everything dips like a sea. *Big painting No. 6* is the perfect example. This is a cartoon of brush strokes on a canvas, red, green, black, yellow. The paint sweeps and drips along its heavy black outlines. Disney's sorcerer's apprentice is at work. And of course the thought of using paint to create an illusion of paint, a cartoon of paint, is dazzling. Lichenstein got the idea, he says, from a comic-book image of a mad artist crossing out, with a large brush stroke, the face of the fiend that was haunting him.

'I was very interested in characterizing or caricaturing a brush stroke. The very nature of a brush stroke is anathema to outlining and filling in as used in cartoons. So I developed a form for it which is what I am trying to do in the explosions, airplanes, and people – that is, to get a standardized thing – a stamp or image.'

The cartoon provides Lichtenstein with more than irony, though. It gives him a texture. His paintings, with their dotted surfaces, are a version of newspaper, they are like newspaper in close-up. The result is visually very exciting, and you wonder why no one borrowed from the press before. This texture, heavy outlines, simple shapes, crude colours, Lichenstein has created an authentic style from these things. George Washington, a sponge, a temple at Corinth, as well as all the love and war topics, become cartoons, take on the glamour, the stylized unreality, of the comics. A painting called *Seascape* is almost a pure abstract. The sea and sky are blue dots on a white ground. Between them lie thin, slightly waving bands of plain white, plain yellow, and red dots on a yellow ground, in that order, descending. Shadows on the sea are

represented by a thick, seeping, winding black, the black of bad characters' hair in Disney. The dots create a dazzle, the black creates movement. Like a de Staël or a Turner, the painting is figurative or abstract, as you like: sea in the sun or colours on a canvas. It doesn't matter.

And in a sense, all Lichtenstein's work is as close to abstraction as this. He does, as he says, use the cartoon for 'purely formal reasons'. A box containing an engagement ring looks like a red and white explosion. An explosion looks like a red and yellow flower. This, I think, is what Richard Hamilton means when he speaks of Lichtenstein's 'emotional remoteness'. Girls cry, tanks grind through the mud, but we, the watchers, have the same response: we find the pictures beautiful and try to identify the discomfort that is hiding at the back of our heads.

The abstraction, in other words, is moral as well as visual. Lichtenstein's figures and landscapes mimic the visible world only to insist on their distance from it. His work is not only ironic, it is an ironic *impersonation*, a cruel echo of our clumsy and dishonest perceptions. It is, as he says, 'mock insensitivity'. The world of the comic books is a world of insistent, undifferentiated glamour, a world which refuses reality. The heavy outlines close off the characters from blurred humanity, the faces never have teeth, only a sheet of whiteness in the mouth. 'I'm interested in portraying a sort of anti-sensibility that pervades the society and a kind of gross over-simplification.' Lichtenstein refines on his models, but the impersonation remains. The distance remains. The glamour remains. However complex and ironic the intention, Lichtenstein *is* drawing cartoons. He *is* presenting a beautified, standardized humanity, a bright, clean landscape. And the show at the Tate, whatever else it may be, is for us, who rarely read comics, what the comic books are for the people who read them. Ironic art often short-circuits in this way.

And this, I think, is the source of the discomfort the paintings provoke. It is a sort of puzzle. Long waves sweep up in arcs, hinting at Hokusai and Art Nouveau, they drop their improbable foam, and a girl with purple blue hair drowns in this harmless sea, thinking, 'I don't care! I'd rather sink than

call Brad for help!' *Drowning girl* is an astonishing work, for me the most successful in the exhibition. Plainly it moves beyond irony. And plainly the short-circuiting effect is part of Lichtenstein's calculation. The girl just is beautiful. And yet, and yet. The painting has the force of a disturbing pun. It raises a question about its right to make a statement in this way. It answers the question perfectly, but somehow retains it. The continuing question is part of the painting's effect. The lie, the illusion, turns into truth, but a taste of untruth lingers.

All this may sound literary, but Lichtenstein is a poet, he deals in ambiguities. This is not a metaphor. Lichtenstein's paintings are literally full of *ideas*, thoughts about painting, about delineation, about displacement, 'notions', as Richard Hamilton puts it, 'about the conflicts of flatness and illusory space'. His style, as he himself suggests, is conceptual rather than visual, painting with him becomes a form of reflexive fiction, self-conscious, ironic, like a poem by Stevens. The painting comments on its quality, it acquires a voice, and the century has turned. Art no longer aspires, in Pater's words, to the condition of music. It aspires to the condition of language. [1968]

Representations in protest

Reyner Banham

When Robert Fraser was inside – after being busted along with the Rolling Stones – Richard Hamilton was among the artists who helped assemble the stopgap exhibition that kept Fraser's art gallery open and demonstrated how strong was the feeling of solidarity and sympathy for him. Now Fraser has returned the compliment with the first one-man show of Hamilton's paintings for some time. And Hamilton has maintained the theme: nearly half the present show consists of variants of the image of Fraser and Mick Jagger handcuffed in the police van.

This persistent image – the two faces half-concealed by the hand raised to show the handcuffs, framed within the precise outline of the window of the van – ought, by current standards, to be a straight protest picture, a sacred icon of victims of arbitrary authority (Sacco and Vanzetti, Jan Palach, or who-have-you). But it doesn't work by the current rules. The victims do not fall into a prefabricated category of hardship approved by the apparat of the established left (the New Left felt otherwise), nor does their offence. Nor of course did they die because of their differences with authority.

Yet this 'martyrdom' was more of a public occasion and more deeply resented by more people than anything that has yet happened in Ulster, even. Remember those posters of Mick Jagger with the legend LET HIM THAT IS WITHOUT SIN JAIL THE FIRST STONE? You do? Good; they are the first step to an understanding of as much as can be verbalized of what is new and unsettling about the Hamilton version.

Recall first the Jagger image – effective because it was a mechanically coarsened and simplified photograph. Destroying the conventionally 'photographic' quality of a picture (sharp focus and softly graded shadows) is a very handy technique for making artistic-type images out of dull pictures, as Professor Gombrich used to demonstrate in lectures of his jokier period, in order to make philosophical points about art and illusion. But the image makers of the underground scene aren't interested in aesthetic philosophy, what they have got is a nifty mechanical short-cut for turning common visuals into protest art.

At first sight it seems very like what Hamilton has done, but not at second sight. There, on the same wall as the six versions of *Swingeing London* (typical Hamilton title), is a preliminary sketch which explores the forms and contents of the original photographic image, alters, amplifies, clarifies. The half-round moulding where the wall of the van joins the headlining in its roof, for instance, is made very explicit in the sketch, though invisible in the photo and in the etched version. The given image has been worked into, worked through and worked out. And yet the final painted versions are all, conspicuously, paintings of news photographs; they

do not simplify or monumentalize away the actuality of the original.

Hamilton is not a simple person, and his relationship to photography and the many means of reproducing it is not simple either – was any obsession ever? Turn round in the gallery and look at the other wall: variations, improvizations, explorations, commentaries on a seaside picture postcard of Whitley Bay, greatly enlarged. The image is even measured against other methods of transmitting seaside reality – a sculptured sample of a petal bathing hat and a length of dress material.

This kind of pictorial discourse on the divergence between the matter represented and the various means of representing it has been a constant, consciously, in his art for as long as I have known him – and that goes back well before either of us had read any McLuhan, and before McLuhan had begun to distinguish between medium and message.

When I first got to know Hamilton he was working on an exhibition of the strictly invisible – micro-photographs, X-rays, out of Darcy Thompson's *Growth and Form*. He was also painting pictures of perspective – not *in* perspective, but pictures about the construction of perspectives. Later, there were pictures whose subject matter was the picture itself from changing viewpoints. And then just before the whole progression disappeared up its own introspective orifice, came his first pop paintings in 1957. Their theme was US product-styling; and although they were still preoccupied with the means of representation (one used at least four different pictorial conventions for the shine on chromium), they did have subject matter (cars, toasters, fridges, sexpots) external to the business of painting the picture.

It was the beginning of a long, oblique, often evasive return to subject matter of importance, even living human beings. But very warily; profound admirations and deep commitments were gift-wrapped in visual puns and hinted at by titles that were as gnomic (or mulish) as his rare explanatory articles of the time. Behind this exploration towards the ability to say things in paint that had direct human relevance lay the influence (among others) of two outstanding human beings.

One has been mentioned in all recent writing about Hamilton: Marcel Duchamp, the old past-master of art jokes that transcend humour and art. The nonsense with perspective in the upper part of Duchamp's *Large Glass* was right Hamiltonian, but the relationship has hardly been the normal sort of 'influence'. It began as admiration, proceeded through scholarly annotation and scrupulous reconstruction of Duchamp's work, to collaboration and finally to something very deep and private. Outsiders were not invited into it, but the presence of the relationship invaded the whole Hamilton scene – to the point that my son (a regular visitor to the house) rang home heart-broken from school when he read in the newspaper of Duchamp's death.

The other outstanding person was his wife, Terry Hamilton. Her totally unanticipated death almost eight years ago ended a marriage of involvement more intense than they usually make them nowadays. She was, among many other things, protest-oriented, but one of the beautiful, electric protesters, not one of the drips; and she summed up (for me) one of the crises of our time: how to reconcile unavoidable admiration for the immense competence, resourcefulness and creative power of American commercial design with the equally unavoidable disgust at the system that was producing it?

It is important to realize how salutary a corrective to the sloppy provincialism of most London art of ten years ago US design could be. The gusto and professionalism of wide-screen movies or Detroit car-styling was a constant reproach to the Moore-ish yokelry of British sculpture or the affected Piperish gloom of British painting. To anyone with a scrap of sensibility or an eye for technique, the average Playtex or Maidenform ad in American *Vogue* was an instant deflater of the reputations of most artists then in Arts Council vogue.

But how to maintain this discriminating admiration in the face of the conditioned-reflex atomic sabre-rattling of the Eisenhower regime? Terry – too honest and intelligent to close her mind to either half of the dilemma – had no solution to offer, and bequeathed us the problem. Richard almost solved it on the spot; his incredible 1963 painting, *Hugh Gaitskell as a famous monster of filmland,* used technique that Madison

Avenue could have envied, as the servant of political disgust.
It was one of the most exquisitely disagreeable and fiendishly
committed pictures of the decade, an ornate raspberry from
the conscience of the outraged left.

As a political statement pure and simple it misfired. Too
much of a shocker in those days when the corpse of Gait-
skell's reputation was still protected by a gentlemanly DM-
notice (*de mortuis*, etcetera) and too much of an original to
find a context in which its message could register. Nowadays
it could conceivably have appeared on the cover of *Black
Dwarf*, I suppose; but more importantly, other contexts have
appeared in which less politically pre-digested protest can
register, contexts developed out of pop painting and pop music,
and the general sub-culture that nurtures and uses them. And
if pop painting and pop music have any common foci, one
of them is certainly Robert Fraser's gallery, where you are
quite likely to meet a Beatle or a Stone.

So there is no sense in complaining that the Hamilton/
Fraser situation is 'inbred'; better words would be 'appro-
priate' or even 'inevitable'. Having admitted so much, turn
back to the *Swingeing London* pictures; their quality grows
with revisiting. They have a slow burn, rather than an
immediate impact, because they are not simple mechanical
transformations of news images into protest icons, but have
a whole unique biography behind them, and a learned aware-
ness of the illusionistic techniques that have been the craft of
western art since the Renaissance.

The main set of six variations are remarkably divergent in
mood and technique and colour, yet each is the same state-
ment by the same man about the same event. This is not a
paradox either – listen to yourself describing the same incident
in the same form of words six times and you'll hear what
I mean. The only variation in the physical form of the picture
comes not in any alteration of the composition, but in putting
the handcuffs in three dimensions in the sixth variant. Only,
what is in the original image is not a neat clear picture of a
pair of bracelets; the wrists of the victims are in motion
because the hands are being raised, and all the camera has
caught are disconnected metallic blurs.

A.S. C

Recreated as shining projections on the picture plane they have a very curious effect. Thus: one of the most intriguing aspects of the original image was that the news camera caught the movement at the only moment when the two connected hands were almost symmetrically disposed in front of the faces. This exactly balanced disposition gives all the purely painted versions an almost Palladian calm that refines away rhetoric, establishes a cool that overrides any extravagance of colour or tonal contrast. But the shining lumps of metal in motion break that calm, pierce that cool.

They are zigzags, a blob, a curve, standing proud of the picture surface like scar tissue. They have a right to be there because they are on the original photograph, they have a right to a metallic finish because that is what the marks on the photo represent. But they blister the painted image, outrage it as manacles outrage human flesh. The sequence of six pictures culminates, along with many strands in Hamilton's life and work, at this point where what happens to the means of representation has become an allegory of what has happened to the subject represented. [1969]

The worst is not yet come

John Berger

To begin with a few facts:

1. Francis Bacon is the only British painter this century to have had an international influence. The most comprehensive exhibition ever held of his work is in its last days in Paris. It has received generous critical acclaim in France.

2. Bacon's exhibition is paired with one devoted to Fernand Léger. It would be hard to find two painters whose work is more opposed. But the two exhibitions have one thing in common: the remarkable consistency from the first works to the last of the artist's vision. In both cases one is confronted by a fully articulated world-view.

3. Bacon is a painter of extraordinary skill, a master. Nobody who is familiar with the problems of figurative oil-painting can remain unimpressed by his solutions. Such mastery, which is rare, is the result of great dedication and extreme lucidity about the medium.

4. Bacon's work has been unusually well written about. Writers such as David Sylvester, Michel Leiris and Lawrence Gowing have discussed its internal implications with great eloquence. By 'internal' I mean the implications of its own propositions within its own terms. Bacon's work effectively imposes its own terms on most of those who are interested in it.

Before I question the terms of Bacon's world-view, I want to say something about criticism. The critic in the *Nouvel Observateur* wrote that it was too soon to assess Bacon's work, and that we should wait another quarter of a century. To make statements like that is to misunderstand the role and limitations of criticism. Criticism can never exhaust or fully define a work of art. The notion of criticism as *assessment* is an academic one. It pretends that the critic is a freelance examiner, grading works for the convenience of the market and society. Properly speaking, criticism can only be concerned with the uses to which a work of art is put or may be put. It defines the nature and value of an actual or proposed discourse between work and public.

A great work will be put to many uses and will produce many discourses during different periods of history. But the more closely I, as a critic, examine a work, the more I have to say about the world, not about it. About the work-for-itself I can say nothing. All that can be said about a work of art *within its own terms*, it is already saying about itself.

The Paris exhibition is large, and each painting has been given plenty of space. A blood-stained figure on a bed. A carcase with splints on it. A man on a chair smoking. One walks through the galleries as if through a park – or some gigantic institution. A man on a chair turning. A man holding a razor. A man shitting.

But where is – what is – the meaning of the events we see? In the catalogue, most of the events are called *Studies*. The

painted figures are all quite indifferent to one another's presence or plight. Are we, as we walk through, the same? A photograph of Bacon with his sleeves rolled up shows that his forearms closely resemble those of many of the men he paints. A woman crawls along a rail like a child. One can read in the catalogue that in 1971, according to the magazine *Connaissance des Arts*, Bacon became the first of the top ten most important living artists. A man sits naked with torn newspaper around his feet. A man stares at a blind cord. A man reclines in a vest on a stained red couch. There are many faces which move, and as they move they give an impression of pain. There has never been painting quite like this. Is its purpose to leave one indifferent but fascinated? It relates to the world one lives in. But how?

Bacon's work is centred on the human body. The body is usually distorted, whereas what clothes or surrounds it is relatively undistorted. Compare the raincoat with the torso, the umbrella with the arm, the cigarette stub with the mouth. According to Bacon himself, the distortions undergone by face or body are the consequence of his searching for a way of making the paint 'come across directly on to the nervous system'. Again and again, he refers to the nervous system of painter and spectator. The nervous system for him is independent of the brain. The kind of figurative painting which appeals to the brain, he finds illustrational and boring.

'I've always hoped to put over things as directly and rawly as I possibly can, and perhaps if a thing comes across directly, they feel that it is horrific.'

To arrive at this rawness which speaks directly to the nervous system, Bacon relies heavily on what he calls 'the accident'. 'In my case, I feel that anything I've ever liked at all has been the result of an accident on which I've been able to work.'

The 'accident' occurs in his painting when he makes 'involuntary marks' upon the canvas. His 'instinct' then finds in these marks a way of developing the image. A developed image is one that is both factual and suggestive to the nervous system.

'Isn't it that one wants a thing to be as factual as possible, and yet at the same time as deeply suggestive or deeply

unlocking of areas of sensation other than simple illustrating of the object that you set out to do? Isn't that what art is all about?'

For Bacon the 'unlocking' object is always the human body. Other things in his painting (chairs, shoes, blinds, lamp switches, newspapers) are merely illustrated.

'What I want to do is to distort the thing far beyond appearance, but in the distortion to bring it back to a recording of the appearance.'

Interpreted as process, we now see that this means the following. The appearance of a body suffers the accident of involuntary marks being made upon it. Its distorted image then comes across directly on to the nervous system of the viewer (or painter), who rediscovers the appearance of the body through or beneath the marks it bears.

Apart from the inflicted marks of the painting-accident, there are also sometimes *painted marks* on a body or on a mattress. These are, more or less obviously, traces of body fluids – blood, semen, perhaps shit. When they occur, the stains on the canvas are like stains on a surface which has actually touched the body.

The double-meaning of the words which Bacon has always used when talking about his painting (*accident, rawness, marks*), and perhaps even the double-meaning of his own name, seem to be part of the vocabulary of an obsession, an experience which probably dates back to the beginning of his self-consciousness. There are no alternatives offered in Bacon's world, no ways out. Consciousness of time or change does not exist. Bacon often starts working on a painting from an image taken from a photograph. A photograph records a moment. In the process of painting, Bacon seeks the accident which will turn that moment into all moments. In life, the moment which ousts all preceding and following moments is most commonly a moment of physical pain. And pain may be the ideal to which Bacon's obsession aspires. Nevertheless, the content of his paintings, the content which constitutes their appeal, has little to do with pain. As often, the obsession is a distraction and the real content lies elsewhere.

Bacon's work is said to be an expression of the anguished

loneliness of western man. His figures are isolated in glass cases, in arenas of pure colour, in anonymous rooms, or even just within themselves. Their isolation does not preclude their being watched. (The triptych form, in which each figure is isolated within his own canvas and yet is visible to the others, is symptomatic.) His figures are alone, but they are utterly without privacy. The marks they bear, their wounds, look self-inflicted. But self-inflicted in a highly special sense. Not by an individual but by the species: Man – because, under conditions of such universal solitude, the distinction between individual and species becomes meaningless.

Bacon is the opposite of an apocalyptic painter who envisages the worst as likely. For Bacon, the worst has already happened. The worst that has happened has nothing to do with the blood, the stains, the viscera. The worst is that man has come to be seen as mindless.

The worst had already happened in the *Crucifixion* of 1944. The bandages and the screams are already in place – as also is the aspiration towards ideal pain. But the necks end in mouths. The top half of the face does not exist. The skull is missing.

Later, the worst is evoked more subtly. The anatomy is left intact, and man's inability to reflect is suggested by what happens around him and by his expression – or lack of it. The glass cases, which contain friends or a pope, are reminiscent of those in which animal behaviour-patterns can be studied. The props, the trapeze chairs, the railings, the cords, are like those with which cages are fitted. Man is an unhappy ape. But if he knows it, he isn't. And so it is necessary to show that man cannot know. Man is an unhappy ape without knowing it. It is not a brain but a perception which separates the two species. This is the axiom on which Bacon's art is based.

During the early 1950s, Bacon appeared to be interested in facial expressions. But not, as he admits, for what they expressed.

'In fact, I wanted to paint the scream more than the horror. And I think if I had really thought about what causes somebody to scream – the horror that produces a scream – it would

have made the screams that I tried to paint more successful. In fact, they were too abstract. They originally started through my always having been very moved by movements of the mouth and the shape of the mouth and the teeth. I like, you may say, the glitter and colour that comes from the mouth, and I've always hoped in a sense to be able to paint the mouth like Monet painted a sunset.'

In the portraits of friends like Isabel Rawsthorne, or in some of the new self-portraits, one is confronted with the expression of an eye, sometimes two eyes. But study these expressions; read them. Not one is self-reflective. The eyes look out from their condition, dumbly, on to what surrounds them. They do not know what has happened to them; and their poignancy lies in their ignorance. Yet what has happened to them? The rest of their faces have been contorted with expressions which are not their own – which, indeed, are not expressions at all (because there is nothing behind them to be expressed), but are events created by accident in collusion with the painter.

Not altogether by accident, however. Likeness remains – and in this Bacon uses all his mastery. Normally, likeness defines character, and character in man is inseparable from mind. Hence the reason why some of these portraits, unprecedented in this history of art, although never tragic, are very haunting. We see character as the empty cast of a consciousness that is absent. Once again, the worst has happened. Living man has become his own mindless spectre.

In the larger figure-compositions, where there is more than one personage, the lack of expression is matched by the total unreceptivity of the other figures. They are all proving to each other, all the time, that they can have no expression. Only grimaces remain.

Bacon's view of the absurd has nothing in common with existentialism, or with the work of an artist like Samuel Beckett. Beckett approaches despair as a result of questioning, as a result of trying to unravel the language of the conventionally given answers. Bacon questions nothing, unravels nothing. He accepts that the worst has happened.

His lack of alternatives, within his view of the human

condition, is reflected in the lack of any thematic development
in his life's work. His progress, during thirty years, is a
technical one of getting the worst into sharper focus. He
succeeds, but at the same time the reiteration makes the worst
less credible. That is his paradox. As you walk through room
after room in the Grand Palais, it becomes clear that you can
live with the worst, that you can go on painting it again and
again, that you can turn it into more and more elegant art,
that you can put velvet and gold frames round it, that other
people will buy it to hang on the walls of the rooms where
they eat. It begins to seem that Bacon may be a charlatan.
Yet he is not. And his fidelity to his own obsession ensures
that the paradox of his art yields a consistent truth, though
it may not be the truth he intends.

Bacon's art is, in effect, conformist. It is not with Goya
or the early Eisenstein that he should be compared, but with
Walt Disney. Both men make propositions about the alienated
behaviour of our societies; and both, in a different way,
persuade the viewer to accept what is. Disney makes alienated
behaviour look funny and sentimental and, therefore, accept-
able. Bacon interprets such behaviour in terms of the worst
possible having already happened, and so proposes that both
refusal and hope are pointless. The surprising formal similari-
ties of their work – the way limbs are distorted, the overall
shapes of bodies, the relation of figures to background and
to one another, the use of neat tailor's clothes, the gesture
of hands, the range of colours used – are the result of both
men having complementary attitudes to the same crisis.

Disney's world is also charged with vain violence. The
ultimate catastrophe is always in the offing. His creatures have
both personality and nervous reactions; what they lack (almost)
is mind. If, before a cartoon sequence by Disney, one read
and believed the caption: *There is nothing else*, the film
would strike us as horrifically as a painting by Bacon.

Bacon's paintings do not comment, as is often said, on any
actual experience of loneliness, anguish or metaphysical doubt;
nor do they comment on social relations, bureaucracy, indus-
trial society or the history of the twentieth century. To do any
of these things they would have to be concerned with con-

sciousness. What they do is to demonstrate how alienation may provoke a longing for its own absolute form – which is mindlessness. This is the consistent truth demonstrated, rather than expressed, in Bacon's work. [1972]

A well-hung hang-up

Angela Carter

Cock modestly detumescent, Andrew Cooper III, *Playgirl*'s Man for June, leans against the bonnet of an extremely power-ful car, both car and boy studies of potency *in potentia*. The winged symbol on the radiator suggests the erection the young man decently forbears to unfurl, but it's plain to see he's superbly hung. The centrefold shows him fresh from a sunset sea, white towelling robe falling away from his emblematic virility. He also displays himself for woman's pleasure in tennis kit; in blue-jeans and tee-shirt; and in a sort of Chinese shroud, carrying two curious unidentifiable objects.

Playgirl, the magazine for women, gives us Andrew Cooper III unclothed, as if his flesh were his function, like that of a beautiful woman. But his biography equates male sexuality with money and power in the traditional manner. 'He raked in his first million by the time he was 21.' The biographical notes authenticate him; he has a history as well as a torso. We read of his endearing habits. He likes to climb mountains in the nude. Freedom, he says, is everything to him. He water-skis like a champ, plays tennis like a demon, handles a camera like a pro. Therefore, he exists. He has a soulful look, reminding us that his iconic derivation may be as much from the pin-ups of the rock stars in fan mags of the sixties as it is from his lascivious sisters in the tit mags who part their legs and leer with far greater a culturally sanctioned abandon. He looks too butch to be true. He is hairy as an ape.

The pin-ups of male nudes in *Playgirl* and *Viva* serve at least one socially useful function. They gratify early adolescent

curiosity as to actual appearance of the male sex organ, which exercises pre-pubescent girls a good deal until they're traumatized by their first flasher. The tit mags cannot gratify the curiosity of young boys in quite the same way since the law that denies Andrew Cooper III his erection also precludes photographs of the actual vulva. (Every so often with female frontals, in the darkroom a clitoris appears under the enlarger. Catastrophe!) But the magazines don't appear to aim at the pre-bra set. The tone of the contents is resolutely sophisticated, so their purpose cannot be simply educational.

Playgirl, like *Playboy*, of which it is not the stablemate, has a 'philosophy', the *Playgirl* philosophy, which is one of responsible sexual freedom.

The nature of this femininity is demonstrated by ads for vaginal deodorants, vibrators, slenderizing devices, bust developing creams and exotic underwear. There is a certain egalitarianism in that men are not spared these excesses, either; the *Playgirl* shopping guide suggests, 'Give your man "Hot Pants" for Father's Day. Either "Super Cock" or "Home of the Whopper" styles. 100 per cent cotton stretch waist band. Specify style and size (small, medium, large).' ('Small' and 'medium' is poignant. One letter on the doctor's page asks: 'Can they really double penis size?')

Viva, stablemate of *Penthouse* and *Forum* and so truly in the vanguard of the sexual revolution, is less up-front, less brash than *Playgirl* with, perhaps, some pretensions to feminism as well as to femininity. Nevertheless, the *raison d'être* of both publications is the full frontal male nude pin-up; and, from the context, one can assume the purpose of these pin-ups is, like all pin-ups, purely titillatory. *Playgirl* has a circulation of a million and a half, *Viva* something less but gaining. And I assume, from the context, that the person they want to titillate is a maturish professional woman not unlike, perhaps, me. Fat chance, I tell you; fat chance.

The poverty-stricken aesthetic behind these nudes cancels out all the erotic promise of the flesh itself; and all flesh, even that of Andrew Cooper III, is potentially erotic. For one thing, in the ideology behind the aesthetic lurks the notion that, as a general rule, women are looking for love; and there-

fore the flesh, to please a woman, is not presented specifically as flesh-in-itself. It is 'well known' that women are not aroused by hardcore porn, so the titillation has a top dressing of sentiment. A picture story in *Viva* actually depicts, in saccharine soft focus, a wedding night. The sensitive, open-pored face of Jerry, *Viva*'s 'sexy yachtsman', spreads across an entire page and he talks about love. 'First, of course, I'm attracted to the body, but then the mind becomes important. The relationship is really in the mind.'

The pseudo-biographies of the models in the tit mags have, in contrast, a sprightly fakery. Marisa, Portland, Tracy, know that nobody would recognize them with their clothes on, anyway; that they exist exclusively as the ingenious articulated toys in a porno Disneyland, and do not need to pretend to have hearts.

The aesthetic of the prick-and-bum mags is: butch is beautiful. 'Jerry, young light-hearted master of the waves,' thrusts masterfully through the ocean, proudly naked steers his yacht. A pair of nude skiers have been snapped in mid-flight. The necessity to portray the male nude in action, demonstrating Hemingwayesque conspicuous virility, drops them straight into the absurd. Almost all the young men exhibit pale bikini marks on their deeply tanned, terribly hairy frames. He-man—that curious over-qualification that works like a double negative. Joy through strength. This must be an atavistic memory, in however vague and distorted a form, of the nude, discus-throwing youths, the Beautiful Athletes, the figures on vases, the pin-ups of the locker rooms of Athens.

The models we have for lovely boys are too few to create a tradition. Perhaps, also, they express far too explicitly the notion of the male body as an object of desire, as an instrument of pleasure, not as a pillar of strength; a tender master, a house-trained Heathcliff. Donatello's delicious David is, according to the colour supplements, a 'masterpiece of homosexual art'; hands off, girls! Similarly with Michaelangelo's celebrations of vulnerable, narrow-chested striplings and Caravaggio's fat, sinister Bacchus with his fruit hat *à la* Carmen Miranda. Not a trace of such heroic and joyous imagery to be found in these glossy pages. No room for complex

sensuality, only for simple virility.

The picture of a naked man belongs to a different aesthetic convention than that of a naked woman. The female nude's nakedness is in itself a form of dress, since the lengthy tradition of European art will clothe even the vulgarest pin-up with a heavy if invisible cloak of associations. She knows how to wear nothing. Further, she is perfectly secure in that, so garbed, she can always expect approval. But what is sauce for the goose is not necessarily sauce for the gander.

The objects which will accessorize the nakedness of the pin-up – her erotic apparatus of beads, feathers, white stockings, black stockings, corsets, scarves, bodices, frilly knickers, hats – are sanctioned by a tradition that extends back as far as Cranach and beyond. Andrew Cooper III's towelling robe has no such cultural resonance. His blue-jeans belong only to the tradition of porno-kitsch.

The dreamy narcissism of Dolores or Marsha, one hand straying towards her crotch, refers directly back to the slumbrous Venuses of the Renaissance. Helene, Natasha, Jane, are continually peeking into little hand-mirrors with the intense self-satisfaction of a Titian goddess. Boucher's Mademoiselle O'Murphy is a *Penthouse* pet already. It is a central contradiction in European art that its humanist celebration of the human form should involve rendering the nude – in the name of humanism – an object.

But women have the advantages of their disadvantages. Our relation to our own bodies is both more intimate and more abstract than that of most men to theirs. Naked, a woman can never be less than herself, for her value in the world resides more in her skin than in her clothes. Naked, she loses her name and becomes a blue nude, the bather, woman dressing, Suzie, Gina, Europa, Eve, Venus. But this personal anonymity is the price of a degree of mystification of her naked body that means she can accede to a symbolic power as soon as her clothes are off. A man's symbolic power, however, resides in his clothes, indicators of his status. The story of the Emperor's new clothes would have a different meaning were the hero an Empress. The spectators would have thought she had done it on purpose.

The tranquil and unconcerned pride with which nude women in European art since the Renaissance display their usually generous breasts, the rendezvous (remember) of love and hunger, means that, if not in the world, then at least as art the women have been certain of creating a positive response when they pretend to be a triumphant icon of nourishment and sexuality – of love, in fact.

The male models of *Playgirl* and *Viva* do not exhibit such self-confidence, and no wonder. Andrew Cooper III, and Gerry and Woody and all the chaps, are acting in a void. They are playing deeply against the cultural grain. The tradition that there is of the male nude in European art is so deeply part of our culture we don't even think of it as a male nude, which is what it is, though the genitals are not displayed. (They're not in most female nudes outside graffiti, either.) The icon of the naked woman as the source of nourishment and sexuality is balanced by the icon of the naked man in physical torment. 'It is no accident,' says Kenneth Clark in *The Nude*, 'that the formalized body of the "perfect man" became the supreme symbol of European belief.'

However, the formalized body of the 'perfect man' had to become a supreme icon of sado-masochism before that happened; and the only heir to that tradition in our merciful age of unbelief is Francis Bacon. And it isn't simply 2000 years of crucifixions and pietas working against the male body as an image of joy: it is two millenia of Sebastian transfixed by arrows, St Lawrence with his gridiron, St Bartholomew being flayed, decapitated Holofernes, Prometheus with the birds gnawing his liver, martyrdoms, executions, dissections. Marat stabbed in his bath. It is almost as though, in order to excuse themselves for painting a beautiful male body, the artists had to deprive it of serenity and turn it into an image of horror and despair.

Against this rage can beauty hold a plea? Can Andrew Cooper III pit his cloud-scraping six foot four inches of bone and muscle against the ghastly association of the naked man, the Man of Sorrows, whose erotic accessories are blood from a spear thrust in the side and a crown of thorns?

I think it will take more than the sexual revolution, what-

ever that is, to transform the lugubrious cultural heritage of torture and death which surrounds the male nude in western art. It is no wonder that poor Andrew Cooper III, to whom I mean no harm, poor boy, cannot master much conviction for his role as pin-up. Nobody told him what he was taking on. [1975]

Horror pictures

John Berger

Donald McCullin is an internationally recognized war photographer. I would like to write about his recently published book, *The Destruction Business*. First, let us consider the kind of continuing reality which is the subject matter of the book.

The news from Vietnam did not make big headlines in the papers this morning. It was simply reported that the American air force is systematically pursuing its policy of bombing the north. Yesterday there were 270 raids.

Behind this report there is an accumulation of other information. The day before yesterday the American air force launched the heaviest raids of this month. So far, more bombs have been dropped this month than during any other comparable period. Among the bombs being dropped are the seven-ton superbombs, each of which flattens an area of approximately 8000 square metres. Along with the large bombs, various kinds of small antipersonnel bombs are being dropped. One kind is full of plastic barbs which, having ripped through the flesh and embedded themselves in the body, cannot be located by X-ray. Another is called the Spider: a small bomb like a grenade with almost invisible 30-centimetre-long antennae, which, if touched, act as detonators. These bombs, distributed over the ground where larger explosions have taken place, are designed to blow up survivors who run to put out the fires already burning, or go to help those already wounded.

There are no pictures from Vietnam in the papers today. But

on page 92 in McCullin's book there is a picture taken in
Hué in 1968 which could have been printed with the reports
this morning. It shows an old man squatting with a child in
his arms, both of them are bleeding profusely with the black
blood of black-and-white photographs.

In the last year or so, it has become normal for certain
mass-circulation newspapers to publish war photographs which
earlier would have been suppressed as being too shocking.
One might explain this development by arguing that these
newspapers have come to realize that a large section of their
readers are now aware of the horrors of war and want to be
shown the truth. Alternatively, one might argue that these
newspapers believe that their readers have become inured to
violent images and so now compete in terms of ever more
violent sensationalism.

The first argument is too idealistic and the second too
transparently cynical. Newspapers now carry violent war
photographs because their effect, except in rare cases, is not
what it was once presumed to be. A paper like the *Sunday
Times* continues to publish shocking photographs about
Vietnam or about Northern Ireland – even though, apparently,
they do not lead to any increased protest against what is
being done in those places. But in that case, what *is* the effect
of such photographs? This is the question I would like to
ask of Donald McCullin's book.

The book contains about eighty pictures. The first is of a
peaceful beach at Scarborough – deserted except for a woman
and a dog – at dawn, the buildings charcoal-coloured and flat
against the sky, the wet sand like a photographic plate catch-
ing the first light. The last picture is of a small bird dead in
the snow. In the middle of the book is a picture of a herd
of sheep, also at dawn with charcoal-coloured buildings flat
against the sky, being shepherded through Caledonian Market
to the slaughterhouse. Underneath, McCullin has written:
'All I could hear to begin with were those muffled hooves in
the early morning . . .'

Nearly all the other photographs show victims. Mostly war
victims from Cyprus, Biafra and south-east Asia. There is a
short section of victims of poverty and despair in Chicago,

Liverpool and other cities of the west. A few pictures show men fighting. There are no heroic images. In the annals of war photography, there are altogether very few heroic images. (Heroic images of war belong to painting or the cinema, produced long after and far away from the events they pretend to depict.) Yet what makes McCullin's pictures outstanding even among war photographs is the degree of their horror, is how much they can shock.

When photographs are printed in a book, they are not the same as when printed in a newspaper. They are less urgent. There is a sense in which a newspaper belongs to the events it records, it is part of the same process, the same flux: it bears the same stains. A book stays clean and is meant to outlive its making. Yet McCullin's images are so intransigent that their meaning is not much changed by being included in a book.

How does this intransigence work? To take photographs like these, one must have a rare amalgam of courage, physical fitness, fast reflexes, extreme visual sensibility, curiosity, conscience and professional addiction. The last is the most mysterious. Looking repeatedly at McCullin's photographs, I have a feeling that his work is a sustained, but probably justified, act of revenge. It is as though with these pictures he wants to prove something which he was once prevented from saying: as though he knows that this proof may undermine, or even destroy, whoever or whatever it was that once refused him a hearing. I have the impression that most of his photographs are first (at that first instant of decision and reaction) addressed to the same person. The violence he depicts is as much a confirmation as a revelation. A confirmation that he hates, but a confirmation nevertheless. Underneath a street with a British tank in it and a body in the road, he writes: 'This is just a dead old man who went to the assistance of an old woman.'

It seems that McCullin is fully aware of how the meaning of a news photograph can be transformed by the context in which it appears and the copy which surrounds it. He therefore insists on more or less controlling the pages on which his pictures are printed and often writes the captions himself. Consequently, the meaning of his pictures as they appear may

not be completely at variance with the personal meaning they have for him.

Many people would argue that the function of such photographs is to remind us shockingly of the reality, the lived reality, behind the abstractions of political theory, casualty statistics or news bulletins. Such photographs, they might go on to say, are printed on the black curtain which is drawn across what we choose to forget or refuse to know. According to them, McCullin serves as an eye we cannot shut. Yet what is it that they make us see?

They bring us up short. The most literal adjective that could be applied to them is *arresting*. We are seized by them. (I am aware that there are people who pass them over, but about them there is nothing to say.) As we look at them, the moment of the other's suffering engulfs us. We are filled with either despair or indignation. Despair takes on some of the other's suffering to no purpose. Indignation demands action. We try to emerge from the moment of the photograph back into our lives. As we do so, the contrast is such that the resumption of our lives appears to be a hopelessly inadequate response to what we have just seen.

McCullin's most typical photographs record sudden moments of agony – a terror, a wounding, a death, a cry of grief. These moments are in reality utterly discontinuous with normal time. It is the knowledge that such moments are probable and the anticipation of them that makes 'time' in the front line unlike all other experiences of time. The camera which isolates a moment of agony isolates no more violently than the experience of that moment isolates itself. The word *trigger*, applied to rifle and camera, reflects a correspondence which does not stop at the purely mechanical. The image seized by the camera is doubly violent, and both violences reinforce the same contrast: the contrast between the photographed moment and all others.

As we emerge from the photographed moment back into our lives, we do not realize this; we assume that the discontinuity is our responsibility. The truth is that any response to that photographed moment is bound to be felt as inadequate. Those who are there in the situation being photo-

graphed, those who hold the hand of the dying or staunch a wound, are not seeing the moment as we have and their responses are of an altogether different order. It is not possible for anyone to look pensively at such a moment and to emerge stronger. McCullin, whose 'contemplation' is both dangerous and active, writes bitterly underneath a photograph: 'I only use the camera like I use a toothbrush. It does the job.'

The possible contradictions of the war photograph now become apparent. It is generally assumed that its purpose is to awaken concern. The most extreme examples – as in most of McCullin's work – show moments of agony in order to extort the maximum concern. Such moments, whether photographed or not, are discontinuous with all other moments. They exist by themselves. But the reader who has been arrested by the photograph may tend to feel this discontinuity as his own personal moral inadequacy. *And as soon as this happens even his sense of shock is dispersed*: his own moral inadequacy may now shock him as much as the crimes being committed in the war. Either he shrugs off this sense of inadequacy as being only too familiar, or else he thinks of performing a kind of penance – of which the purest example would be to make a contribution to OXFAM or to UNICEF.

In both cases, the issue of the war which has caused that moment is effectively depoliticized. The picture becomes evidence of the general human condition. It accuses nobody and everybody.

Confrontation with a photographed moment of agony can mask a far more extensive and urgent confrontation. Usually the wars which we are shown are being fought directly or indirectly in 'our' name. What we are shown horrifies us. The next step should be for us to confront our own lack of political freedom. In the political systems as they exist, we have no legal opportunity of effectively influencing the conduct of wars waged in our name. To realize this and to act accordingly is the only effective way of responding to what the photograph shows. Yet the double violence of the photographed moment may actually work against this realization.

Finally, let me clarify the limits of what I am saying. I am not attempting a critical assessment of McCullin's important

work as a photographer. I am not suggesting that the reactions to his work which I have described are the only ones possible. What I have tried to do is to explain why, in general, newspapers can publish horrific photographs concerning wars or military actions which, editorially, they may, in some cases, continue to justify and support. [1972]

Arts 2
Films

Paradise killed

Michael Wood

Readers of Anthony Burgess's *A Clockwork Orange* will expect to see violence in the film drawn from the novel, which is written and directed by Stanley Kubrick, and is now showing at the Warner West End. There is less than you'd expect, the minimum, I think, that the movie requires to make sense, and a lot less than in any number of films going the rounds – Boorman's *Pointblank*, for example, or Brando's *One-eyed Jacks*, to say nothing of Buñuel's *Chien Andalou*, where an eye is sliced in half by a razor in close-up.

Yet there has been a liberal outcry about the violence of *A Clockwork Orange*, and this is worth pondering. Obviously, the trouble is not the bashing and kicking and raping that goes on, but the fact that it is the film's hero, such as he is, who does it, and that there is no point of view in the film telling us piously that this is wrong. Or to put that in the film's own stark, comic and unverbal terms, it's not so much beating people up that's offensive, it's enjoying it so, and yelling out a version of *Singin' in the rain* while you do it.

Alex, the thug-hero, kicks a husband as he prepares to rape a wife, and when shooting this scene Kubrick apparently asked Malcolm McDowell, who plays Alex with all the right tones of intelligence, self-pity, nastiness and sycophancy, whether he could sing and dance. McDowell, in fact, thought he couldn't but said he could, being a willing lad, and broke into *Singin' in the rain*, the only song he knows, as he claims. Kubrick bought the rights to the song, used it skilfully in that scene early in the movie, and then created what is perhaps the film's finest moment – a posthumous one. The film ends, the screen shades off into a plain red background, and on the soundtrack, now and during the full length of an extensive set of credits, is Gene Kelly's original breezy version of *Singin' in the rain*.

I see the attraction of the novel for Kubrick, but a puzzle remains. It is not the ordinary difficulty of an adaptation from literature. Kubrick manages that with great skill, boldly using Alex's racy, confected dialect both in the soundtrack and in the dialogue. ('There was me, that is Alex, and my three droogs, that is Pete, Georgie and Dim, Dim being really dim, and we sat in the Korova Milkbar making up our rassoodocks what to do with the evening, a flip dark chill winter bastard though dry.') Kubrick is not afraid to use a narrative voice in a film, doesn't feel it to be clumsy or un-cinematic, and the result is that he uses it well, and when he wants to – in *The Killing* (1956), for example, in *Paths of Glory* (1957), in *Dr Strangelove* (1963).

It is, as Alexander Walker suggests in his book, *Stanley Kubrick Directs*, 'like an aural note he strikes to which he tunes the rest of the film'. Alex's colourful but cool slang does just this, sets the film's tone, and gets it right. But there is a problem. *A Clockwork Orange*, like *Lolita*, is a novel in love with language, and while Kubrick can use some of the language, he can't really duplicate its role in the novel. So that the story, which is really a peg for Burgess's brilliant and intoxicating homage to *Finnegans Wake*, becomes Kubrick's real subject. In Kubrick's *Lolita* (1962), the sardonic drawl of James Mason and the comic capers of Peter Sellers were poor compensation for the loss of the texture of Nabokov's prose, and a similar loss seems to threaten here. That Kubrick this time, while letting the language go in its essential aspects, should nevertheless have created a successful movie, doesn't answer the odd question about why he should be drawn to such impossibly literary texts in the first place.

It is a commonplace of film criticism to say that films deal primarily in photographed surfaces rather than in words; and that faces, manners, clothes, styles, locations, thus come to matter more than they ever do in novels. This is what the American critic, Robert Warshow, meant when he said that the physical difference between one object and another was of enormous importance in the language of film, and André Bazin meant something like it whenever he used the word 'phenomenology', which was often.

For instance, a person who is simply called a doctor in a novel, and given a name, doesn't need the name in a film but has to be made either male or female. The unspecified future of Burgess's *Clockwork Orange* has to be determined in some way for a film; Kubrick had to choose between futuristic sets and actual locations. In fact, he chose both, hoping to suggest, I suppose, the continuity of present and future. If we don't have Alex's milkbar in England yet, we have Alex and his like, ripping up trains on the way home from football matches. He made a mistake here, though, I think. The result is a very messy confusion of styles of dress, architecture, language – especially surprising because it comes from such a stylish and meticulous director. Whatever was wrong with his *2001*, which was plenty, it had style.

In other words, a film has to determine all kinds of things a novel can leave undetermined, make choices where the novel doesn't have to choose, or can choose a balance. For example, Alex is treated by the state for his violent habits, brainwashed out of them by being shown rough films while a serum previously injected into him makes him want to vomit. By repeated association of the sight and the sensation, he will be made to feel sick every time he wants to be violent, and can thus be released into the world, a safe and irredeemably decent citizen. In the novel, both what is being done to Alex and what he sees on the screen are horrible, the connection for us is between physical violence in the world and the moral violence being done to Alex. In the movie, the sequence is entirely dominated by the insect-like clips which are used to keep Alex's eyes open, so that he can't *not* see the films. The clips claw round his upper and lower eyelids, a medical assistant keeps putting drops into his eyes to keep them clear. In terms of the story, the holding of Alex's eyes open in this way is the least of what is being done to him, but in visual impact it assumes the form of an extreme torture, something much worse than anything Alex is seeing in the films, or has ever done to anyone, and an embodiment of every wrong that he is suffering.

The film, then, even more than the novel, tilts in favour of Alex, and against the inhuman state which has him in its

clutches. I don't quarrel with the tilts, but Kubrick backs them up with some very heavy-handed stuff, all pointing the same way. A big thing is made out of the indignity of having to surrender your clothes and personal belongings when entering prison; out of the brutal, military stupidity of the chief warder. *Land of hope and glory* sounds meaningfully when the Minister of the Interior pays the prison a visit, demonstrating that here, as in *2001*, Kubrick generally uses music for elephantine ironies, and that the brainwave about *Singin' in the rain* was a real exception.

Other tilts are more controlled and more interesting. The plastic, aseptic sexuality infesting the world of the film — present in all its decors and in the behaviour of its people – is a characteristic Kubrick touch, and an exploration of something that is only hinted at in the novel. From *The Killing* on, where a man's love for his faithful wife brought destruction on a whole gang of criminals, through *Lolita*, which is much more about Humbert's obsession leading him to death than Nabokov's *Lolita* was, to *Dr Strangelove*, where a man sits astride a vast, falling, phallic bomb dropping towards a holocaust, sexuality has meant murder in Kubrick's work.

There is an old-fashioned morality here, of course, about sex as evil, and there is a certain amount of straightforward sexual fear, no doubt; but mainly there is an intense and disturbing metaphor for a derailed world, a world where the act that ought to lead to life leads to death, and where the thought of death can bring an inhuman man back to life. It is this pattern of preoccupations which provokes Kubrick's main change in Burgess's plot: the old lady, killed by Alex more or less accidentally among her cats, becomes a tough, devouring female principle embodied by Miriam Karlin, proprietor of a health farm, furiously exercising among the cats, which now seem predators rather than an old biddy's harmless mania. There may even be a subdued pun on the idea of 'pussy' lurking in Kubrick's intentions. Miriam Karlin swipes out at the intruding Alex with a bust of Beethoven, and he retaliates by picking up a piece of modern sculpture which is standing around, a shiny white plaster representation of a massive penis and testicles. After a struggle, Alex pounds

Miriam Karlin to death with this instrument. His culture literally put this all too meaningful weapon in Alex's hands.

The same implication runs through another change Kubrick has made in Burgess's plot, this time a change of emphasis and motive. After Alex is cured of his ugly habits, and with them of being human at all, he is picked up, in the novel, by people who encourage him to commit suicide so that his death can be used politically against the reigning government and its complacency about the way it is handling criminals. Alex tries to kill himself by jumping from a high window, fails, and the blood transfusion which his injuries call for clears his system of his conditioning, and he becomes his old ultra-violent self, as he would have put it. This reversal is simply a general irony, an image of the world which doesn't know where it is going, where the designs of man are corrected by the hand of God, perhaps.

In the movie, the same things happen, but make up an entirely different story. Alex's release from his brainwashed condition is no longer an accident, but part of the government's deal with Alex, a turning of the tables on the people who wanted to use Alex's death as subversive propaganda. This is all made perfectly clear to Alex, who accedes glee-fully, and the film ends with him and the rosy-faced Minister of the Interior grinning in full agreement, a murderous society and a murderous thug in perfect smiling concord, joined in unholy wedlock.

The point is not that society creates criminals in any elementary sense, but that a society and its criminals may well have identical habits and interests, and may gang up on all those of us who live between them, caught between crime and order, and victimized by both. The streets are not safe at nights, and our humanity is not safe either day or night in the inhuman social orders we have made for ourselves, and often defend, perversely, to the death.

A Clockwork Orange is, surprisingly, a modest film. Kubrick probably feels it to be a half-way house on his way to his project for a grandiose film about Napoleon. It is skilful and intelligent – better than *2001*, for my money, and more serious than *Dr Strangelove*; which makes it Kubrick's most success-

ful movie since the impeccable *Paths of Glory*. There are a couple of lines in Burgess's novel which don't find their way into the film but perfectly define its perspectives and its achievement. They are a deformation of the opening of Schiller's *Ode to joy*, celebrated in Beethoven's *Ninth Symphony*:

> Boy, thou uproarious shark of heaven,
> Slaughter of Elysium . . .

Sharks in heaven, the murder of paradise, the cancellation of that pseudo-hopeful climax of *2001*, where an astronaut, in a piece of what Andrew Sarris has called instant Ingmar, was born again. I, for one, am happier with the cancellation, with the attempt to look at some kind of human truth, however unpalatable, before hoisting us into mechanical myth. Alexander Walker writes, meaning well, that Kubrick has never underestimated himself. I take that to imply, if unintentionally, that he is inclined to overestimate himself, and that is probably right. [1972]

To serve . . .

Paul Mayersberg

A film about public schools in England had to be made sooner or later. It's only odd that it's taken so long to get to the screen. But having taken so long, *If . . .* was well worth the wait. A few years ago the chances were that a film about public schools would have turned into a British think-pic from the Basil Dearden/Michael Relph team in the terrible tradition of *Sapphire*, *Victim* and *Life for Ruth*. Such a film would have been likely to be both for and against public schools, endorsing proper notions of fair play.

In the event, Lindsay Anderson's *If . . .* comes as a very pleasant surprise to those who dreaded a 'thoughtful' film on the subject, and presumably as a rather nasty shock to those who expected fairness and tolerance in the treatment of this

controversial subject. *If . . .* constantly lands blows below the belt. The film has no compunction in dealing out rabbit punches, kicks in the shin, and the occasional knee to the groin. As a real public school, the College in *If . . .* is fairly extreme in its presentation of tough prefects and weak masters. While this does not seriously impair the authentic atmosphere (the College is a truthful image of a public school), it does appear to load the dice against any possible virtues of the system.

In fact, the film's tactics, in having scene after scene of repression, are monstrously unfair. But the system itself is monstrously unfair. And so the ultimate effect of the tactics is totally just. When, at the end of the movie, the three rebels and their girl take up automatic weapons and start mowing down the teachers, prefects, boys and their parents outside the school chapel on Founder's Day you feel that this is a matter primarily of comeuppance.

If . . . has a public school setting and story, but it's not solely (or perhaps even mainly) about public schools, any more than *The Big Knife* was solely about Hollywood or *The Hustler* solely about gambling. Among other things, *If . . .* is a film about institutions and the way institutions divide a society, and often in the process conquer it. The movie focuses on the life and attitudes of a boy who refuses to be institutionalized. Mick Travers (ingeniously played by Malcolm McDowell) is a boy who prefers private thoughts to a public character and is given to rhetorical fantasies rather than phlegmatic inhibitions. To the prefects, Mick is an unhealthy boy, a threat to the stability of the school. When we're introduced to him on the first day of the winter term, his face is covered by a long scarf which is wound round it. All you can see are his eyes. The scarf in fact hides a moustache which Mick has grown in the holidays. So Mick is immediately identified as a rebel. In the College, the slightest deviation from conventional behaviour, or even conventional appearance, becomes an act of treason. The College in *If . . .* is a world of crime and punishment, of authority and servitude. At one point the headmaster lectures Mick on the glories of service. The notion underpins the whole of public school life.

Service equals acceptance. To serve is not to rock the boat.

In this public school, it isn't the masters who represent the real authority and power, but the prefects, called Whips, and the senior boys. Next to the Whips the masters seem weakly liberal. The most rigid, unthinking adherents of any system are always the new converts. *If . . .* is not a film which has very much to say about education. There are no comparisons with other schools. That isn't part of the intention. Like Lindsay Anderson's previous feature film, *This Sporting Life, If . . .* is about *the* system, and the ways in which the system provokes and deals with rebellion. From the beginning of the movie, the implications of the story, events and characters go far beyond the apparently parochial setting of a boys' boarding school.

The fact that *If . . .* is about boys under eighteen gives the conditioning process of this institutional hierarchy a very sinister tone. You could transfer the Jesuitical line from *The Prime of Miss Jean Brodie* – 'Give me a girl at an impressionable age and I'll make her mine for life' – to the ethos of *If . . .* But whereas Muriel Spark's book is about a teacher's relationship to her pupils, *If . . .* is about the boys' relationships to one another. The College is a feudal hierarchy, a sado-masochistic society in which carrying out orders is as exciting and rewarding as giving them. Service is all.

While the College fears Mick and what he stands for, we as audience begin to fear the College and what it stands for. The clean, open-faced boys on the first day of term become much more threatening in their uniformity than the eccentric entrance of Mick dressed up as the Whitechapel killer. He even moves around as if he's skulking in a pea-souper. 'Violence and revolution are the only pure acts,' he says. Mick represents Luis Buñuel's dictum that the only possible response to the world is a permanent state of rebellion.

Quite apart from the rebellion in word and deed contained in the excellent screenplay by David Sherwin, the whole structure of *If . . .* and its visual style reflect the mind of Mick as a man in revolt. The movie is divided into eight sections in the manner of some of Jean-Luc Godard's films. It sports titles like 'Ritual and Romance', 'Discipline', 'Resist-

ance' and 'Forth to War'. These take on the force of chapter headings in a manual for revolutionaries. In many respects *If . . .* is a documentary. It closely details life in a public school in short, pointed scenes. It has no plot. The film is a modern version of a medieval frieze. A frieze in motion. The style is ideal for so ritualistic a subject: public school life is a series of events and occasions with a staggered, rather than a fluid, movement. But while the film is fragmented, it's also extremely logical. The story *has* to end in violence.

The walls of Mick's study make up a collage of pictures cut from magazines and newspapers which range from cheesecake pin-ups to scenes of war and violence. A picture of Che Guevara occupies a significant place. Mick sees himself as a junior Che. The photo-montage in his study is a reflection of his state of mind. The disparate images collectively represent frustration. Mick is disoriented, split between obedience and rebellion. Mick is frustrated because he would like to fight his enemies like a soldier. Eventually, he gets his wish. Mick wants sex. He wants the girls in the pin-ups. In a 'fantasy' sequence, which takes place in a roadside café, Mick fancies the girl behind the counter. He gets her. He wants to turn his rhetorical thoughts into physical actions. He wants to dominate his environment instead of being dominated by it.

When I referred to the scene with the girl as a fantasy sequence, I did so because the event is very unreal in that it's rather unlikely, to say the least, and is acted and presented in a stylized way. It is also photographed in monochrome whereas for the most part the movie is in colour. But Anderson's use of monochrome in the film for certain sequences does not always denote fantasy. Many scenes, which you feel must be fantasy sequences (including perhaps the end), are shot in colour. So there is no direct correlation between fantasy and monochrome. In fact, I'm not certain why monochrome is used at all. Except it may be that, like the collage of pictures on Mick's wall – inevitably a mixture of black and white and colour – the film itself is a mixed collage. If this is so then the arbitrariness of the mixture is immaterial, or essential. There need be no formal logic in the choice or selection of sequences for colour or monochrome.

This makes the whole question of fantasy and reality in
If . . . rather interesting. Life for an adolescent boy is a very
ambiguous mixture of fantasy and reality. It is not very
important to try and distinguish between them. Perhaps if
you did you would move further away from an understanding
of that state of mind and body. The ambiguity is natural, and
a stage in normal development. As a director, Lindsay Ander-
son shares at least one characteristic of Mick's personality: a
strong need for images that are both seductive and shocking.

When Mick takes his airgun and fires darts systematically
into pictures on his walls, the images that meant so much to
him themselves become targets. So Mick symbolically attacks
and destroys what he wants and what he hates simultaneously.
His diet of images is so rich that he is sick. Mick's images are
icons, necessary perhaps at a certain time, at a stage in history
or in psychological development, but when they are no longer
necessary they must be destroyed.

This seems to me the central point of *If . . .* If one takes a
public school as an icon which has long outgrown its useful-
ness, why has it not been destroyed? Why do we still serve it?
If . . . is a film which makes you very, very angry. [1968]

Boy in a cage

Paul Barker

Kes is a film about the way we try to tame most of our
schoolchildren; about – in its director's words – 'a waste of
human spirit'. Anyone who has ever taught, or been taught,
in a run-of-the-mill secondary modern school, or in the lower
stream of a comprehensive, knows what a battlefield of will-
power nearly every classroom is. Chiefly the teacher's will.
He needs to fit these boys (the boys more than the girls) to
his concept of a decent, orderly, *quiet* class.

It's wrong just to fault the teachers. This is what parents
and employers largely want of the staff in such schools. They

want the children assembly-belted into leading decent, orderly, wage-earning lives. *Kes* brilliantly puts across this permanent feeling of aggression and suppression. It was filmed at a school in Barnsley in the West Riding, and in or around Barnsley itself. The actors, with one exception, are local children, teachers or northern club entertainers.

The title of the film is the name of a bird; but the subject of the film is the bird's owner, Billy Casper. He is one of the children who are being crudely moulded for that moment when, as they approach fifteen, the youth employment officer will check rapidly through the job possibilities and settle for 'manual'. Somebody has to hump dustbins; somebody, if you live in Barnsley, has to go down the pit.

There is one passage in the film which is as boldly effective as a tabloid headline. Jud Casper, Billy's brother, goes off to his shift in the pit. He wears a shirt and trousers that make him look like a man in the army; maybe they are army-surplus. The pithead reeks rust and muck and flaking brick. As the miners tramp across and start to go down the shaft in the decrepit cage, the soundtrack cuts to the drone of children singing in school assembly. After a few moments, the picture cuts to the assembly hall, too. This is where Billy goes; it's new-shoddy ten years after it was opened, and the teachers stand like special constables during assembly, on the look-out for whisperers or dozers. Billy is about to leave school, but he doesn't want to go down the pit. His brother, on starting work, only swapped one cage for another. The same route stretches ahead for Billy.

The storyline reinforces this image of a cage. Like the young kestrel, 'Kes', that he catches and decides to train, Billy can be caged and controlled, within limits; but beyond them, he remains wild, despite all the efforts at taming. School is a cage; home is a cage; work (whether down the pit or not) will be a cage: but every so often Billy will escape.

The director of *Kes* is Ken Loach, whose best-known work has been in television: *Cathy Come Home* and *Up the Junction*. His first feature film was *Poor Cow*; *Kes* is his second, and he himself prefers it. It's a film that avoids two temptations that could have trapped it into a false

picturesqueness.

On the one hand, the trap of the nature film: swooping wings, proud beak, green fields and woods. All these are there, but they are played down; the shots are cut back, sometimes tantalizingly so. Loach, like the Barry Hines novel the film is based on, is interested in Billy more than in the bird.

The alternative trap is the industrial picturesque of dark stone back street, with children playing – like Opie informants – on the worn sets; all warmly evocative of a *Coronation Street* working class. This only bobs into *Kes* occasionally. Billy lives on a council estate, straggling at the edge of Barnsley. By comparison with the redbrick rush-job look of these houses, the dark stone of the older streets seems solid. In the council houses, whenever a door is shut in anger, the soundtrack records a thin bang, not a slam. This is where the working class lives now.

Loach does catch beautifully how, in the West Riding, the countryside which creeps in so close to the towns is a release from the confines of industrialism. Billy is a loner: he walks among the trees, chews grass with the knowing munch his grandfather would have recognized. But Loach is concerned less with a specific portrait of a boy than with his film's general social message. Just as Cathy personified the homeless, Billy Casper personifies the 'Newsom children' – those secondary-school children who will leave early and fill most of the country's jobs.

In casting the film Loach followed through the logic of his belief that human potential is being wasted. Some child in school in Barnsley ought to be able to play the lead part. David Bradley was chosen to play Billy out of about thirty other children who'd been seen. The son of a miner, he is at this school himself. As Billy, he looks the part perfectly. He even looks fed right – as if he ate nothing but fish and chips and crisps and pop. When he strips to play soccer, his ribs stick out. Beneath each eye there is a diagonal line of tiredness running across the top of the cheek. His anorak is a size too small; his hair was last brushed a fortnight ago. His resilience shows through, and – when he is training Kes – his ability to be absorbed in a task. Like most of the cast he

helps give the film the rough edge of documentary. The head-master of the school in *Kes* is in fact head of a nearby school. 'The relationship didn't just stop when the cameras stopped turning,' Loach says.

The constant suppression is shown best in two sequences. One – the most direct – is where the headmaster canes Billy (for falling asleep in assembly) and some other boys who've been caught smoking. The head gives them a joint harangue. In a way, he'd rather not cane them; but what choice has he? 'I taught your father, MacDowall,' he tells one of them. 'Things are no better now than they were then . . . We can never tell you anything . . . mere fodder for the mass media . . .' And the caning goes ahead. The school is not blackboard jungly; just deadening.

The other sequence is the games period, when Billy is forced to turn out, even though he detests football, and is thrust by the PE master into a borrowed pair of ludicrously oversized shorts. The PE master is played by a professional wrestler who also, it happens, teaches English. It is a very precise piece of casting. He sums up all the pressures on Billy – all the more so for living in a world of mock-heroic fantasy not unlike that of many of the boys. In the boys' soccer game he plays as captain of one side – only half-joking when he speaks of himself as Bobby Charlton. He makes sure his side plays with the wind. By suddenly reverting to referee, he sends off the other side's captain. (In mimicry of television, Manchester United/Spurs scores are flashed across the bottom of the screen.) But Billy, fooling around, lets a crucial goal through. The PE master keeps him in the showers and turns them full cold.

Billy's life is of a piece. Home is where the narrowing-down of Billy's future begins. His mother, deserted by her husband, is off every Saturday night with her new boy-friend. There is a gross, accurate Saturday night scene, with her and Jud slanging each other across the tables of beer.

Jud's own relationship with Billy is almost entirely a bully-ing one (paralleling the bullying that Billy sometimes gets at school). The film opens with a shot of Jud and Billy sharing the same cheap, ugly bed. Billy and the alarm clock wake Jud

for the pit; but when Billy asks for the alarm to be re-set for his own getting-up time, the only answer is 'Set it thissen'. Jud's face has self-confidence and self-assertiveness in its bones. It is Jud who, at the end of the film, will kill Billy's kestrel, and throw it and Billy's brief freedom into the dustbin. Billy spends some money of Jud's on fish and chips instead of putting it on a double. The double comes off. Billy must be punished.

The details tell. When Billy is told he could get a book on training kestrels from the public library, he asks, 'Where's that?' And on getting there, he finds he can't take a book out because he's not a member and he would have to take the card back to his mother to sign. He steals one from a second-hand bookshop instead.

One part of Billy that can't be squashed is his gaiety. As he trains Kes, whom he's caught in a nest near his home, he talks to it like a miner to his whippet – 'Come on, lass' – and it soars to his hand across the fields. The quality of Billy's life is delicately caught: a blithe toughness among the shoddiness. This is epitomized when Billy squats down on a hillside, against a background of chimneys, to read a *Dandy* he's delivering. Loach cuts a whole strip from 'Desperate Dan' into the film.

Kes is being held up over distribution. Because it has a U certificate, the trade seems to think it's for kids. Yet, at the very least, all education committees should see it, compulsorily. A new school building and pale pine desks are not enough; nor is a *New English Bible* to read the lesson out of at assembly.

I remember one shot of the council estate: those ugly, boxed houses – then behind them the untidy huts, where the tenants can do what they *really* want. It is in one of them that Billy rears his hawk; and where, after he's gone down the pit, he may try again, I suppose. Or keep a whippet. [1969]

Monsieur Chaplin

Michael Wood

Monsieur Verdoux, 1947: Chaplin, playing a dapper wife-murderer, modelled on Landru, meets up again with a poor young girl he had thought of poisoning earlier in the film. She is rich now, successful, married to a munitions manufacturer. 'That's the business I should have been in,' Verdoux remarks, and asks what sort of chap her new husband is. 'Very kind and generous,' the girl says, 'but in business he's quite ruthless.' 'Business,' Verdoux says, 'is a ruthless business, my dear.'

The early Chaplin, if he could have talked in films, would not have put it quite like that, but he would, I think, have agreed without hesitation. Not only business, but life itself is a ruthless business in all the Chaplin films I've seen, and not the least of the little tramp's attractions for us is that he survives; loses the girl maybe, but gets off with his life. The soulful fellow in the baggy pants, tight jacket and bowler hat is loveable, of course, but not half as loveable as we tend to see him in retrospect. He was never above stealing sweets from children and made a point of kicking people's backsides when they were not looking. Above all, he was cunning, not merely vulnerable.

There is a splendid sequence in *The Great Dictator* (1940), which marks the last appearance of the little tramp, where several men have to eat puddings to determine which of them is to risk his life. One pudding contains a coin, and the man who gets the coin will be chosen. Chaplin gets the coin, inevitably, but quickly transfers it to his neighbour's pudding. The neighbour in turn finds the coin and passes it on while *his* neighbour is not looking. At one point, several other coins having entered the game, Chaplin eats the lot in a casual mouthful. When he stands up the coins jingle in his innards

like pennies in a piggy bank, thereby giving him away. The joke is on Charlie, of course, but we are entirely with him, because he is not keen on dying, and neither are we. He is crafty, a survivor; and a survivor, as Falstaff taught on the battlefield at Shrewsbury, is the opposite of a hero.

In *Limelight* (1953), playing a version of the tramp grown old and past it, Chaplin faces a girl who wants to kill herself, and asks her if she is in pain. When she says no, he says, 'Well, that's all right,' as if pain were the only conceivable reason for suicide. We can see an insensitive optimism here, and something of the kind does run all the way through *Limelight*. Chaplin psychoanalyses the girl back to confidence in herself with a swift, crude lecture. 'Dr Freud, eh?' he says, when he learns that the girl's troubles may be psychosomatic. But even so you have to know a lot about pain in order to be able to speak of it in that authoritative, offhand way. It is survivor's talk.

Survival in Chaplin's early films, some of which are now reappearing on TV, is a matter of brilliant, desperate improvization. But there is more, a certain flourish, a curious superfluous grace. Not only do you eat your boots when there is nothing else to eat, but you eat them as if they were exquisite, a gourmet's delight, as if you were eating them not out of mere need, mere hunger, but from choice. There is an odd liberty in the midst of deprivation here, and this kind of paradox is very frequent in Chaplin. He is awkward, clumsy, out of phase with things, always falling over and being knocked about. But he is also unnaturally poised and light-footed, even his falls and stumbles resemble dance steps – think of Chaplin taking a corner at speed, hopping outwards on one leg, or staggering elegantly along a street after being hit on the head with a frying-pan. He is some kind of kin to Fred Astaire, and W. C. Fields said Chaplin was the greatest ballet-dancer that ever lived. From Fields this may not have been entirely a compliment.

Chaplin manages far worse than we do; but also far better, in unforeseen ways. In *Shoulder Arms* (1918), he is no good with a gun but, disguised as a tree, he puts a whole passing

line of enemy soldiers out of action. Forms of maladjustment are converted into forms of extravagant triumph; his extraordinary physical grace is the answer to his extraordinary physical incompetence. Chaplin lives on either side of the normal, and indeed when he manages to behave like the rest of us, is immediately punished. He gets a job in a factory in *Modern Times*, and comes out still twitching, jerking his arms spastically, as if they were machinery he can't switch off. In the same film he presumes simply, as André Bazin said, that the future will resemble the past, and that a man might dive off a diving board into a lake, and not find the water was only a foot deep. He is wrong. For him the most ordinary realities are unreliable, pitfalls wait in the safest places.

And it is for this reason that Chaplin, like Keaton, always displays such amazing patience in the face of excessive, improbable calamity. The two come together in Chaplin's *Limelight*, a twin memorial to the old silent days, and to the dogged, lunatic, indefatigable stoicism which is the signature of all great clowns.

Mention of Keaton calls up the obvious comparison. Many people have come to prefer Keaton to Chaplin, partly no doubt because his stony face and stiff gestures have the kind of helpless eloquence we now look for in our victims. And beyond this, Keaton clearly is the more perfect artist: his films are beautifully coherent, composed, satisfying. But Chaplin, it seems to me, remains more disturbing than Keaton, gets under one's skin more, just because he is a tough man behind the sentimentality.

The Great Dictator, for example, is a poor film about Hitler, an attempt to laugh him out of existence. The world, the movie suggests, has degenerated into a knockabout comedy, with buffoons like Hitler and Mussolini in high places. The trouble is that being ridiculous was the least of fascism's failings, and Chaplin himself wrote in his *Autobiography* that he could not have made the film if he had known about the German concentration camps. Yet this same poor film about Hitler is a profound film about Chaplin and his creations, for Chaplin plays both Hitler (called Adenoid Hynkel in the movie) and a Jewish barber, alias Charlie the tramp, and

curious interchanges take place.

Hynkel, to start with, gradually becomes Chaplin's little man, that same graceful bungler from the silent era. He thinks of taking over the world, and bounces a globe which is a balloon on his head, on his fingers, on his feet, as he performs a slow ballet to the strains of *Lohengrin*. When he confronts Mussolini, in the beaming person of Jack Oakie, he loses every round, and once again we are back in those silent films where a tiny Chaplin was bashed about by a beefy bully. It is all very funny, but our sympathies are clearly with Hynkel. He drapes himself grandiosely in a cloak, then reaches out a hand to receive a dispatch. He can't get hold of the dispatch because he can't get his hand out of his cloak. Here is a poor fellow trying for a bit of dignity against all the odds, and these are strange feelings indeed to summon up around Hitler.

But the conversion in the other direction is even stranger. The Jewish barber finds himself in uniform, is mistaken for Hynkel, and makes the famous concluding speech of the film, asserting the essential brotherhood of man and the hope of a better world. The soundtrack distinguishes clearly between this speech and Hynkel's earlier tirades in a horrible, if comic, mock-German. But the camera doesn't; and in close-up, filling the whole screen, ranting, screeching, frowning, looking furious (although in fact he is inspired only by universal love), the barber's face is Hynkel's face, since both faces are Chaplin's. I find it hard to believe that a great mime like Chaplin, a master of silence, didn't know what he was doing here. In any case, why would Chaplin play both the tyrant and the tyrant's characteristic victim if he didn't want to suggest an affinity between them? And it is perfectly natural, if Hitler can become one of Chaplin's touching little men, that we should then see his touching little men as capable of becoming Hitler.

In fact, very complex ambiguities have haunted all Chaplin's avatars. He is, as Isabel Quigly wrote in her excellent book, *Charlie Chaplin: early comedies*, on both sides of every situation. He is a waif, the lost soul you want to take home. But

he is also, and always was, something of a rake, a bit of a toff and a bit of a cad, a dodgy character, just the sort you'd rather not have in the house. There was a faint whiff of androgyny about him too, a hint of sexual ambiguity. In a photograph taken some time just after the First World War by Edward Steichen, Chaplin appears in a smart double-breasted suit, legs slightly crossed, leaning on a cane, a soft derby in his right hand, which rests on his hip. His hair is greying, his bright smile seems a little sinister. Behind him he casts a tall shadow which, because of the cane and the hat, is that of the tramp. Steichen was just playing with the idea of a split between the creator and his creature, no doubt, and it remained for Chaplin himself to spell out with cruel clarity what the picture really meant. It took him some time, for the man smiling in the foreground of that photograph, throwing up behind him the shadow of the tramp, is unmistakably, to the eyes of hindsight at least, Monsieur Verdoux, Chaplin's natty gentleman killer, the super-adjusted, skilful man, the tramp's alter ego in just the way that Hynkel is the alter ego of the Jewish barber.

In Chaplin's early films, there were fragile moments of kindness amid life's general ruthlessness. Such moments often looked false or sentimental or forced because the surrounding ruthlessness was so total. In *Monsieur Verdoux*, ruthlessness becomes the only available form of kindness. Verdoux is a man who murders women in order to support his own wife and child, and even thinks he may be doing his victims a favour by freeing them from a hard and cruel lot. So that when Verdoux goes to the guillotine, Charlie does indeed go with him, as André Bazin said. The survivor has ceased to survive, has given himself up. But it is not because society, as Bazin suggested, has committed the horrible error of executing Charlie. It is because Charlie held within him, always, the horrible promise of becoming Monsieur Verdoux.

These are grim thoughts to apply to Chaplin, and I don't mean to suggest that his films seem grim, or anything other than very funny, or at their worst, as in *Limelight*, merely melodramatic and pretentious. But I do think this grim scheme of things makes sense of Chaplin's career, and helps us to

see at least one of the sources of his enormous charm. For forty years he danced on thin ice over very dark water, and we loved him for making the ice seem thicker than it was.

[1973]

A set of caricatures

Paul Barker

As I came out of the showing of *Fellini-Satyricon*, an ugly, rather literary-looking figure was saying to his friends, in a curiously thin and high-pitched voice: 'It's the story of my life.' Down the street, a bar was raucous with a bad imitation of country-and-western. In Leicester Square gardens, the statue of Shakespeare presided over several hippies, some visiting Swedes, and a flock of late-flying Americans taking in London as well as Stratford-on-Avon. In the other direction lay, chiefly, strip-shows and porn shops. Most of the men within sight had hair which once would have been classed as girls'; many of the girls wore trousers. At least half the people in the street were foreign or black. The evening paper had a story about car-racing – a sport which combines high fashion, high expense and a high death rate.

It was a concatenation that Federico Fellini would have liked. 'It seems to me,' he says, 'that we can discern disturbing analogies between Roman society before the definite advent of Christianity – cynical, impassive, corrupt, dissolute – and today's society . . . Then, as now, we find ourselves confronting a society in the fullness of its splendour, but already with the signs of progressive disintegration.' And the catalogue of cultural overblownness in my opening paragraph is like the denunciations, by Petronius, Juvenal and Persius, of late-Roman society: reproaches of imitative art, untraditional sexual pastimes and ways of dressing, selling-out to the foreigner.

Some other things, such as Games more fatal than car-

racing, are unreproached. An inscription found in the gladiatorial barracks at Pompeii says, 'The philosopher Seneca is the only Roman writer to condemn the bloody Games.' The lack of any comparable condemnation shows up a superficiality in the so-called satirists. They seem, even, to feel a camp attraction towards what they sneer at. Juvenal, like Suetonius, has a *News of the World* ring: 'Isn't this disgusting? Look.' The writers are most interested in being able to turn some elegant phrases, make a few good gags, and work in plenty of sex. At this distance their denunciations read lamely.

Much of what Fellini claims for his *Satyricon* is as exaggerated as Petronius's claims for the original might have been. The film bears little resemblance (thank God?) to a serious critique of the third quarter of the twentieth century. In writing about his *La Dolce Vita*, Pauline Kael accused Fellini of producing a sort of *Ben Hur* for the more, but not *very* much more, sophisticated. 'The movie,' she says, 'is so moral in its emphasis that all vice (all non-innocent fun?) seems to be punished by boredom and defeat. But why are people looking so eagerly at the movie, hoping for ever more horrifying views of that unrestrained high life? The sweet, soft life is just what hard-working moralistic people envy . . . (Perhaps you don't decide it's dull until after you've had a lot of it? Morality becomes a function of exhaustion.)' Fellini's intellectual 'justification' of his *Satyricon* is similarly flawed.

Fortunately, this doesn't matter. When Dr Johnson transmuted Juvenal for his own times, he had to wrap the result in heroic couplets. But we have, in films, the precise equivalent of that Roman invention which was called, at first, a *satura*. To us, 'satire' describes a tone, rather than a form. To begin with, form was the point: a *satura* was a hodgepodge, a miscellany.

A film, too, is diverse. The unsuccess or irrelevance of one part doesn't kill the whole. One *sees* films in bits. Only the very young tell one another the stories of films. Most film-addicts talk about the shots, the sequences, the episodes. (Film criticism shares in the nature of the subject. By far the best books are the collections of good journalism, like Kael and Agee. By far the worst are attempted assaults on high

aesthetics.) In his *Satyricon*, it isn't just from Petronius that Fellini borrows. In every sense it is a *satura*, a miscellany. It is the best replica of the *feel* of Petronius and the rest, that I have come across.

Fellini began his career as a caricaturist. The sketches on which he based the casting and design of this film show that he retains the technique. The film itself oozes caricature. You come away from it very conscious of lips and eyes and tongues. Throughout the film, whatever else is supposed to be going on, figures simply sit and stare at the camera. Their faces are extraordinary; so are their gestures. An old bawd, Calpurnia, is placed down-frame right and posed like a Beardsley drawing of Messalina. When she moves into the action, it is chiefly in order to waggle her tongue – obscenely wet and fresh in that cosmetic-plastered face – as a commercial gesture of invitation to her brothel.

Eye-riveting images, with no explanation and perhaps not needing one, abound. A huge head, three times the height of a man, is drawn along an alley, almost blocking it. A kind of huge crate, full of people, is tugged past a window. Perhaps the first is on its way to some show in the arena; perhaps the second is on its way to the galleys. But we never know for certain; each only takes place in the background.

Yet, in fact, such images are more important than the action. The level of the acting, as such, in *Fellini-Satyricon*, is well below the water-line. The two main characters – the bisexual Encolpius and his friend/rival Ascyltus – emote like tailor's dummies. As played by Martin Potter and Hiram Keller (which is, presumably, how Fellini wanted them played), they are an embarrassment. However, your eye rests on Encolpius and Ascyltus surprisingly seldom. The film does not depend on them. They are a thin, unimportant narrative device. It is as if Fellini doesn't *want* a theme to get in the way of the pictures.

As story-telling, the only real successes in *Fellini-Satyricon* are the two digression-tales embedded in the film: that of the widow of Ephesus (the original of Fry's *A Phoenix Too Frequent*) and that of the witch, Oenothea. These are beautifully, nonchalantly, done. The widow's decision to make love

with the soldier, instead of watch over her dead husband, is shown just by a movement of the eyes.

It remains a film about images, not about stories. Some shots are as carefully composed as a seventeenth-century painting. The screen appears to have an almost 'painterly' surface when, for example, the greasy brick walls run with condensed steam in the baths where Encolpius and Ascyltus squabble over a boy-friend. The brothel that they visit rises up like the inside of a Tower of Babel painted by Piranesi. There are sudden, worrying, surrealist sights: a white horse standing in a shallow pool; a crowd on a hilltop, made, by the clever use of parallax, to zoom across the screen.

And hardly any of this is done artily. The verve of *Fellini-Satyricon* is one of the best things about it. The brothel may look like Piranesi; but when it collapses, because of jerry-building, it is Cecil B. DeMille. Rocks fall; animals panic; children are snatched up. And not even DeMille could have outreached Fellini's version of Trimalchio's feast. Again, the main action is not the point. It's of little importance that another of Encolpius's friends, the poet Eumolpus, is consigned to be roasted in the ovens because of mocking Trimalchio's own verses. This is merely an occasion to photograph a huge, black spit turning in front of the red, roaring flames – cooking, in slave-tended luxury, a row of small field-birds. It's a Technicolor film, but black seems to have a special zest for Fellini. The black of the spit. The strident black imagery of a Nazi-style march on Rome. The black, harsh beaks of ships. And then the softer black of people – of Donyale Luna, for example, as Oenothea.

The film cuts from episode to episode, without much explanation. This is particularly true of the first half. The second half is less good because it tries somewhat harder to have a plot. There are also scenes – like one where a citizen, before killing himself, manumits his slaves – which seem to be nothing more than extended footnotes on Roman customs. In the first half, even these footnotes take on a life of their own. There is a grisly telling-of-entrails. There is a horrible portrayal of Roman low-comedy: in a parody of divine Caesar's miraculous powers, a man's hand must be chopped

off and restored; the part is played by a slave, therefore, whose hand is really chopped off.

There was once a classical scholar who, when asked if he would join in an attempt to prevent classical texts from being lost, said No, but he would join in at trying to lose a few more of the tedious ones. Parts of *Fellini-Satyricon* – like the manumission scene – will, with luck, get cut by impatient distributors; or maybe the mice will get at a few reels. If the film became wholly, like Petronius's own *Satyricon*, a set of brilliant fragments, it would better achieve what it sets out to do. The relation between that chopped hand – the decline it reveals in the *separation* between art and reality – could linger in the mind as a correlation to some of today's avant-garde, chopping up chickens on stage. But nothing would be forced. [1970]

W. C. Micawber

Michael Wood

The scene is the frozen north, created by a set designer who is either entirely without talent or entirely without interest in his job. A large, portly man with flat feet, a bulbous nose and remarkably shifty eyes, nattily dressed in what a sporting gent of the 1930s might think he ought to wear in the Yukon, goes to the door of his rude shack, opens it, half-steps out into the blizzard, and ponderously says, 'It ain't a fit night out for man nor beast.' A handful of synthetic snow, clearly flung by someone behind the set, hits him in the face. The faint allusion to Chaplin's *Gold Rush*, the complete absence of anything resembling realism in the scene, make this very funny – a city's man's parody of the pioneering life. A few moments later the man returns to the door, opens it, and says again, in the same tone, 'It ain't a fit night out for man nor beast,' and the same handful of snow, or one very much like it, hits him in the face again. What's more, the routine is repeated

several more times in a very short film, with only one variation; the last time the man says his line, he waits and flinches, but no snow is thrown. The film is *The Fatal Glass of Beer*, one of four shorts that W. C. Fields made for Mack Sennett in 1932 (the others were *The Barber Shop*, *The Dentist* and *The Pharmacist*); and the portly, shifty, snow-smitten man is Fields himself. The movie has one other very famous line. 'I think,' Fields says at one point, heaving himself to his feet, 'I'll go out and milk the elk.'

In America, Fields has a reputation on a level with that of the Marx Brothers, and for good reason. He can be seen with the same sort of frequency in the same sort of cinemas. I think he is probably less well known in Britain, and correspondingly the BBC's recent season of Fields films seemed to lack the context of familiarity which many comedians really require. Chaplin is funny because he is funny; but he is also funny because he is Chaplin, because we know him, and because at a certain stage almost anything he does becomes funny. The same is true of Groucho Marx. Groucho wags his eyebrows, waves his cigar, and we have started to laugh. It doesn't really matter what he says, as long as it's one of those things Groucho says. 'I could dance with you till the cows come home,' for example, as he tells Margaret Dumont in *Night at the Opera*, quickly adding, 'Come to think of it, I could dance with the cows till you come home.'

I mentioned *The Fatal Glass of Beer* because it sets up within a single film that continuity of expectation which such comedy thrives on, and because Fields's career in the movies is that sort of career. It is the life, in a series of separate and on the whole mediocre films, of a compelling comic character, a raffish, boozy, sly, charming, pompous and victimized figure, a man with a constant look, as Arthur Knight says in his book, *The Liveliest Art*, of 'outraged dignity and larcenous innocence'. He is the enemy of every piety of American domestic life, the wry, drawling foe of home, wives, children, pets and respectability in general, a version of Antichrist in Disneyland. 'I love children,' Fields says in more than one of his movies, 'as long as they're properly cooked.' Or in a sharper form, answering a hypothetical interviewer who

asked if he liked babies: 'They're very good with mustard.'

The children in Fields's movies are monsters even by Hollywood standards – one of them eats a canary, the feathers are seen still clinging to its mouth – and the women are all garrulous and domineering. (Mae West is a partial exception – she pushes Fields around but she is also an ally against decency.) Fields himself, equipped with fat cigar and jaunty straw boater, somehow looking both seedy and faintly elegant at the same time, is usually the beleaguered father and husband, the hapless, muttering misogynist, and he has a set of tiny gestures of surprise, oddly delicate and fluttering in so corpulent a figure, which suggests a curious vulnerability, a man *never* ready for what hits him. On the other hand, he is extremely cunning, full of schemes for getting rich, evading the law and sneaking a drink, and it is this mixture of helplessness with a striking talent for devious self-help which makes Fields such a great comic character, scapegoat and survivor all in one, like most great clowns.

Fields composed his own epitaph. 'I'd sooner be here,' it was to say on his tombstone, 'than in Philadelphia.' He was born William Claude Dukenfield in Philadelphia in 1880, of 'poor but dishonest' parents, he was later to say, although there is no evidence that they were anything but poor. He tried his hand at a bit of mild dishonesty in his youth, pretending to drown at Atlantic City in order to attract a crowd around a popcorn and candy stand (I take this and other details from *W. C. Fields by Himself*). But his vocation was already clear. He became a proficient juggler, and toured the world in vaudeville, finally appearing in Ziegfeld's Follies and sharing the bill at an English command performance with Sarah Bernhardt, who didn't normally like appearing with magic acts, animal acts and jugglers, but made an exception for Fields.

His best-known trick was to balance a top hat on one foot, place a cigar on the hat, and then with a single wave of his ankle flick the hat on to his head and the cigar into his mouth. He made a few films between 1915 and 1931, but became the Fields we know and cherish (but hardly love) with his first major movie, *Million Dollar Legs*, in 1932. There followed, among other films, *Tillie and Gus*, 1933; *It's a Gift*, 1934;

You Can't Cheat an Honest Man, 1939; *My Little Chickadee*, 1940; *The Bank Dick*, 1940; and *Never Give a Sucker an Even Break*, 1941. Fields was Micawber in Cukor's *David Copperfield* (1935), but I have always felt that he didn't look or sound right there, didn't properly represent either Micawber or himself, because he was trying to play one character *across* another. He died in a sanatorium in Pasadena in 1946.

Fields, even more than Groucho Marx, created a manner which was a mask. Obviously his screen hostility to women, children and dogs was not all feigned, but it was not simply true either. *W. C. Fields by Himself*, which is edited by Fields's grandson, has photographs of the great child-eater as a proud and benign dad and grandad. But then in the same book are scolding letters from Fields to his wife which seem to have come from Fields the movie character. Here he is responding to the news that his son has been praying for him: 'While I appreciate the spirit in which Claude offers prayers for my success, I wish he would not bother further. Prayers never bring anything. You should know better than anyone. They may bring solace to the sap, the bigot, the ignorant, the aboriginal and the lazy – but to the enlightened it is the same as asking Santa Claus to bring you something for Xmas. So please tell him to utilize his time to better advantage.' I take it that a genuine bad temper and ill-nature are speaking here, but the letter is dated 1922 and reveals a manner in the making, orotund but also self-caricaturing.

By 1932, say, the same sort of words from Fields could mean just what they say or more or less the opposite, and when Fields writes to his son in 1939 that he regrets 'not being able to break bread with you and mother on the natal day' (meaning Christmas), it is impossible to tell whether he is being mildly grandiose or mildly sarcastic: saying what he feels he ought to say or parodying all the people who feel they ought to say such things. Or rather it is perfectly clear that he is simply being W. C. Fields now, master of the opaque old-world cliché; and sarcasm and grandiosity, along with parody and formality, all disappear into the intricate neutrality of this style.

But what remains in the mind from Fields's movies, even

more than the manner, is a certain cruelty, a sour, steady vision of life as mostly hard knocks. In *The Barber Shop*, a scalding hot towel is slapped on to a customer's horribly exposed face. In *The Dentist*, the tormentor first can't find the mouth of a man with a beard ('He must have a mouth or he couldn't talk. Just keep on talking, sir'), then grinds away with a drill, pausing only to remove handfuls of crockery from the man's jaws, and finally drilling through the top of the man's head. 'This will be a little painful,' the dentist says next. 'Do you want me to stun you?' The man nods and the dentist hits him on the head with a blackjack.

Of course, there was a lot of random cruelty in early film comedies and in vaudeville, but cruelty in Fields seems exceptionally lucid and close to home. The scalding towel and the dentist's antics are just that bit nearer to reality than we usually like comedy to be, and Fields's achievement is that he still has us laughing. He shows ordinary life to be full of ghastly perils, but his moral is merely that we should tiptoe through it, try to attract life's attention as little as we can. And we are in any case entitled to our small revenges. 'I did not say this meat was tough,' Fields remarks to a forbidding waitress in *Never Give a Sucker an Even Break*. 'I just said I didn't see the horse that usually stands outside.' [1974]

Music

A star is made

Andrew Weiner

David Cassidy is an American television actor and singer. He is also a 'star'. The week before last, Cassidy played six concerts over three days to a total audience of around 50,000 people at Wembley's Empire Pool, the major venue of his current British tour. Those 50,000 did not go to see a television actor and singer. They went to see a 'star'. And they were not disappointed.

Cassidy belongs to that special breed of star: the teen idols. He achieved this position through his role in the successful American television show, *The Partridge Family*. This weekly series, produced and programmed specifically for younger viewers, follows the fortunes of a fictional family who perform in their own rock 'n' roll band. Not a singer at all, but a struggling actor, 20-year-old Cassidy secured the part of 16-year-old Keith Partridge after occasional bit parts in *Bonanza* and *Marcus Welby MD*. The show continues. Cassidy will be twenty-three next month. Keith Partridge is still sixteen.

At the beginning, Cassidy had his doubts about the show. He thought the scripts were 'terrible'. But he needed the work and wanted the recognition. He thought that the songs he was asked to sing were 'bubblegum'. One of these songs, *I think I love you*, was issued as a single and sold five million copies. David Cassidy became a teen idol. He suppressed his doubts about the music. To date, Partridge Family and David Cassidy albums have sold over eight million copies. People like them.

For the last twenty years and more of relative teenage affluence, there have been teen idols. From the movies (James Dean) to rock 'n' roll (Elvis Presley) to television (Richard Chamberlain's *Dr Kildare*) and back to rock (the Beatles) and television pop (the Monkees).

Over the years, the commercial development and exploitation of such idols has been refined down into a more and more exact science. The marketing men now know their target audience: early teenage and pre-teen girls. They know their very best medium of communication: the television series. They know their most lucrative multi-media property: the television pop star who is also a recording artist. They know, more or less, how such an idol should look and walk and talk and sing. They know how to strike the right balance in the television show between music and humour and drama. They know how to work the publicity machine, from the fan magazines on up. And they know how to milk the final product for its full market value, through record sales and publishing royalties and personal appearances and general merchandizing. They hit on the right formula with *The Monkees*, and they did it again with *The Partridge Family*.

All this sounds very calculated, very manipulative, very exploitative. And so it is, from one point of view. But it's too simple to depict the marketing men as foisting off a useless and pointless product upon a young and completely brain-washed audience. Because those marketing men are, to the best of their quite considerable abilities, giving the audience exactly what it wants.

If the audience didn't want it, they wouldn't buy it. Cassidy believes as much. 'You can only hype them to a certain degree. There has to be something there.' Something there. But what? It's possible to try and isolate all the various reasons for Cassidy's success: to break down the particular combination of good timing and massive television coverage and appropriate looks and speech and singing style which has established his present power over his audience.

It seems fairly certain, for example, that music never had very much to do with it. Cassidy has a pleasant but unexceptional voice, well suited to the ballads which make up the most commercially successful part of his repertoire, noticeably strained when he attempts anything louder and faster and more aggressive. His songs fall, for the most part, into that genre of rock 'n' roll known as 'High School Confidential', a genre which is really not rock 'n' roll at all:

Cherish is a word I use to describe
all the feelings that I have hiding here for you inside.

The message is usually romantic, rather than explicitly sexual. But there are obvious sexual undertones, which become mild overtones in the course of his onstage choreography. The appeal appears to be to very young girls, just graduated from doll play to the weekly love comics, seeking a 'real' love object in what is only a more elaborate fantasy rehearsal for, or alternative to, day-to-day reality. Cassidy's fans perceive him as beautiful and innocent and untouched, and they individually achieve fantasy possession of him, choosing to believe that he sings only for them. Cassidy understands this: 'There's one song I do, *I woke up in love this morning*, and I find a place where I can sort of point to them. And they each think I mean *them*, and I do.'

So Cassidy unlocks romantic and sexual feelings and emotions in his fans. And because his fans have as yet very little understanding of these newly awakened feelings and emotions, they can only regard their idol as in some way unique and magical and omnipotent. As Cassidy's veteran road manager told *Rolling Stone* magazine: 'For many of the girls, it's the first time their little thighs get twitchy.'

It's possible, then, to reduce down the Cassidy fantasy machine into its component elements. It's possible, but finally it probably isn't very helpful. To the casual observer, Cassidy's qualities appear as relative and transactional. But to Cassidy's true fans they are innate and immutable, the magical qualities of a 'star'.

A star, so legend goes, is a person possessed of charisma, of an aura of the extraordinary. A person, moreover, in touch with strange and mysterious forces. And it's true that a star does possess charisma, that he *is* in touch with such forces. But charisma is hardly 'innate', and those forces are 'mysterious' only to the extent that we refuse to examine them. David Cassidy is a star only so long as his audience wishes him to remain a star. David Cassidy has power over his audience only so long as their need for him exceeds his need for them.

The attribution of 'magical' qualities to particular individuals

can be viewed, in one way, as a regression to childhood. It implies the same inability, or refusal, to distinguish reality from unreality. And this process seems particularly evident in the case of Cassidy, whose own starmaking audience are barely out of childhood, if indeed they are not still children.

It's too easy, though to sneer at or dismiss the apparently exaggerated reactions of Cassidy's fans. True, they wait at airports for hours to catch a brief glimpse of him. They chase him everywhere he goes. They scream a great deal. But all this is appropriate behaviour, long-established practice, an open code of communication between fans and their idol. They choose to wait at airports, they choose to scream. They do so because Cassidy is a star. They made him a star. They choose to worship him as a star.

Now it may be obvious to us that David Cassidy would not be a star, would not possess charisma, if no one had ever seen or heard of him. But it's also obvious the Mona Lisa would not be considered great art if no one ever saw it. Or that if gold had no exchange value, it would not be valuable. It may be obvious, but it's also beside the point. We are dealing with social perceptions, and social perceptions are continually reified. Gold becomes 'valuable', the Mona Lisa becomes 'great art', David Cassidy becomes a 'star'.

The attribution of magical qualities to a particular individual may well be the result of a failure (or deliberate refusal) to see his mere humanity. But it also seems to be a fairly well established feature of human nature. People wait at airports to see David Cassidy. People wait outside Buckingham Palace to see the Queen.

So David Cassidy is a star. And stars are something very special. Alone together at the top, because they need to maintain a certain sense of distance. Close-up, their safety may be at risk. Or they may appear as too nearly human. Charisma always shines brightest at a distance. Get too near, and you might see Cassidy's famous spots. You might even sense his impatience with the whole charade.

Stars keep their distance. They have their private jets and huge estates and big cars and swimming pools – all kinds of amusements in compensation. And not only is this the

accepted way for stars to spend their money: it is the *expected* way, necessary fuel for the admirer's fantasy. For a while, it feels good up there. Cassidy loves performing. 'It's the biggest high I can get,' he tells the *Daily Mirror*. Though there's always a catch. 'When I come off, it's freaky, man. It's a shock to your system.'

For the moment, Cassidy keeps running. He still dislikes a lot of his songs. He hopes to quit *The Partridge Family*. He's embarrassed by, but past thinking about, the fan magazines, with their endless photo sessions with articles about 'David Cassidy's dream wife'. It's all part of the deal, like the David Cassidy tee-shirts and David Cassidy lovebeads and the David Cassidy bubblegum. It's part of the deal, and quite beyond his control. But he hopes to make changes.

'I don't need to work for money. I just want to let the people hear me sing.' Sing what? Sing what the people want to hear. If Cassidy wishes to remain a star, he must continue to define himself by the expectations of his audience, an audience of romantically yearning weenyboppers. Most rock stars find themselves caught in a similar way, trapped by the expectations they themselves have created. But Cassidy, as a pop star, is even worse off, because he didn't for the most part set those expectations in the first place: television producers and marketing men did that. So he's caught in a trap of someone else's making. And that, perhaps, is the crucial difference between rock and pop:

> I am a clown, look at the clown
> always a laughing face
> whenever you're around
> always the same routine
> I never change
> not funny ho ho
> funny strange.

Early intimations of self-pity. But there's no reason at the moment to feel especially sorry for David Cassidy. He's got very rich, and he's made a lot of people temporarily believe themselves to be happy. The real self-pity – and pity – must come later, if they come at all. Right now, David Cassidy is a star. And that is all we need to know. [1973]

Wicked messenger

Michael Wood

Bob Dylan's new album, *John Wesley Harding*, is a kind of homecoming. Traditional in style, western in flavour (Dylan has acquired a faint yodel in the last two years), it is a return from pop to folk. It is a homecoming in another sense too. Dylan is quieter now, less angry. The album is named after a well-known Texas outlaw, a Robin Hood of the west, who never hurt an honest man. 'I pity the poor immigrant,' Dylan sings – he pities the mean settler of early America, the cruel and unhappy man who built his town with blood. And he does pity him. There is nothing here of the hard ambivalence of the earlier *Only a pawn in their game*. In another new song, a lonesome hobo kindly warns us not to follow along his road, and the wicked messenger, in the song of that name, learns what people really want to know. 'If you cannot bring good news,' people cry, 'then don't bring any.' On this record, splendid as much of it is musically, Dylan seems to settle for that sorry wisdom. Mellowness, maybe. It sounds like defeat.

Bob Dylan came east in 1961, from a dying mining town in the midwest. He played the guitar and mouth organ, and sang in coffee-houses in New York. His songs were wise and anonymous and tired, in the style of Woody Guthrie; he sang in a hoarse, weary voice that was centuries old. But the insights were fresh, they were as young as Dylan. He was twenty then.

'Oh my name it ain't nothin',' he sang, 'my age it means less.' He was the wicked messenger, a ragged clown, as he called himself. He shuffled like Chaplin. He railed on our blindness, indifference, stupidity. 'The times they are a-changin',' he sang, and they were. He had, and still has, an uncanny gift for hitting off complex shifts of history in a simple phrase. He reviewed the American past in a ballad.

We have always had God on our side, he sang, whatever we did. Killing Indians, killing Germans, forgiving Germans, hating Russians, we have had God on our side. The mouth organ interrupts, and you think of the song as a sweeping morality about political lies and religious hypocrisy, and then Dylan's droning voice returns and pokes the precise question at you. He has been thinking about Christ's betrayal, he sings:

> but I can't think for you
> you'll have to decide
> whether Judas Iscariot
> had God on his side.

Dylan's songs are extremely precise. *The ballad of Hollis Brown* is the story of a poor starving farmer who takes his shotgun and shoots himself in despair, along with his wife and five children. A folk song would have left it at that, or closed with a few wise lines about hunger. Dylan points out that somewhere in the distance, as those seven people die, there are seven new people born. In *The lonesome death of Hattie Carroll*, which tells of an elderly kitchen-maid killed by a rich young man twirling a cane, a moaning, relentless chorus tells us not to cry yet, not to weep at Hattie's death, or her poverty, or the young man's cruelty, or his indifference, or his getting out on bail, but *now*, when the judge looks solemn and the killer gets off with six months, now is the time for our tears.

The precision may take the form of an ambivalence. Dylan's first big hit was *Blowin' in the wind*, now a classic of folk song. How long, the song asks, can we go on turning away from suffering, how long can we pretend we don't see? The answer, the refrain replies, is blowing in the wind. But what does that *mean*? Is the answer blowing in the wind like sand, gone for ever? Or is it caught in the wind like a kite, available but just out of reach? Dylan, who is a good poet, knows what he means, and he means both things. He is never simple, he is always accurate.

A doubt sets in here. After all, how much do people listen to the *words* of either folk songs or pop songs? Aren't they just something that goes with the music? The answer is that there isn't a simple answer. A lot of lyrics are just acoustics –

listen to the split syllables of the early Beatles songs, or the soft whimpering of the Supremes. Words here are not used as language in any ordinary sense, they are signs for general emotions, indicating joy, sorrow, absence, need, and so on. On the other hand, it is more or less impossible to think of a Sinatra song without remembering most of the words.

Dylan covers the whole range. He writes mindless blues with pointless words, he can be shrill and silly, he writes verse which at times is as precise and poetic as Auden's. He writes good tunes, and the tunes are always *more important*. But to miss the words is to miss a lot. It is like not listening to the lovely lyrics of Lorenz Hart. Except that Dylan is tougher, and you may not like what you hear.

Boots of Spanish leather, for example, is a traditional dialogue between parting lovers. It has a haunting tune. The girl is leaving for Spain, is there nothing she can send back? Oh no, the boy says, just come back yourself. Is he sure? the girl asks. There must be something. Oh no. And then it dawns on the slow-witted boy that she is leaving for good, and he slips into a folk farewell ('take heed take heed o' the western wind') and then adds that, Yes, there is something she can send back. Spanish boots of Spanish leather.

Around 1964, Dylan changed his style, went over to the jangling electric backing of Presley and the tinny gospel piano of singers like Kay Starr. His voice became deeper, more nasal, developed a sneer. There was a certain amount of nostalgia in this, probably. The styles of Kay Starr and Elvis were ten years out of date by that time. They were another form of folk music, part of the fast-fading American past. But more than that, I think, Dylan turned to pop for the same reason that painters too were turning, or had turned, to commercial culture. Folk was a dead end, a kind of academy of song. Pop was to Dylan what cartoons were to Roy Lichtenstein: loud colours, simplified shapes, a whole idiom to play with. That, and the chance of a better irony, a better attack on society's sentimental heartlessness.

Dylan's songs of this time often have the effect of a late Billie Holiday number: *God bless the child*, for example, where the Lady's hurt, brittle voice tells a sour story, while

irrelevant strings sing and an expensive Hollywood chorus murmurs in the background. The irony was unconscious then, in the early fifties, an accident of show-business. But Dylan *constructs* such ironies. The pop organ squeals, guitars rattle, and Dylan, to a sweet romantic tune, sings about a girl clawing out his eyes.

There are other changes. Dylan gives up the archaic country diction. He makes more jokes. People die happily ever after, they win friends and influence their uncle. 'You don't need a weather man,' he sings, 'to know which way the wind blows.' Freed from the folk idiom, he works extraordinary tricks of language –

> Then take me disappearin'
> through the smoke rings of my mind

– and above all, he trades in his messenger's voice and opens up a circus. His songs are a hallucinated parade, where John the Baptist and Galileo rub shoulders, where Jack the Ripper meets Delilah, where a lady called Melinda is the goddess of gloom, where Cain and Abel and the Good Samaritan pass, where Pound and Eliot are involved in a ludicrous fight, and where Einstein, looking 'immaculately frightful', is disguised as Robin Hood. You wouldn't think to look at him, Dylan muses, that once upon a time he was famous for playing the electric violin. There is a Dr Filth and an Insanity Factory. There are heart-attack machines. Inside the museums, Infinity is on trial. The *Titanic* sails at dawn. The location is always the same, whether it is called Tombstone, or Juarez, or Highway 61. Sometimes it is simply a room. It is *Desolation Row* (the title of a song), a drifting allegory, it is Dylan's mind. As he says, he has faded into his own parade, he is on a trip.

These songs are private, then, in a sense. Dylan has withdrawn from the times. And yet the message of these lyrics, with their lunacy and sadness and their repeated circus images, is clear enough and not that private. If Dylan has withdrawn, if his songs are a crazy circus, it is because the world itself has taken to the sawdust.

Not only the content of the songs changed. The whole tone changed. The early songs were hopeful, they were addressed

to people who might do something, thick-headed, thick-skinned people, perhaps, but not unmovable. The ballads of poor folk, the laments for injustice, all asked a single question: *Is there anyone who cares?* Dylan was crying in a wilderness probably, but he was crying. The later songs, when they are not private, are meaner. They are sung to rich girls and helpful liberals. They batter and bewilder them and bring them down, and then they crow. The question has become: *How does it feel?*

In this sense *Like a rolling stone* is the exact sequel to *The ballad of Hollis Brown*. How does it feel, Dylan yells, to be on your own, a complete unknown, no direction shown, like a rolling stone? And where *The times they are a-changin'* was an insight and an announcement, an invitation to look closely at history's roulette, a song like *Ballad of a thin man* is simply a sneer. Something is happening, we are told, but we don't know what it is. A sword-swallower returns our throat to us, saying thanks for the loan. From this point of view, the new album is a return to warmth. We still don't know what's happening, a Dylan fable on the sleeve of *John Wesley Harding* suggests, but it doesn't matter. There are miracles.

We have to respect Dylan's anger, and his meanness. One can exaggerate the values of toughness, I know, but Dylan's angry songs have an integrity which few people managed in America before last summer, when it became clear that the ghettoes have decades of violence in them still, and that the road to Khe Sanh is paved with good intentions. Dylan had private reasons for disenchantment, no doubt – he sings at one point of the dust of rumour and the dirt of gossip. But in any case he saw straight. By 1966 he had been through the despair which is now growing in America at the thought of having to choose between Johnson and Nixon for President. John the Baptist, in a song called *Tombstone blues*, tortures a thief, and then asks if there is a hole he can get sick in.

All this is simplified. Dylan has eight albums out, one of them a double one. His range as a songwriter, in terms of moods and angles, is immense. He is perhaps more faithful to himself than I have managed to suggest. Across all the sad-

ness and change, the jokes and the bitterness, at the height of his most cruel and synthetic songs, his mouth organ blows between verses, like a quavering old love which has never left him, and the final impression is that Dylan has not changed that much.

He has never been either a folk singer or a pop singer in any simple, definable sense. His early songs were subtler than folk, his middle songs were harder than pop, and his new songs, I think, are a pause before he takes off again. He is not the prodigal son after all. He is 27 years old, he has wasted no time, and let's hope he's not repentant. [1968]

Energetic requiem

Michael Wood

The Beach Boys conjure up conflicting images in most people's minds. On the one hand, bronzed lads in the sun, striped shirts, white pants, high waves crashing behind them. Songs about surfing, hot rods, young love, changes of heart, teenage betrayal. A pounding rock beat, falsetto voices humming in harmony, chasing each other in sequence, high-pitched Bill Haleys in a glee club on the sand. Southern California mindlessness. Pleasant enough, but hardly worth much notice.

On the other hand, high pretensions, intricate arrangements, dulcimers (dulcimers?), organ, elaborate studio sounds. Church rock. *Sergeant Pepper* as a set of lush (pardon) madrigals; the Four Freshmen turned into five sophomores and converted from jazz to rock 'n' roll. Talented but phoney.

Both images are fairly accurate. They reflect the development of the group, the place they started and the place they're at now. The images measure the road from *Surfin'*, which was their first hit, to their present stalemate. They also reveal what has become a conflict within the group. Brian Wilson, the composer, arranger and producer of most Beach Boys songs and albums, is a restless, innovative figure – musically

more significant probably than either Lennon/McCartney or Bob Dylan. A genius of sorts. Since 1964 he has refused to tour. The rest of the group are the Beach Boys we used to know. They want to keep their steady, good-humoured commercial mould, make money and stay popular. Why not? If one adds to the fact that three of the Beach Boys are brothers (another is a cousin and another is a school friend), that they all live in or near Hawthorne, California, and that Father and Mother Wilson seem to brood over the whole scene like Aeschylean emblems of the past, then the stage looks set for something steamy out of O'Neill or Faulkner.

But nothing happens, as far as we know. There are fights, flights, escapes, returns. There are compromises, like the appalling album, *Smiley Smile*, a fey collection which is neither art nor rock. Records may come out, tours go on; but *musically*, silence.

Smiley Smile was a salvage operation. Brian Wilson had been working with Van Dyke Parks, a pop poet and singer, on an album to be called *Smile*, a jokey piece of high art which sounds, by all accounts, like a first-rate disaster from the start. Something went wrong, mercifully, and the album fell through. Legend has it that the recording was completed nevertheless, that all the tracks are laid up somewhere (in heaven?) and are dazzling masterpieces. I doubt it.

Certainly the two or three rescued tracks on *Smiley Smile* (*Heroes and villains*, *Vegetables*) don't offer much hope. The rest of this LP represents, I suppose, the group's concessions to Brian ('All right, Brian, if you want to do art, let's sing part-songs and madrigals') and Brian's own dejection. There is really not a spark there, except in *Good vibrations*, an earlier, successful single picked up and stuck on the album.

There are lots of sparks elsewhere. Between those mindless beginnings and today's sad end (end?) there is at least one perfect album (*Pet Sounds*) and a lot of good songs (*Little Saint Nick*, *Don't worry baby*, *Please let me wonder*, *Let him run wild*). I picked up *Pet Sounds* in a sale a while ago. I bought it because I had always mildly liked the Beach Boys, had listened to *Good vibrations* and *God only knows* on countless juke-boxes, and thought the noise would be nice to

have in the house. I wasn't prepared for the quality of the album at all. The range is narrow; it's all shades of pale, as the song says. But the shades are delicate and beautiful, full of quiet changes and subtle sounds.

Pet Sounds is like subdued Richard Strauss turned to rock – looping melody lines over a steady, old-fashioned running bass.

The secret is there. A firm line from the bass guitar (usually Brian Wilson), thick chords from two other guitars, and some very sensitive drumming by Brian's brother Dennis. The other brother, Carl, plays lead guitar. This sound is so solid that the group can afford all kinds of melodic and harmonic effects on top of it. The result is still rock. Over the steady foundation there are sharply syncopated tunes ('Don't/ wor/ry/ba/by,' every syllable just behind the beat), choral and symphonic backings, elaborate counterpoint, high-voiced solos, plenty of organ and cymbalo, a breathy brass harmonica, a lot of friendly shrieking and shouting. The music comes first, the lyrics have plainly been created afterwards.

You can hear this on the title track of *Pet Sounds*. It's a tuneful instrumental piece to which the words have just not been added. You can hear it even more (or less) on the other instrumental number on the album, *Let's go away for a while*. Faint, thick chords, strings, guitars, pale trumpets make a backing à la Bacharach, and you realize that this time neither the words nor the tune is there. Just the backing. They've gone away for a while. It's a haunting track.

The priority of the music frees the lyrics from the flat doggerel which tends to come when you write the words first. Instead you get long, crowded free-verse lines which simply go wherever the melody goes:

> Well it's been buildin' up inside of me
> for oh I don't know how long.

Or:

> Each time things start to happen again
> I think I've got somethin' good goin' for myself
> but what goes
> Wrong?

This last song, called *I guess I just wasn't made for these*

times, is a kind of masterpiece, a slow, moaning, rocking, arching tune with strange dips and breaks. The prosy lines become plaintive poetry.

The lyrics generally are relaxed, easy, sometimes sharp:

In the moonlight they're peaceful but inside
 they're so uptight
They trip through the day and waste all their thoughts
 at night
But how can I come up
And tell them the way that they live could be better?
I know there's an answer . . .

The lack of a logical connexion often creates interesting spaces between ideas:

 You know it seems the more we talk
 About it
 It only makes it worse to live
 Without it
 But let's talk
 About it . . .

and broken rhythms do nice things to otherwise straight-forward statements:

 Love is here
 Today and it's gone
 Tomorrow it's here
 And gone so fast . . .

Perhaps the best example of how unpretentious and attractive these songs can be is *Caroline No* (an exclamation? a Chinese girl?). There is a faint rattle of chains (maracas?), a deep resonant boom on the bongos, then a slow, rocking (as in rocking the cradle) beat, and the tune lifts and falls gently:

 Where did
 Your long hair go?
 Where is the girl I used to know?
 How could
 You lose that happy glow,
 Oh Caroline No?
 Who took
 That look away?

I remember how you used to say
You'd ne-
ver change but that's not true
Oh Caroline You
Break my heart . . .

Pet Sounds is a better name than it looks. Brian Wilson is interested in noises of all kinds. *Caroline No* is the last track on the second side of the album. As it fades out, you're ready to change the record when you realize there is more to come. Dogs bark, a bell rings, a train approaches, roars past, the dogs bark some more, silence. The point presumably is to remind us that there is music everywhere, as Mr Bloom thought in the Ormond bar.

Music is arranged noises: our pet sounds. The other pet sound on the album is a cymbalo (I think) laying down a curious, muted sleigh-bell effect which haunts almost every song, stiffening the soft organ sound with a kind of metallic support. Then the voices and guitars create that thick, whirring backing which we have come to associate with Motown. A high voice does battle against a chorus of dense noise: a concerto.

A good deal of the power not only of the Beach Boys but also of singers like Mary Wells, Maxine Brown, Dionne Warwick, comes from this solo struggle: frail little girls (I'm talking about the sound) pitted against the warring roaring orchestration of the world. Only the Beach Boys are boys, and at one point their publicity men began to worry about their image. Effeminate! So the Beach Boys recorded a stirring, hearty sea-shanty called *The sloop John B.* After all, we weren't supposed to think they were hippies. Then the Beatles legitimized long hair and the publicity men could stop worrying.

In fact, the falsetto voices, like the train passing and the dogs barking, are just noises: sounds not signals. They don't mean anything except what they mean to the music. Brian Wilson is very conscious of what he is doing. He wants to give his work 'dynamics', he says, 'and a marketable reality'. But both things are to be musical. 'I'm very aware of the value and power of speaking through a song. Not messages –

just what you can say through the music.'

Pet Sounds flopped commercially but is now a firm part of
the intellectual rock canon. It's recommended by all the teach-
yourself-the-scene books. So we're back with the conflicting
images – dumb old rock versus bad new madrigals. Well, not
quite, because there is now a third, median image: the modern
classic.

Can these three avatars really be all that different? Yes,
of course. They are. And no they're not, because there is
something odd at the heart of the best of the Beach Boys'
music which holds all these conflicting aspects at once. There
is a strange melancholy even in the early energetic songs, a
note of mourning as they sing of happy days a-surfin'. So that
these healthy, clean-cut lads take us closer to the sources of
American sadness than even Bob Dylan does.

Dylan's rusty, warning, scolding voice is clearly *outside* the
distress it diagnoses. It belongs back in some other America,
some legendary country where not quite so many things had
gone wrong: open country, hillbilly kindness.

On the album *Beach Boys' Party*, the group sings a Dylan
song (*The times they are a-changin'*) and three Lennon/
McCartney songs (*Tell me why, I should have known better*
and *You've got to hide your love away*). The results are very
revealing. Dylan makes them uneasy. 'Al's going to sing a
protest song.' 'A what?' 'A protest song.' 'I can't hear ya,
Al . . .' Al sings the song miserably, unfeelingly, and the
group makes funny noises. By contrast, those boisterous
Beatle songs sound sadder than you've ever heard them. And
this is an album recorded at a *party*, praised for its spontaneity,
gaiety and fun.

In this sense the girl-voices *are* signals, not just sounds.
They are early messages of Californian fear, high-pitched
hints of tears and tear-gas, and they come from *inside*, from
the nice boys on the campus. They can't sing Dylan songs
because they're the people Dylan is talking about. And their
own 'protest song' is a swan song, a lovely lyrical lament: 'I
guess I just wasn't made for these times.'

Wrong. You were made for these times, and the music
and your voices know it even if the words don't. And for you,

alas, these times are not a-changin'. They're a-freezin'. The sad beauty of the best Beach Boys songs is that all their musical and moral energy comes out as a requiem. 'Please let me wonder,' they sing. From teenage girls to broken cars to mum and dad to a dwindling, dying world, the chances close one by one.

The Beach Boys will never say kill the father and fuck the mother, like the Doors. And even a bouncy old rock number like *Barbara Ann*, in their voices, emerges beneath the firm beat, the fine arrangement and the likeable good humour as a kind of quiet accusation and epitaph:

> You got me rockin' an' a-rollin'
> Rockin' an' a-reelin'
> Barbara Ann.

[1969]

T. Rex is king

Andrew Weiner

Last year T. Rex sold over four million records in Britain. That's more than anyone ever sold here before in one year, more even than the Beatles. This year they'll probably do even better. Marc Bolan is the founder, leader and the lead singer of T. Rex. He wrote all their hits. He wrote *The children of the revolution*, recently their sixth straight official number one hit single:

> you can bump and grind
> 'cos it's good for your mind
> you can twist and shout
> let it all hang out
> but you won't fool
> the children of the revolution.

Marc Bolan is also a best-selling poet now, second only to Mary Wilson: over 20,000 copies of *The Warlock of Love*; a second volume coming up soon.

Marc Bolan is Mark Feld, a Jewish kid escaping from the

dead-end streets of Hackney, clear away but still running hard. Gatsby-like, he created himself in his own image. At thirteen he appeared in *Town* magazine as Mark the Mod, the neatest dresser in the whole East End, the main man in the amusement arcades with his razor-cut hair, Burton's suit and alligator shoes. But fashion was only a psychic escape. Probably he never had much doubt about the real way through. Every Saturday he'd watch the rock 'n' rollers parading in and out of the Hackney studios for Jack Good's killer TV show of the day, called *Oh Boy*: Gene Vincent, Eddie Cochran, all of them. And then the lead singer with his local skiffle group must have given him an idea or two: that was Helen Shapiro.

Add to that a fierce sense of destiny ('I'm different. I've always known I was different, right from the moment I was born') and it all looks simple enough, an apparently direct line to where Marc Bolan, superstar, is now: flash clothes and flashier rock 'n' roll. Somewhere in between, though, the picture gets more complicated. Two years in Paris, apprentice to a black magician. All kinds of spells. Satyrs and sunken continents and secret alphabets. Flying saucers over Glastonbury, and lines of ancient force. Bolan is still a believer: 'A successful hit rock 'n' roll single is a spell.'

He made his first record way back in 1965, for Decca, and they decided to call him Marc Bolan. But he didn't yet have his spells right because the song (*The wizard*) just didn't happen. Two years later he reappeared as lead guitarist with a hard rock band, John's Children, who scored one hit single and then quickly fell apart. The record company repossessed the amplifiers and so Bolan, of necessity, switched back to acoustic guitar. In early 1968, the winter following English rock's brief summer of love, he found a bongo player and began Tyrannosaurus Rex.

Tyrannosaurus Rex played acoustic rock, second-hand Tolkien being set to third-hand Buddy Holly, Del Shannon's Greatest Mantras. They found success of a kind with a closely defined and fiercely dedicated minority audience, mostly the sort of hippies who read *Lord of the Rings* and shuffled tarot cards and ate macrobiotic food and waited around for Atlantis

to rise up out of the sea: acid veterans, burnt-out victims of an unknown war. Tyrannosaurus Rex played in the clubs and colleges, they played for free in Hyde Park, they played on John Peel's 'progressive' rock radio shows. And they made albums which sold comfortably, albums with titles like *My people were fair and had stars in their hair* or *Prophets, seers and sages, the angels of the ages*. They even made a few extremely small-time hit singles.

Finally, Bolan's bongo player left to go 'political'. Bolan found himself an unpolitical bongo player, Mickey Finn. He started playing electric guitar again. He hired a bass player and drummer to fill out the sound. He abbreviated the name of his band, to T. Rex, perhaps for the benefit of Radio One deejays. And then, in late 1970, he put out *Ride a white swan*. Lyrically, it showed no great change of direction:

> wear a tall hat just like in the old days
> ride a white swan with a tattooed gown
> take a black cat and put it on your shoulder
> and in the morning you'll know all you know.

But what made all the difference was Marc Bolan and his brand-new electric guitar, managing to sound uncannily like his old *Oh Boy* hero, Eddie Cochran.

Bolan had discovered his spell: electricity. *Ride a white swan* rode up all the way to number one, astonishing almost everyone. Bolan then claimed to have been singing rock 'n' roll all along. Maybe so. But before it is anything else, rock 'n' roll is supposed to be *noisy*, otherwise it just doesn't count. Rediscovering this, Bolan got back to where he'd always belonged.

Almost immediately, T. Rex started getting a very different sort of audience at all their live performances: young girls who screamed and rushed the stage, teenyboppers, *fans*. Marc Bolan was suddenly a rock 'n' roll superstar. It was like coming home. Soon enough, he started writing songs with lyrics more in keeping with his new role:

> well she's faster than most
> and she lives on the coast
> uh huh huh.

Hot love, and then *Get it on*, his succeeding smash hits, are

classic mainstream rock 'n' roll. They have flash, they have style, they have a nicely balanced line in sexual innuendo. Bolan knows his rock 'n' roll well, nearly every phrase and riff and echo of every hit song of the past two decades. His great talent is in permutation and in synthesis, and his best songs are brilliantly contrived. His worst are just poorly contrived. If *Get it on* feeds successfully off Chuck Berry, *Telegram Sam* feeds off *Get it on*.

Lately, T. Rex have moved closer to straightforward commercial pop, entering a sort of early Beatles phase. And Bolan is very good at that, too. No one writes songs as catchy as *The children of the revolution*. The lyrics as a whole probably make sense to no one except Bolan, but no one seems to care too much about that, and they always seem to *sound* right:

> you won't fool
> the children of the revolution
> no you won't fool
> the children of the revolution
> no no no.

Whatever else he might lack as a lyricist, Bolan has a very neat line in incantation.

Marc Bolan is now England's number one rock 'n' roll superstar. The teen and pre-teen girls curl their hair like his and wear tinsel stars, and maybe pin up his picture inside their school desks. Imitation and identification: Bolan is both fantasy lover and androgynous icon. T. Rex concerts tend to give the appearance of a giant puppet show. Marc Bolan is their living doll. As he sings in *Cosmic dancer*:

> I danced myself out of the womb
> is it strange to dance so soon?
> I danced myself into the tomb.

This kind of audience reaction isn't new, of course. It is new only in the context of the seventies. They don't call T. Rex the 'new Beatles' for nothing. The circle turns and turns. It's now ten years since a then unknown Liverpool band scored a moderate first chart success, *Love me do*. At the time, an event of small significance. The Tornadoes were number one with *Telstar*. Frank Ifield, Ronnie Carroll and Pat Boone were all comfortably placed. No one realized then that the

coming of the Beatles signified the beginning of a new, second generation of rock 'n' roll: as the advent of Elvis Presley had established the first such generation. No one talked about rock generations in those days.

When Marc Bolan made *Ride a white swan*, he similarly stumbled upon a new and previously unrecognized teenage audience: upon a third distinct rock 'n' roll generation – all ready to set up their own new heroes. Bolan was first, and so foremost. Since then we've seen others move up to join him at the top – the Slade, David Bowie, the Faces – just as the Rolling Stones and the rest followed the Beatles in the early sixties. Then, it was the teenage crooners like Pat Boone who were brushed aside by the new generation. This time around it looks like being the turn of the ageing heroes of the Beatles generation, the 'progressive' artists of the post-*Sergeant Pepper* era, from the Rolling Stones on down.

Before the Beatles turned into colour supplement cultural heroes, rock 'n' roll was, in Nik Cohn's phrase, 'teenage property'; that is, something which gave you not only entertainment but also a distinct identity as part of a distinct generation, something which no one else wanted or understood; something which you almost certainly outgrew. But now the whole Beatles generation have moved into their twenties and taken their music with them – what they choose to regard as a more valid and meaningful kind of music than Marc Bolan's new-style teenybopper boogies.

Here, then, is the basis of a fairly wide generation gap in the fabric of the mass rock audience. For Bolan's new teenage rock 'n' rollers are no more concerned with musical progression and lyrical complexity and social commentary than their older brothers and sisters were back in the heyday of the Beatles and the Stones. They want the very same things their brothers and sisters have now outgrown: the excitement and glitter, noise and outrage, a focus for their own separate identity as a new and unique generation. Marc Bolan, who is pushing twenty-five years old, has managed to give them these things.

T. Rex may never capture and unify the entire rock audience as the Beatles once did. Perhaps no one will ever work

that trick again. The audience has grown too enormously since the early days of the Beatles. The age and interest – and class – range it now encompasses is too diverse. But T. Rex already appeals to a very large fragment of the audience. And already, in fact, single-handed Bolan has revived English rock 'n' roll. At a time when nearly all his contemporaries were becoming more and more obsessed with instrumental virtuosity, Bolan picked up an electric guitar and started playing the only three or four chords he knew.

The point of it all, he realized, was not to play 'well'. It was to play *effectively*, to reach for and attain some kind of response from the audience. The biggest response possible: and that meant number one hit singles, *Top of the Pops*, Radio One. Once upon a time, rock 'n' roll used to be a popular mass art form. Thanks to Marc Bolan, it is so again. [1972]

Family man

Andrew Weiner

A special offering from BBC television: fifty minutes of Tom Jones, the Welsh Elvis, the ex-coalminer who conquered Las Vegas; and now British pop's number one *family entertainer*.

What exactly do the television programmers mean when they speak of 'family entertainment'? Ideally, the phrase conjures up a cosy picture of the nuclear family clustered happily around their set, sharing a common pleasure in a spectacle catering for, and confirming, their mutual tastes and outlooks. In practice, though, it's a lot more likely to mean some formula which is either actively pleasing, or at least inoffensive, to those who control the channel change switch during peak viewing hours. Audience dictates content: and he who pays the rental calls the tune.

Most pop music fails to be family entertainment. It is neither pleasing nor inoffensive to a substantial majority of the adult television audience. So it is either smothered with

plastic and tinsel for the pre-peak teenybopper audience, as on *Top of the Pops*, or it's treated with an awesome reverence in the late-night low-budget cultural ghetto of *The Old Grey Whistle Test*. Only a select group of pop stars can survive or thrive in the family variety shows and specials that make up the staple diet of peak viewing hours. A *very* select group. Count them on both hands. And then subdivide again, into the inoffensive and the positively pleasing.

On the one hand, the inoffensive: Cliff Richard, the New Seekers and, latterly, the Osmonds. Although these people are primarily teenage entertainment, they are also acceptable to a family audience. In point of fact, they make a commodity out of their youth, co-operating eagerly with the subtle tokenism of the television programmers. Pop's very own revolving-door Negroes. Uncle Cliffs. If they can be said to offer any particular positive quality, it is surely a quality of real or imagined innocence. The innocence of 15-year-old Donny Osmond is both charming and unthreatening for the mums and dads. Contrast him with Mick Jagger and the Rolling Stones, who clearly knew too much too soon; who dared to sing songs like *Let's spend the night together* on that former all-holy of family entertainment, *Sunday Night at the London Palladium*; and who refused to stand waving from the revolving stage, thus becoming a target for almost universal adult hostility.

And then, the positively pleasing: Engelbert Humperdinck, Cilla Black and, quite outstandingly, Tom Jones. These people aren't just tolerated by the adult television audience; they're very strongly liked. And though they retain some vestige of a teenage audience, they make their most direct appeal to the mums and dads. Tom Jones, in particular, is something very special. He has very definite positive qualities and those qualities are not – on the face of it – very likely for a successful family entertainer.

For one thing, he's neither young nor innocent; he is thirty-two. He sings, like the old-style crooners did, from age and experience. But Tom Jones is no crooner. He sings his fair share of the soft and melancholy, sings about unrequited love and of sentimental memories; but that's not what he does

best, and it's not the true root of his success. It's when he
starts singing very loud and very hard, singing his own brand
of soul and rock 'n' roll, moving his body and screwing up
his face in real or mock anguish and passion, that he becomes
unbeatable family entertainment.

Because, finally, what Tom Jones is selling is sex. Not
sentimental anticipation and reflection, but hard, aggressive
sexuality; nothing else. And that's why his success is so
remarkable. Selling sex to a family entertainment audience is
no easy matter. It requires enormous delicacy, a very fine sense
of pace and timing, a slow but certain build-up.

Consider his Christmas TV special. This opened, nearly
inevitably, with a seasonal song: appropriate location film of
snow, open spaces, purity. Tom Jones riding a sleigh. Tom
Jones playing snowballs with little children. Tom Jones walking
his dog. Tom Jones singing five almost uniformly deadening
fake sentimental slow ballads. All of which is necessary. It
establishes him as a nice man, a family entertainer; it makes
him safe.

Cut now to the studio set, recorded live. Tom Jones singing
his very first hit, his theme tune, *It's not unusual*. He's come
a very long way since 1964. No more ruffled blouses; now he
wears a jacket and tie, well in the vanguard of mainstream
consumerism, an immaculate insider. The hair is long, but
not so very long, and he certainly wouldn't think of tying it
with a ribbon any more. Once upon a time, Tom Woodward
jumped a bandwagon; cashed in, with his stage name, on the
then successful movie. Now the tables are turned: yesterday's
gimmick has become today's superstar, and who remembers
that movie any more?

This song, *It's not unusual*, is hard and fast, almost rock
'n' roll. But that's no rock 'n' roll band behind him on tele-
vision: balding trumpeters, guitarists who sit on stools,
violinists with sheet music. They pump out the notes and it
all meshes into a quite acceptable pastiche, but it can hardly
be called rock 'n' roll, it's simply very good choreography.

His voice. It's distinctive all right; it really does have
character. All kinds of individual mannerisms, bitten-off words
and yelps, and weirdly uneven variations of intonation. It's

distinctive and it's effective, but it doesn't appear to have a great deal to do with the 'meaning' of the song:

> It's not unusual
> to see me cry
> I wanna die . . .

As a sad song, it's literally incredible. The only emotion is one of pure exuberance.

Another change of pace. 'Speak softly love . . .' He can do this slow stuff in his sleep, and when he bothers to concentrate he does it very well. It is entertaining enough in its own way, and there's no doubt that he could make a good living from crooning alone, just like Sinatra and Bing Crosby, or their spiritual heirs, Andy Williams and Engelbert Humperdinck. But though this kind of sentimentality is necessary to the Tom Jones image, necessary to round off his repertoire and make it acceptable, it isn't sufficient. If he stuck to this, he'd probably be no more popular than Engelbert.

A break for Dusty Springfield. Tom Jones returns, without his jacket, for the obligatory duet. The song is imitation 'soul'. It can, of course, be argued that soul music in its modern American form has no necessary emotional component and is actually no more than an elaborate jigsaw puzzle of phrases, gestures and technical devices. But even if that is true, Tom and Dusty and the Johnny Spence Orchestra are clearly missing some of the pieces.

And now the climax of the show. Tom Jones alone. Up-tempo soul:

> Come on down with me
> let's get it on . . .

And this time, with conviction. He's dancing with real agitation now, starting to sweat. Sign and meaning coalesce. We reach the essence of his performing persona. This nice man, seen so recently frolicking with children in the snow and walking his dog and singing of his unrequited love, is now issuing an invitation to sexual intercourse:

> Baby I've got to have it . . .

Chuck Berry surely couldn't get away with that in peak viewing hours. Nor Mick Jagger. But Tom Jones is no psychic outlaw, he's a fully guaranteed insider, a family entertainer:

and that makes all the difference.

So Tom Jones sells sex. It's gross, perhaps, minutely choreographed, uncomfortably mechanical, totally unsubtle. But it electrifies his audience. They like to see Tom Jones scream and sweat and jerk his body and screw up his face and undo his tie. Will he throw it to the audience? *Is* there an audience? The television cameras never answer this mysterious question. But there's no doubt that Tom Jones has, somewhere, an enormous audience.

Who are they? Women, predominantly. Over twenty and over thirty and some even older. Housewives with young and teenage children. More aware of their sexuality than any previous generation, in need of a more explicit form of vicarious stimulation than any crooner could provide, yet still requiring that certain delicacy of presentation. They can't connect with the ambivalent and narcissistic sexuality of a Mick Jagger. They can connect with Tom Jones.

So one thinks of sex, and of age. Tom Jones never did have much of a teenage audience. He zeroed in almost immediately on his real territory, discovered his true function. That function was to take the most exciting and powerful insights of a younger generation and make them accessible and acceptable to an envious older audience. And he's performed that function very well. It's taken him all the way from rags to riches, a true working-class hero.

Tom Jones knows what he's doing, and we have to admire him for it. Admire him even as he slows the pace again for his big finish. Micky Newbury's appalling *American trilogy* – which is actually no more than *Dixie* spliced into *Glory hallelujah* and *All my trials* – is a song which has almost nothing to do with the tradition or experience of an English television audience. But that doesn't appear to worry Tom Jones. Superstars, at least, exist in a global village:

> In Dixieland
> I'll make my stand
> I'll live and die in Dixie . . .

Momentarily, he means every word of it, sliding from Dixiecrat to oppressed cotton-picker in one effortless moment, undoubtedly a great entertainer. And there's no doubt at all that

someone is counting on selling this show to an American network. The invisible audience screams for more and he gives it to them, 'BAMA BAMA BAMA LOO', courtesy of Little Richard, and goes completely berserk – the Mick Jagger of middle England. [1973]

John Lennon's schooldays

Michael Wood

A heavy man with glasses sits on a chair looking at a green monster with four legs. Caption? 'An adult looks at a Beatle.' The caption is mine, but the drawing is John Lennon's. It appears in his second book, *A Spaniard in the Works*.

There are four-legged things everywhere in Lennon's drawings: sheep, cats, cows, Sherlock Holmes on his knees. The first book, *In his own Write*, has a huge Wrestling Dog ('But who would fight this wondrous beast? I wouldn't for a kick off'), and a piece called 'Liddypool' is accompanied by a sketch of chatting quadropuses.

It is a child's world, or a world that Thurber might have drawn for a child. Animals and freaks have comic dignity while adults look silly and too big, bending over and crawling. A double suggestion runs through the writing in both books: adults *are* silly, they give children rubbish to read and expect them to like it; and left to themselves, adults are worse than children – they talk jabberwocky about politics and colour and religion, and they believe what they say.

So we get Enig Blyter's famous five – all ten of them taking off from Woenow Abbey: ' "Gruddly Pod, Gruddly Pod," the train seemed to say, "Gruddly Pod, we're on our hollidays." ' There is a trip to Treasure Ivan with Large John Saliver, Small Jack Hawkins, Cpt Smellit and Squire Trelorgy. But Prevelant ze Gaute also appears, and Docker Adenoid along with Harrassed MacMillion and the late Cassandle of the Mirror on the Wall. The Bible, hymns, newspapers, the telly, bad

films: the world shrinks to the nonsense of a book for small children.

The trick is simple, a standard schoolboy game. You retreat to baby-talk, to mock-childishness, to the linguistic pranks of Lewis Carroll and Edward Lear. This is your revenge on all the language, life and literature that people are asking you to take seriously. You bend and break what they teach you; you make their world sound like wonderland. Vile ruperts spread through a village, an old man leaves his last will and testicle, there is dirty weather off Rockall and Fredastaire. A day is a red lettuce day.

The jokes are John Lennon's, but they have already seen good service in most grammar schools in this country. The grammar school is the place for this intelligent, informed and infantile humour, I think; and school may have been more important for Lennon and McCartney than either home or Liverpool, whatever sociologists and trendmen say. Grammar school pupils are alert, disciplined and frightened. Their pleasures are psychological – torturing a nervous teacher – and fairly secret.

I remember a joke that ran for months when I was at school. Whenever a teacher left the room, someone would draw a head, side view, on the blackboard. It would be a policeman in a huge helmet or a guardsman in a vast busby. At the side of this would appear a drawing of the policeman or guardsman without his helmet or busby. His head would be exactly the same shape as his hat. Another version showed a grotesque clubfoot – with or without a shoe, it looked the same.

Thinking back, I can see two things in our enjoyment of those gruesome gags. First, a hope that the world would stay simple, that our fears of mess and complication might prove to be unfounded. Just think. If the mask should fall to reveal a face just like the mask, if the truth about life, which parents and teachers hinted at so darkly, should turn out to be exactly like the façade, then they would be the fools with their conspiracy theories, and we would be right in our scared simplicity. And, secondly, I think we were fascinated by disease and deformity, which represented the future ugliness of life

itself. If we could keep that at the level of a joke, if we could tame it in the safeness of school, everything would be all right.

All this is in Lennon. The adult world makes him larf, and his books are a vengeance. He has verbal forms of the club-foot joke – Mr Borris Morris, in the story of that name, has a happy knack of being in the right place at the right place – and a splendid visual version. Two beggars stand side by side, each complete with stick, trumpet, dog and begging tin. One of them has dark glasses, and his dog has dark glasses too. The man carries a placard on his chest, saying: I am blind. The other man also has a placard. It says: I can see quite clearly. Thus does the world shed its secrets for the innocent. Although for the person who can make such a joke, as for the boys who could laugh at our drawings, innocence is already a fantasy, an incipient nostalgia, no longer a state of mind.

But most strikingly Lennon sets up a gallery of deformed and violent people, a literal menagerie of creatures born on the blackboard during a break. A man clubs his wife to death. A friendly little dog ('Arf, Arf, he goes, a merry sight') is put to sleep. Eric Hearble, who has a growth on his head, loses his job teaching spastics to dance (' "We're not having a cripple teaching our lads," said Headmaster'). Randolph is killed at Christmas by his pals ('at least he didn't *die* alone did he?') and a girl wonders about flowers for her wheelchair at her wedding – luckily her father comes home and cancels the husband. Little Bobby, 39 years old, gets a hook for his missing hand as a birthday present. Only the hook is for the wrong hand, his good left hand, and they have to chop that off to fit the hook.

It is absurd to compare Lennon to Joyce. Lennon's puns are piecemeal, scattered and unequal. Joyce's punning in *Finnegans Wake* is a system, a metaphysic for melding worlds. When Joyce writes of the flushpots of Euston and the hanging garments of Marylebone, the Bible and London really collide. But Lennon has some fine effects. A pun is what Durkheim in another context called a logical scandal, it is an escape from linear meaning. It is language on holiday, and Lennon occasionally gets the authentic glee of this.

'Anything you say may be used in Everton against you.'

'Father Cradock turns round slowly from the book he is eating and explains that it is just a face she is going through.' People dance with wild abdomen, and send stabbed, undressed envelopes.

Why is there so little of all this in the songs Lennon writes with Paul McCartney? McCartney's sobering influence? Hardly. More likely both are being tactful towards their public. They know that people are offended by nonsense, by things they can't understand; they know that people tend to take jokes that baffle them as a personal insult, a calculated exclusion. And their songs after all are a commercial enterprise – Lennon and McCartney have written well over 100 songs since 1962, and their work has been recorded by almost everyone you can think of.

Certainly there are occasional puns – 'It won't be long/Till I belong to you.' *A Hard Day's Night*, the nonsense title of a film and a song, comes from a Lennon story called 'Sad Michael'. There are all the double meanings concerning pot and LSD on the *Sergeant Pepper* album, there is the sound play of by, buy, bye-bye in the song *She's Leaving Home*. And the songs have developed towards complexity.

Lennon and McCartney's early lyrics were thin and conventional: 'Well my heart went zoom/When I crossed that room.' There was rain in the heart, there were stars in the sky, birds were always threatening not to sing. The tunes were good, some of them as good as those of Rodgers or Leonard Bernstein. But the gap between words and music in pieces like *If I Fell*, *And I Love Her*, *Ask Me Why*, *Not a Second Time*, was embarrassing for anyone who wanted to take the songs seriously. The best lyrics, which went with up-tempo numbers like *I Feel Fine*, *All My Lovin'*, *Can't Buy Me Love*, were the ones which said the least. They said yeh, approximately. I'm not suggesting that Lennon and McCartney didn't know how conventional they were being, or that they couldn't have done better. But they didn't do better, presumably because they weren't interested.

Now they are interested. We get the sharpness of 'Your day breaks/Your mind aches', where the rhyme really does something. People, characters, begin to take the place of the

anonymous lover of the early songs, shouting, sobbing, missing, losing, promising his standardized love. We get Rita the meter maid, and the man who wants to be a paperback writer. We get Eleanor Rigby and all the lonely people, and the sights and sounds of Penny Lane. To say nothing of Billy Shearer, Sgt Pepper and Mr Kite. And we get the complex compassion of songs like *Wait* ('If you heart breaks/Don't wait') and *She's Leaving Home*, where the girl going off writes a note 'that she hoped would say more', and her parents moan their incomprehension: 'We gave her most of our lives . . .' The whole work develops a sense of waste, of 'tears cried for no one', as one song has it.

But still, the music has developed more than the language, and the language is not a main attraction in these songs. Lennon and McCartney's words are still less important than those of Bob Dylan, or Lorenz Hart, or Cole Porter, or Ira Gershwin. We have to look elsewhere for the link between the songs and Lennon's stories.

The link is not hard to find. It takes us back to school, and Lennon and McCartney's repeated flights into the past. Think of the titles: *Yesterday*, *The Night Before*. Think of the nostalgia in songs like *Things We Said Today*, or *In My Life*: 'There are places I'll remember all my life.' Think of the echoes of melodrama and music hall in the *Sergeant Pepper* album, the jaunty George Formby tone of *When I'm 64*. In *Good Morning Good Morning* we take a walk past the old school – 'Nothing has changed, it's still the same' – and *She Said She Said* flings a bewildered boy out of the classroom on to a hard life. The girl tells him that she knows what it's like to be dead, and he can only reply:

> No no no you're wrong
> when I was a boy
> everything was right
> everything was right.

Lennon and McCartney in their songs do indeed 'live the past in the present', as Richard Poirier wrote about them in *Partisan Review* last year. But it is a personal and sentimental past, not a historical one – it is the specific past of good schooldays, when the world was simpler and adults looked like fools.

Lennon and McCartney are not naïvely nostalgic, but they are nostalgic. Their songs and Lennon's stories express the *good child*'s hostility to grown-ups. That is what we mean by the youth of the Beatles, an attitude not an age – after all, they were in their twenties when they began to make it around 1962. The attitude is not dangerous, at worst it deserves a detention, and this is why adults have been so keen to endorse the Beatles. This is safe play for children, mild naughtiness, and much better than breaking up Margate or digging up Paris.

The Beatles are a middle generation between the old conformers and the new rebels, between those who find it hard to believe that the world will change and those who know it's got to. Lennon and McCartney protest against the world adults have made, of course. They hate its pain and loneliness. But their protests are quiet, and their only answer so far has been escape into dope or India.

But the question remains. The Beatles have bypassed adulthood, and this links them with the revolutionary students, who are asking why they should grow up when growing up means napalm, treachery, compromise and Porton Down. For years we have sold maturity as a virtue, we have preached the careful ethic of the status quo. But the Beatles are nearly thirty and wildly successful, on anyone's terms. If they haven't grown up yet, why should they now? [1968]

Arts 4
Marketing and Design

The wound in the face

Angela Carter

I spent a hallucinatory weekend, staring at faces I'd cut out of women's magazines, either from the beauty page or from the ads – all this season's faces. I stuck twenty or thirty faces on the wall and tried to work out from the evidence before me (a) what women's faces are supposed to be looking like, now; and (b) why. It was something of an exercise in pure form, because the magazine models' faces aren't exactly the face in the street – not low-style, do-it-yourself assemblages, but more a platonic, ideal face. Further, they reflect, as well as the mood of the moment, what the manufacturers are trying to push this year. Nevertheless, the zeitgeist works through the manufacturers, too. They do not understand their own imagery, any more than the consumer who demonstrates it does. I am still working on the nature of the imagery of cosmetics. I think it scares me.

Construing the imagery was an unnerving experience because all the models appeared to be staring straight at me with such a heavy, static quality of *being there* that it was difficult to escape the feeling they were accusing me of something. (How rarely women look one another in the eye.) Only two of the faces wear anything like smiles, and only one is showing a hint of her teeth. This season's is not an extrovert face. Because there is not much to smile about this season? Surely. It is a bland, hard, bright face; it is also curiously familiar, though I have never seen it before.

The face of the seventies matches the fashions in clothes that have dictated some of its features, and is directly related to the social environment which produces it. Like fashions in clothes, fashions in faces have been stuck in pastiche for the past four or five years. This bankruptcy is disguised by ever more ingenious pastiche – of the thirties, the forties, the fifties,

the Middle East, Xanadu, Wessex (those smocks). Compared with the short skirts and flat shoes of ten years ago, style in women's clothes has regressed. Designers are trying to make us cripple our feet again with high-heeled shoes and make us trail long skirts in dog shit. The re-introduction of rouge is part of this regression; rouge, coyly re-introduced under the nineteenth-century euphemism of 'blusher'.

The rather older face – the *Vogue* face, as opposed to the *Honey* face – is strongly under the 1930s influence, the iconographic, androgynous face of Dietrich and Garbo, with heavily emphasized bone structures, hollow cheeks and hooded eyelids. Warhol's transvestite superstars, too, and his magazine, *Interview* – with its passion for the tacky, the kitschy, for fake glamour, for rhinestones, sequins, Joan Crawford, Ann-Margret – have exercised a profound influence. As a result, fashionable women now tend to look like women imitating men imitating women, an interesting reversal. The face currently perpetuated by the glossies aspires to the condition of that of Warhol's Candy Darling.

The main message is that the hard, bland face with which women brazened their way through the tough 1930s, the tough 1940s and the decreasingly tough 1950s (at the end of the 1950s, when things got less tough, they abandoned it), is back to sustain us through the tough 1970s. It recapitulates the glazed, self-contained look typical of times of austerity.

But what is one to make of the transvestite influence? Is it that the physical image of women took such a battering in the sixties that when femininity did, for want of anything better, return, the only people we could go to to find out what it had looked like were the dedicated male impersonators who had kept the concept alive in the sequined gowns, their spike-heeled shoes and their peony lipsticks? Probably. 'The feminine character, and the idea of femininity on which it is modelled, are products of masculine society,' says Theodore Adorno. Clearly a female impersonator knows more about his idea of the character he is mimicking than I do, because it is his very own invention, and has nothing to do with me.

Yet what about the Rousseauesque naturalism of the

dominant image of women in the mid-1960s? Adorno can account for that, sociologically, too. 'The image of undistorted nature arises only in distortion, as its opposite.' The sixties face was described early in the decade by *Queen* (as it was then) as a 'look of luminous vacancy'.

The sixties face had a bee-stung underlip, enormous eyes and a lot of disordered hair. It saw itself as a wild, sweet, gipsyish, vulnerable face. Its very lack of artifice suggested sexual licence in a period that had learned to equate cosmetics, not with profligacy as in the nineteenth century, but with conformity to the standard social and sexual female norm. Nice girls wore lipstick, in the fifties.

When the sixties face used cosmetics at all, it explored imports such as kohl and henna from Indian shops. These had the twin advantages of being extremely exotic and very, very cheap. For purposes of pure decoration, for fun, it sometimes stuck sequins to itself, or those little gold and silver 'good conduct' stars. It bought sticks of stage make-up, and did extraordinary things around its eyes with them, at about the time of Flower Power. It was, basically, a low-style or do-it-yourself face. Ever in search of the new, the magazines eventually caught up with it, and high-style faces caught on to flowered cheeks and stars on the eyelids at about the time the manufacturers did. So women had to pay considerably more for their pleasures.

The sixties look gloried in its open pores and, if your eye wasn't in to the particular look, you probably thought it didn't wash itself much. But it was just that, after all those years of pancake make-up, people had forgotten what the real colour of female skin was. This face cost very little in upkeep. Indeed, it was basically a most economical and serviceable model and it was quite a shock to realize, as the years passed, that all the beauty experts were wrong and, unless exposed to the most violent weather, it did not erode if it were left ungreased. A face is not a bicycle. Nevertheless, since this face had adopted naturalism as an ingenious form of artifice, it *was* a mask, like the grease masks of cosmetics, though frequently refreshingly eccentric.

At the end of that decade, in a brief period of delirium,

there was a startling vogue of black lipstick and red eye-shadow. For a little while we were painting ourselves up just as arbitrarily as Larionov did before the Revolution. Dada in the boudoir! What a witty parody of the whole theory of cosmetics!

The basic theory of cosmetics is that they make a woman beautiful. Or, as the advertisers say, more beautiful. You blot out your noxious wens and warts and blemishes, shade your nose to make it bigger or smaller, draw attention to your good features by bright colours, and distract it from your bad features by more reticent tones. But those manic and desperate styles – leapt on and exploited instantly by desperate manu-facturers – seemed to be about to break the ground for a whole new aesthetic of appearance, which would have nothing to do with the conformist ideology of 'beauty' at all. Might – ah, might – it be possible to use cosmetics to free women from the burden of having to look beautiful altogether?

Because black lipstick and red eyeshadow never 'beautified' anybody. They were the cosmetic equivalent of Duchamp's moustache on the Mona Lisa. They were cosmetics used as satire on cosmetics, on the arbitrary convention that puts blue on eyelids and pink on lips. Why not the other way round? The best part of the joke was that the look itself was utterly monstrous. It instantly converted the most beautiful women into outrageous grotesques; every face a work of anti-art. I enjoyed it very, very much.

However, it takes a helluva lot of guts to maintain oneself in a perpetual state of visual offensiveness. Most women could not resist keeping open a treacherous little corner on sex appeal. Besides, the joke went a little too near the bone. To do up your eyes so that they look like self-inflicted wounds is to wear on your face the evidence of the violence your environment inflicts on you.

Black paint around the eyes is such a familiar convention it seems natural; so does red paint on the mouth. We are so used to the bright red mouth we no longer see it as the wound it mimics, except in the treacherous lucidity of paranoia. But the shock of the red-painted eye recalls, directly, the blinding

of Gloucester in *Lear*; or, worse and more aptly, the symbolic blinding of Oedipus. Women are allowed – indeed, encouraged to exhibit the sign of their symbolic castration – but only in the socially sanctioned place. To transpose it upwards is to allow its significance to become apparent. We went too far, that time. Scrub it all off and start again.

And once we started again, red lipstick came back. Elizabeth I seems to have got a fine, bright carmine with which to touch up her far from generous lips. The Victorian beauty's 'rosebud mouth' – the mouth so tiny it was a wonder how it managed to contain her teeth – was a restrained pink. Flappers' lips spread out and went red again, and the 'generous mouth' became one of the great glamour conventions of the entire twentieth century and has remained so, even if its colour is modified.

White-based lipsticks, colourless glosses, or no lipstick at all, were used in the 1960s. Now the mouth is back as a bloody gash, a visible wound. This mouth bleeds over everything, cups, ice-cream, table napkins, towels. Mary Quant has a shade called (of course) 'Bloody Mary', to ram the point home. We will leave our bloody spoor behind us, to show we have been there.

In the thirties, that spoor was the trademark of the sophisticate, the type of Baudelairean female dandy Dietrich impersonated so well. Dietrich always transcended self-pity and self-destruction, wore the wound like a badge of triumph, and came out on top. But Iris Storm in Michael Arlen's *The Green Hat*, the heroines of Maurice Dekobra, the wicked film star in Chandler's *The Little Sister* who always dressed in black to offset her fire-engine of a mouth – they all dripped blood over everything as they stalked sophisticatedly to their dooms. In their wake, lipstick traces on a cigarette stub; the perfect imprint, like half a heart, of a scarlet lower lip on a drained Martini glass; the tell-tale scarlet letter, A for adultery, on a shirt collar . . . the kitsch poetry of it all!

Elizabeth Taylor scrawls 'Not for sale' on her bedroom mirror in her red, red lipstick in *Butterfield 8*. The generosity the mouth has given so freely, will be spurned with brutal ingratitude. The open wound will never heal. Perhaps, some-

times, she will lament the loss of the tight rosebud; but it has gone forever.

The revival of red lipstick indicates, above all, I suppose, that women's sense of security was transient. [1975]

Shades of summer

Reyner Banham

'And now,' this bird was telling Olivier Todd (BBC-2's answer to Jean-Paul Belmondo), 'they are buying sunglasses just to wear on top of their heads.' What did she mean *'and now'*? Glasses over the hairdo became compulsory on the Columbia campus as long ago as 1963, and at St Tropez the following year. By the beginning of the 1965 season, Sea-and-Ski had their 'Boywatchers' on the American market – plastic Alice bands to restrain the mandatory long, sun-bleached tresses of surf-girls-USA, with a single, long inset strip of Polaroid so that they could be dropped over the eyes when appropriate.

'Boywatchers' died the death before the season had even got its knees brown, and not because there was anything wrong with the design functionally, or the ergonomic analysis on which it was based. As it correctly presupposed, the prime function of sunglasses, statistically, was to keep the hair tidy, the secondary function was to conceal eye movement while studying form (hence the name) and, in extreme circumstances only, to shade the eyes from glare. But they broke the un-written rule that sunglasses may not depart from spectacle format – two separate lenses in a folding frame. Sea-and-Ski have learned their lesson; this year's gimmick glasses from their catalogue may have mudguards and surfer competition stripes, but they also have separate lenses. The market will not accept green eyeshades or wrapround visors, however reason-able they may appear to squares. But granny specs, with their minute, oval or letter-box lenses are an immensely commercial proposition, though they flout every utilitarian criterion the

Consumers' Association will advance in its threatened *Which?*-hunt on shades.

The blatant extremism of granny specs – it is *de rigueur* to wear them so far down the nose that they don't even conceal eye movement – underlines key aspects of the psychology and sociology of sunglasses. But first, listen to the saga of how they nearly *didn't* become a commercial proposition.

Back in the early fifties, manufacturers (the factories are mostly in France and Italy – look inside the frame of your sunglasses – or in Japan) were scrapping their plant for making metal frames, because plastics offered greater simplicity, economy and flexibility in production. Then, at the beginning of last year, accompanied by scandalized tut-tutting from the rest of the industry, one Italian manufacturer whose products reach the English market under the Correna trade-mark, re-tooled for metal frames. But the tutting came to an embarrassed halt when it became apparent that, thanks to the Lovin' Spoonful, the Byrds and the second-hand clothes bit, metal-framed granny specs were going to be the season's big action. The rest of the business had to sit by and watch Correna make a killing. Or not, because at this point the backwash of the Rhodesian crisis sent copper prices so high that metal-framed specs of any sort were ceasing to look like a profitable proposition at all. However, you only have to look at the posters in the Tube and the crowded racks in the chemists to know that Correna survived and are flourishing.

But, still, it can be dodgy. Most manufacturers apparently won't look at production runs much under half a million, and even if this is split internationally between half a dozen or more giant wholesalers, any one wholesaler still stands to lose a bomb if he picks a loser. More likely, all the wholesalers will go down the drain together, because fashion moves more or less simultaneously all over the world in this market. For, once you eliminate sundry small pockets of specialized professional shade-wearers – skiers, airline pilots, Israeli infantrymen – the rest of a pretty large annual sale (something between one and two million pairs in Britain, it is thought) is to a pure fashion market, putting increasingly expensive gear to increasingly frivolous use. And granny specs are the epitome of that

frivolity, worn simply for show. Even if you were so square as to push them right up against the eyeball, they still wouldn't eliminate peripheral glare (which may be the main problem ophthalmically; observe how working sunglasses have very wide lenses, or even wrap round the sides). The score with shades-for-show seems to be the progressive attenuation of functional disguise.

The great pioneers of shades, like Garbo and Farouk, may have intended to exploit the domino-mask effect, and thought they were making themselves unrecognizable (Farouk!?), but all they were really doing was signalling their desire to be treated incognito – 'That's Garbo, being alone.' There the matter rested while sunglasses were either too expensive for the hoi polloi, or were seaside trash bought for the giggle, along with kiss-me-quick hats. Then, just before the affluent kids moved in with their mad Mod money, a subtle change came over shades; they became the disguise/uniform of certain semi-underground groups. From Dizzy Gillespie onwards they became the standard rig for cool jazz people, ostensibly to conceal the effect that 'the habit' was having on the pupils of your eyes. Or, alternatively, they became the only piece of solid capital investment possessed by surfers and other quasi-delinquent bodies (if you'll pardon the term) of beach layabouts.

For all these subcultures, the sinister power-image aspect of shades (currently exploited in the Harp lager ads) is also a conscious overtone (ever notice how, all through the Bond/Uncle country, the good guys never wear shades, while THRUSH and SMERSH practically live in them?). But by the time you get to granny specs, all that is left of this disguise-bit is a symbolic statement of the order 'I am disguised as a man wearing sunglasses.' When things have gone that far, the actual shape, form or colour of the shades hardly matters, as long as they can be recognized as sunglasses – i.e. have two separate lenses and sidepieces. Otherwise the freedom to follow fancy or fashion is practically absolute and as long as the shape can be anything from narrow horizontal strips to tall ovals, diamonds or halfpennies, one or two class-oriented theories about sunglasses will have to bite the dust. Thus,

while it is true that sunglasses are pretty classless, like the rest of Mod gear at present, the idea that a pair of shades is a substitute for 'a good bone structure' (i.e. makes you look like a horse-faced aristo) is visibly untrue. They are just as likely to make you look like a Martian or Benjamin Franklin.

But that, probably, is what it's all about anyhow: instant role playing. 'Look, crowd, I'm John Lennon/Lolita/Dan Gurney/the dreaded Grimley Fiendish/les Ton-tons Macoutes/Beethoven/Brigitte Bardot/your Aunt Edna.' It's another way of manipulating your image, and quicker than having a body like Charles Atlas in ten days. [1967]

Sundae painters

Reyner Banham

Ice-cream waggons must be about the biggest invisible objects in residential Britain. If they are 'seen' by adults it is metaphorically – as problems, as threats to the road safety of children, their chimes an invasion of environmental privacy. But next time a waggon enters your field of concerned liberal attention, try looking at it with your eyes instead, because the chances are much better than evens that you are looking at a genuine, good-as-autographed David Cummins.

Cummins? Cummins of Crewe (Crewe!?) produce about 500 ice-cream vans a year, and totally dominate the British market. David Cummins, of the founding family, is the man who must be credited with designing (for want of a more accurate word) this highly saleable product. And you won't find him sitting down to a drawing-board to do it. More likely he will fumble out a fag packet and a ballpoint and 'We'll do a curve something like this, then a sort of thing here, and try to bend it round underneath . . . huh?' The rather shaky drawing, smaller than the thumbnail alongside it, will be for most of the back end of a van, or at least for the

whole of the complex bit at the point where the tail fin meets
the roof and the back window. 'But sometimes,' Cummins says
happily, 'we just draw in the dust on the side of the body.'

He's what intellectual circles would call an autodidact. Left
school a couple of weeks before his A levels; came into the
firm to work on the refrigeration side; learned the trade by
sitting next to Nelly, as the saying goes; and took over from
Nelly as soon as he realized that that worthy was doing it all
wrong ('Technical college? Useless – full of retired railway-
men converting fractions to decimals and back'). His drawing
would get an 'I for incompetent' in any design school. He
knows what an isometric is but can't draw in perspective. Yet
his drawings sell more vans, he claims, than photographs
would. They give all the information that's relevant; isn't that
enough?

Within the works it certainly is. He's working in a kind
of vernacular situation which – in spite of the novelty of its
materials (fibreglass) and technology (soft-serve ice-cream and
stuff) – is the way the master masons of the Middle Ages are
supposed to have worked. Whether they did or no is argu-
able; but, for generations of design theorists now, right back
through Gropius to William Morris and beyond, it has been
an article of faith that in the Middle Ages there were no
drawing-board designers, and the master mason clambered
about the scaffolding making design decisions on the spot and
explaining them to his workforce by scratching thumbnail
sketches on a corner of tile and saying, 'Let us make an ogee
somewhat after this manner, then a quodlibet here, and curve
it (God willing) upon the buttock side . . . Prithee?'

Not that Gropius himself ever worked like that. In spite
of his expressionist rhetoric about 'abolishing the snobbish
distinction between artists and craftsmen', it is not recorded
that he clambered about the scaffold of the Bauhaus building
in Dessau, saying, '*Machen Sie einen Bogen, und etwas hier
damit . . . u.s.w.*' They don't do that kind of thing in the
places where they worry about design, only in the places
where they worry about getting the product on the road and
working for its living . . .

The particular non-medieval vernacular in which Cummins

works isn't as old as he is. He might *just* have been in long trousers when 'somewhere about 15 or 17 years ago, say 1955', the family garage built its first ice-cream van, after a period of building trailers and station waggons ('because they didn't have to pay purchase tax') for friends. Those 1955 prototypes have a distinctly Noddy-car air; the front ends were pure cartoon-faces. But the idiom clearly comes, in fact, from the bus-body traditions of the time, complete with the double-drooping styling line down the side.

Those were metal bodies over a wood frame, and the waggons stayed basically metal-panelled for years. The fibre-glass revolution struck remarkably late, when the big fat Bedford CF van-chassis became available at the end of the sixties. The greatest triumphs of the Rocket-Baroque phase of the Cummins vernacular had been a couple or four years earlier than that, when the space race and Batman had provided a linked set of images that looked entirely appropriate serving the queues outside the Science Museum in the school holidays.

Although tail fins and Batman imagery persist, the whole style has calmed down, matured. Paint is taking over the prime visual role. It's always been important, of course; and from the very beginning Cummins colour schemes have always divided in the same way, with very few exceptions: cream or white above the droopy styling line: pink, sludge blue or sharp green below ('Just done a brown one . . . D'you think brown's all right for an ice-cream van?'). Now, however, these two fields of colour are being colonized by a new tutti-frutti of detached motifs and flourishes. Batman and Robin survive, joined by Disney characters; but the merchandise itself, a whole repertoire of different types of ice-cream, is taking over, garnished with swirling ribbons and stars. And a slight touch of history here and there, where imitation awning stripes, like on the original hokey-pokey carts, adorn the visible side-panels of the roofs.

Occasionally an ambitious van-buyer will ask to have a scene painted on his machine. There were two in the shed last month: one with knights jousting and a castle in the background, the other a Mediterranean village [sic] with a palm

tree. The knights were frankly awful, the palm-tree spread was OK (even if its iconography leaves the package-tour industry with a lot to answer for). But neither seems to me to have much to do with the real ice-cream vernacular. It's all those dancing ice-lollies, overloaded cones, stupefying sundaes, zooming wafers, and saucy Ninety-Nines that are what it's all about, framed in brackets and dotted lines, looped with ribbons and punctuated with stars. And these are legendary – in the sense that there's a legend about them.

Almost the first I ever heard about Cummins of Crewe was from an ice-cream vendor one dozy hot July afternoon off the Balls Pond Road (honest!). Trade was quiet, though he had the bonnet of the Bedford up to keep the engine cool. We passed the time of day, and I admired the paintwork, and he told me it was all done with such obvious loving care because the painters were 'little old men who'd been doing the numbers and stuff on railway carriages at Crewe before they closed the works'.

Not a word of it's true. The basic paintwork is done by regular automotive paint-job specialists like you might find at your neighbourhood body-shop, and the fancy stuff is done by a couple of signwriters named Wilf Cross and Terry Colvin. Though I did feel that a touch of the legendaries was creeping in when Cummins explained that they *used* to have a signwriter named Pasquale Ferrugia, and that what I was assuming (privately) to be a bit of motel art from Venice, on the office wall, was the view from Ferrugia's room on the Grand Canal. Cummins's face was perfectly straight as he told me this, and the painting *was* signed Ferrugia . . .

However, not all is paint that seems so . . . some of the figures and ice-creams are standard transfers. But the ribbon work has to be painted. So, for some reason, do the sundaes. Next time you come upon a Cummins van, have a look at those cherries, each executed with a couple of twists of the brush. They're as delectable a *morceau de peinture* as you'll come upon in a month of.

The Sundaes (and the ribbon work) are also indicative of a certain easy-going self-confidence that pervades the style these days. There's nothing tentative or provincial about it, and

that's just as well since Cummins are now on a 'Today, Crewe; tomorrow, the World' trajectory. Already selling their ice-cream waggons to Europe and even Italy (real coals-to-Newcastle stuff), not to mention Hong Kong, they now have a body shell that goes across the Atlantic, fully trimmed and equipped, and drops on to a standard Chevrolet chassis when it gets there.

Regrettably, only the prototype 'American machine' had a genuine Cummins paint job. The production models will go in underpaint, and will receive local artwork. Admittedly, there are good commercial reasons for this, and the style of Cross and Colvin is more than an ocean different from that of the heavy American coach-painters and Kustomizers. But it might still marry up to some of the more exotic American work. I'd really like to see one of those sundaes and its ribbons floating over the desert scenes that Art Himsl currently paints on Californian supervans.

Meanwhile, I'll settle for the Cummins product as it stands, residual tail fins and all. More than that, I'll salute it as one of the better things to be seen on our roads today. And watch out for Cummins on water too, because he builds and hires out special narrow houseboats for use on the local canals. *In steel.* And when I asked why steel, when everybody else was building rental boats in fibreglass and he had a factory full of fibreglass wizards, he simply said, 'You should see them after they come back after a couple of days' hiring . . . all those narrow stone bridges.'

And there was this pile of chairs in the yard: 'We're doing a night-club in an old cornmill.' In a fit of extreme thickness I asked who had designed it, expecting the name of an architect. 'Well, we did. I mean we're sort of making it up on the spot, you know.' By then I *should* have known. [1974]

Household godjets

Reyner Banham

Had a mini-blackout Christmas morning; no light, no power. Within this domestic disaster-area newly unwrapped gift appliances remained silent, inactive, held in that condition of ideal inutility in which they had sat on the shelves of shops, waiting to be bought – abstract sculptures symbolizing the abolition of household drudgery.

Symbolic they certainly are; powerful jujus of the electronic jungle that daily encroaches on the civilized clearings that have been made by oppressing women, enslaving the servant classes, and maintaining western values generally. Not for nothing are domestic appliances symbols of 'affluent futility', second only to the automobile. They represent one of the more embarrassing collisions between traditional art-culture, and the demotic culture of the way we actually live, and are often set up as symbols of the two-culture clash in much more general terms than that. So when someone raises a small cheer for technology, he will be ridiculed by the guardians of European culture (architectural division) as a 'defender of the Frigidaires'.

Too right, cultivated mates! When I remember how my old rural relations and acquaintances had to cook (in wall ovens that made the kitchen an inferno) or do the laundry (over a steaming copper that rotted the linings of nose and throat) even in the 1940s, I would defend the delivery of a workable gas-cooker or electric washing-machine to Ivy Cottage or Hockley House against the claims of any three masterpieces of modern architecture you like to name. And when I read (in the Architectural Association *Quarterly*, where else?) that 'these gadgets are so numerous, so complex and so difficult to repair that the life of the American housewife is increasingly at their mercy . . . and room for unstructured free behaviour becomes increasingly small', I have to acknowledge

that there is at least one kind of blithering silliness that only my own sex can perpetrate – no woman could write such rubbish.

Much of the room for free unstructured activities enjoyed by women today has been created by giving the average house-wife about the same amount of mechanical assistance (about two horsepower) as was deployed by the average industrial worker around 1914. The difference between Mrs Average and any factory worker is that while *his* power-assists have to run throughout the twenty-four hours, in three shifts, to justify themselves as investments of private or social capital, hers are normally switched off.

Have you ever checked for how short a time the average domestic washer operates in the average week? There would be a nationwide scandal if any mechanical plant in the public domain were so under-employed. And have you actually read the instructions on the new liquidizer? Maximum operating time, forty-five seconds, followed by a shutdown of at least a minute. Even in the first rapture of ownership, plant like this may not run as much as ten minutes in a month. Domestic appliances are where the post-industrial society is at, where the post-Protestant ethic of anti-thrift begins.

Mechanically idle for most of their life, domestic appliances must, of necessity, be more symbolic than anything else. What they symbolize is a kind of mastery (tut! *mistress*ery) over the domestic environment that was not available even to the horribly rich a century ago. Indeed, it was a kind of mistressery that the rich might never know they needed – the area of need was where domestic servants could not be had for love, nor money, nor the exploitation of social custom: the frontier states of the USA.

If appliance culture is recognized as peculiarly American (and therefore Ugh, *nasty*! to sensitive European souls) it is because the USA is where it had to be invented. At a time when my mother was bound in chattel slavery as a living-in apprentice to an Oxford Street store, and most middle-class British housewives could expect to afford to grind the face of at least one skivvy into the kitchen floor, US housewives of seemingly equal affluence beyond the Mississippi were lucky

if they could borrow a neighbour's niece for a crisis month or two. (The hired girl who was always 'in trouble' was about as common in real life as the farmer's daughter in the *other* joke about travelling salesmen.) In large families, labour had to be divided and processes rationalized, mechanized, almost industrialized – the gasoline-powered washing-machine penetrated many parts of the nation well before there were power lines to run its electrically operated successor.

Now that growing affluence and – more important – the beginnings of some elementary justice in the social distribution of wealth have begun to affect the life of Europe, appliances have had to come too, to compensate both for a dwindling domestic-servant class and a growing pseudo-bourgeoisie who feel that they ought to be able to afford servants, only where can you get a girl nowadays (except through the mutual-white-slavery of the *au pair* lark)? It is extremely interesting to note that the first boom industry of the Common Market is not even in cars, but in domestic appliances, the household gods of the Eurobourgeoisie.

The trouble with these plug-in *lares et penates*, culturally, is that they compete, all too effectively, with older household gods. Not only do they get women out of the house (socially more subversive than the quest of the female orgasm, whatever Geoffrey Gorer may say), but when the woman goes back into the house (*any* house) the first thing she notices is not the cunning and masterly play of spaces the architect has devised, nor the subtleties of the decor, but the comprehensiveness of the range of appliances provided.

I don't blame her either, but architects do. This distaff revolt makes them feel threatened, unloved and insecure; but they are usually too much men of principle (or too dumb) to join what they can't beat. 'John Prizeman? Oh, he's just a *kitchen* man!' they say, with ill-concealed contempt that ill-conceals the jealousy beneath. Prizeman should worry, by joining what no man can now beat, he has a unique and secure place in British architecture and may even be remembered for it in the history books. Designing kitchens is a major domestic art.

However, the most acute phase of the beat/join syndrome

is not in architecture but in industrial design. Some of the
most spectacularly banal and clamorously insignificant objects
devised by western man have been domestic appliances.
Remember those hilarious streamlined toasters of yesteryear?
Remember the sober well-designed toasters of more recent
years, praised and bemedalled for not being hilariously stream-
lined – but now looking just as dreary as the old streamliners?

Over the last two decades domestic appliances have increas-
ingly been where it's at in industrial design, and for a very
good reason: power-driven gadgets contain sharp, abrasive,
noisy, hot, fast-moving, vibrating, rotating, sucking, blowing
and electrified mechanisms which must be cased in for safety,
cleanliness and convenience. Non-mechanical appliances tend
not to exhibit any discrepancy between form and function.
Generally they are simple pieces of wood, metal, plastic or
ceramic, in which what you see, and what actually does the
work, are one and the same, so that there is almost nothing
a designer can do to, say, a spoon, a cup, a rolling-pin, a
wine glass or a broom, except fuck it up. This vertical fornica-
tion may escape notice while the new shape remains in vogue,
but time has wrought some horrible revenges on what were
once thought to be well-designed flatware and china.

The difference between the functional guts and the outward
form of an electric appliance, on the other hand, is the
industrial designer's licence to practise. At the present time,
I reckon, about three-quarters of the industrial designers work-
ing inside manufacturing companies are involved in appliance
design, all over the world; while independent design offices
draw up to a quarter of their income from re-styling the case-
work of domestic machinery whose mechanisms are not of
their own design.

Now, the actual restraints on appliance case-design are
relatively slight. The only really stringent ones are electrical
safety and – to a surprisingly lesser degree – mechanical safety
(speaking globally, that is; enforceable standards vary from
country to country). The ergonomic restraints are laughable.
So devoted are the human race to the worship of these house-
hold godjets that they will learn to hold handles of patently
non-anthropometric form, manipulate switches and controls

whose forms patently contradict their functions, and deduce the right information from scales and gauges whose clear intention is to withhold it.

As long as the human race can cope, designers are at liberty to do their thing – well, *nearly*. The precise style in which the case-work is moulded is never completely wilful, because it always sets out to communicate something in symbolic form, and the message is always the same. Whether the styling offers those hilarious old chromium speed-whiskers, or the soberest and staidest Good Design, the message is always: 'Buy me!'.

This point needs to be emphasized because there seems to be a tacit pretence that the use of Good Design is less 'commercial' than the use of Art Deco or Streamform, for instance. To paraphrase Lawrence Alloway only slightly, 'Good Design is just another iconography'; and to recall a sage remark made years ago by that master iconologer, Charles Mitchell, the iconography of Good Design is profoundly classical. In other words, Good Design is the style you use when you want to sell something to the educated, culture-seeking A/B top end of the market – which is visibly where the main commercial action still is in appliance manufacture.

It may well be true that the electric flat-iron is the first appliance that goes into a house after electric power is installed, so that it is now the most endemic of all appliances. But most other domestic machinery tends to be concentrated in the higher income and education brackets. It must be this non-democratic distribution of appliances that accounts for the success of anything so non-demotic as Good Design in the appliance market. This is, *par excellence*, the area of equipment that has come under the dominance of the Bauhaus tradition. Sure, you can find speed-whiskers and Streamform if you know where to look (Portobello Road), but what is in your local showroom exemplifies, or apes, the tidiest kind of grey-on-white, or dual-grey, semi-sharp-edged, generally rect-angular, neo-Bauhaus style. Only dear old Moulinex, among major producers, still tries to keep up the best (or worst) traditions of French slurp.

This almost total market penetration by a single style is

one of the great untold sagas of affluent culture, and will doubtless keep a sizeable part of the PhD industry busy in due course. Even without serious research, it is easy enough to see where the saga starts, because the relevant products are still in production – the exemplary *Küchenmaschinen* made by Max Braun, AG, of Frankfurt-am-Main – or, in short form, the Braun Mixer. This classic (and classical) device began to pick up design awards in the fifties and by the end of that decade had become so revered a cult object that when I made a slight joke about its functional deficiencies at the Hochschule für Gestaltung at Ulm (the 'new Bauhaus'), I produced only a horrified silence, followed by indignant hissing from the audience.

And well might they hiss, I suppose, when the links between the school and the Braun style were so close. In effect, the style was invented at the Hochschule, for their outstanding teacher of industrial design was Hans Gugelot, who was also Braun's chief designer at the material period. He it was who devised the idiom of the square box with slightly rounded corners, the grey-and-white or *grau-im-grau* colour scheme, the perfectly cylindrical knobs and buttons, the use of the sans-serif type-faces, and the very slight curvatures permitted where unavoidable in the case-work of the kitchen goods.

In the end, Braun found themselves trapped within an idiom that couldn't do all the jobs that were asked of it, and I suspect that Gugelot, who was very moral and immovable on the subject, died only just in time to avert a major quarrel with the company. For Gugelot there was no other style conceivable. When he was asked what he would do if fashion changed and Braun found the idiom unsaleable, he would just shrug and pull a long face. So far, however, the style remains highly saleable and thus poses a cultural problem that could become very interesting.

Thus: the Ulm idiom in its abstraction and platonic idealism and aloofness and classicism relates to the most central and elevated concepts of established western culture. In a word, it is that highest that we needs must love when we see it – but is it something that we should let into the house? Within the specifically German pedagogic tradition of the house as

a place of *Bildung*, or spiritual education, beautiful objects have an honoured place in the domestic scene; but is a power-whisk lying on the floor in a pool of spilled mayonnaise among the shards of a glass mixing-bowl a beautiful object? Is a washing-machine crowned with a fine head of greasy suds which have begun to run down the side? Is a skillet crusted with the mortal remains of bubble and squeak? Or a toaster with a miniature mushroom cloud of blue smoke hovering over it?

The cost of bringing the Absolute into the kitchen is to soil it. The Romans did at least keep their ultimate deities on Olympus and let the humble household gods handle the washing-up, but the pretensions of Good Design require us to bring the noblest concepts of the humanistic tradition into direct confrontation with scrambled egg and soiled nappies, and that's not the sort of thing humanism, historically speaking, was designed to cope with. The big white abstractions must be devalued, ultimately, by these associations with dirt and muck and domestic grottitude. Congratulations, then, Ladies of Taste and Leisure, you could be doing a better job of lousing up western culture than was ever achieved by deriding great art or making rude signs at philosophers!

[1970]

Chairs as art

Reyner Banham

Rational appraisal of the way we live now seems to need some such abstract noun as 'furniturization' – to describe how previously unselfconscious and virtually invisible domestic items suddenly become great, monumental objects which demand attention, dusting and illustration in colour supplements. The latest victim is air-conditioning. Until about six months ago, this useful service was performed by simple boxes of works that sat neatly on window sills or lurked in holes

in the wall. But now there are two Italian models, at least, that stand on pedestal bases with crossed legs and casters under. At the next Triennale exhibition at Milan, there will doubtless be fully arted-up versions by named designers – and another service will have been furniturized, another class of self-assertive objects will have got their claws into the living-room carpet, never to be dragged out again.

Dementia supellectilis (galloping furniturization) may be diagnosed as an intolerable tension between culture and technology. Pure technology would probably bring furniture to an end, or at least render it invisible. Take heating; this used to be a continuous pyrotechnic drama enacted in a tiled or marbled proscenium arch, flanked by stage boxes for kettles and pots, and fronted by an orchestra pit full of fire irons, hearth brushes and such. But thanks to technology, heating has now disappeared into the walls or under the floor, leaving naught but a thermostat behind to mark its going.

Remember 'wireless sets'? Great cabinets of mahogany or plastic, now shrunk almost to pocket dimensions by transistors: a classic example of technological de-furniturization. But stereo and hi-fi haven't been defurniturized yet, nor will they be. The usual explanation is that the format of 12-inch records can't be reduced, nor can the size of loudspeakers if the quality of reproduction is to be maintained. But since the normal function of stereo rigs is to provide background sound to parties that are deafening anyhow, this quality-of-reproduction bit is just an excuse. The real reason why stereo is furniturized up – in boxes of expensive wood with a trim of exquisite satin-finish metal – is that it forms the focus of a purely visual cult, expressed in ceremonial gloatings and admirations, all quite outside the rational discipline of technology or the objective study of real-life musical performance.

The very essence of furniturization – or, a better word still, *fauteuillage* – is the precedence of appearance over performance, form over function. Le Corbusier's celebrated *fauteuil grand-confort* (literally just 'a very easy chair') looks marvellously comfortable with its huge cushions of soft down. But when you sit in it, it slowly slides you forward on to the floor with your knees up, and breaks your spine by reverse

flexure in the process. Architects buy these chairs purely out of reverence for the name of the designer, admire them, but avoid sitting in them.

However you look at it, the area worst blighted by furniturization lies right under the human arse. Check the area under yours at this moment. The chances are that it is occupied by an object too pompous for the function performed, over-elaborate for the performance actually delivered, and uncomfortable anyhow.

The chair has become such an exemplar of the whole situation that we can now talk about it in the same abstract, definite-articled way we talk of The weather, The bomb, The deity or other topics of public Muggerage. The chair, of course, has been a symbol for as long as there has been western civilization. God and Caesar had thrones when the human race had to squat in the dirt; ever since the Middle Ages, a professor has had a chair from which to look down on the candidate defending himself from a three-legged stool (the original tripos); and in all public debate, in the Anglo-Saxon tradition, one has to address one's remarks 'to the chair'.

Great power used to reside in having a personal support for the lumbar region (i.e. a backrest) as well as the rump (a mere seat). Clouds of atavism still surround any chair with arms. Despite altars and Last Suppers, no such godhead attaches to tables. For a book, 'coffee-table' is the lowest insult you can throw; and could Ionesco have got half as much absurd drama out of a roomful of tables as he did from *The Chairs*?

The chair has become so potent a symbol that a purely functional chair could now only be designed by a computer or a Martian. For any member of the human race it is too loaded with overtones of westernization (as in Japan), of white man's justice, of corporate power (as in the posters for *How to Succeed in Business*), of godliness, of episcopacy, electrocution, elegance (as in sedan-chair) and, chiefly, of aesthetic self-expression second only to the fine arts. Almost every chair of consequence in our current environment has its designer's handwriting all over it; is signed as surely as a painting.

Chairs are known by the maker's name (Parker-Knoll, for example) only in default of a known designer. Even the Hille polypropylene chair, unpretentious as it is, begins to be spoken of more and more by the trade as 'Robin Day's polypropylene chair'. It has long since ceased to matter what mere manufacturer produces a Breuer chair, a Mies van der Rohe chair, a Corbusier chair, an Eames chair, a Bertoia chair, a Ponti chair. The ultimate proof of the primacy of personal design in public esteem is the reputation of Michael Thonet. This Rhineland cabinetmaker went to Vienna to decorate palaces and finished by inventing the bentwood chair on which café society has sat, and largely still sits, all over the world. He made it dirt-cheap; he made it by the million; he came as near as any human has to making chairs as common and unremarkable as the bums that were parked on them. And now he is remembered as the designer of the most sought-after rocking chair (more sought after than the Kennedy rocker) in the world, the favoured bentwood throne of the leaders of modern design.

Quite as much as painting or sculpture, the great chairs are prized as pure creations of the human spirit, and damn their functions. But unlike paintings or statues, they come armed with functional-type justifications, and for this it looks (deep sigh!) as if William Morris is responsible, as usual. The virtues which he found in things 'believed to be beautiful' or 'known to be useful' meant that an object like a chair, which could be both of those, must obviously outrank a mere work of art, which could only be one. He was a kind of nineteenth-century materialist too: for him, the handicraft virtues resided in material things, independent witnesses to the craftsman's art. For instance: a chair, a *Morris* chair.

Even in Morris's day, the human service definable as seating might have been better served by upholstering a projection from the panelling, or bracketing small saddles off the legs of a table. But the man, and the age, were possession-oriented: to the function 'sit' there had to correspond a separate 'sit-thing' to serve it. This infantile malady of design – identifying every function with a free-standing object to satisfy it – survives in places where Morris is regarded as a tweedy old

nit, and ruthless logic prevails over sentiment. In buying a refrigerator, all one seeks is a volume of chilled food storage rather than a beautiful box. A service, not a thing.

The furniturization of fridges has gone as far as wood-graining the box, or covering it in pop pictures. But fridges will never carry the art prestige of a chair because they are too technically complex for one man, especially an art-trained man, to design right through by himself. So the chair remains almost the only work of personal artistic expression that a puritanical society can permit in its homes – because it has functional 'justifications'. But those justifications are as spoof for chairs as they are for stereo kits. All 'well-designed' chairs are both uncomfortable and inconvenient.

The fault is not the designers': it lies in the basic proposition. The more exactly a chair is shaped to give an ideal posture to a *normal* human being, the more it guarantees discomfort for all possessors of non-standard anatomies and everybody who doesn't care to occupy that particular posture. *Really* comfortable chairs have to incorporate such vast tolerances of dimension, and such margins of sprawl in attitude, that it just isn't worth the expense of spirit involved in designing them. The required tolerance of sprawl is made greater by the fact that it is not humanly possible to sit still. In the most comfortable chair, the unquiet human frame insists on fidgeting into a different attitude about every fifteen or twenty minutes, just as one turns over in sleep.

That explains the comfort of Mies van de Rohe's huge, handsome and apparently un-anatomical 'Barcelona' chair (named after the exhibition where he showed it). It's so big – one metre square on plan – that two or three can gather together on it and fall about at ease. But this does not mean that sheer dimensions guarantee comfort. The average English club or fireside armchair is so designed that, by the time one has lowered oneself into it, one is completely helpless and defenceless, the victim of any upstanding bore or low-flying child; and not very comfortable.

The Barcelona chair, and the outside right (or left) of the dreaded English three-piece suite, are inconvenient in being big and heavy. But even lightweight, well-designed chairs are

inconvenient – because they are only designed for sitting in, and that is the very least of the things that happens to a chair. Most chairs are so little sat in that they could never justify themselves economically on that score. Not only are they bought to be looked at as cult-objects, they are also used for propping doors open or (in French farce) shut. They are used by cats, dogs and small children for sleeping in; by adults as shoe-rests for polishing or lace-tying. They are used as stands for Karrikots and baby baths; as saw-horses, as work benches for domestic trades as diverse as pea-shelling and wool winding; and as clothes hangers. If upholstered and sprung, they can be used for trampoline practice; if hard, as bongo drums. They are persistently employed as stepladders for fruit-picking, hedge-clipping, changing lamp bulbs and dusting cornices. And, above all, they are used as storage shelves for the masses of illustrated print that decorate our lives. (Where do you put *your* copy of the *Radio Times*?)

And the more a chair is anatomically well designed for sitting in, the less use it is the other 95 per cent of the time. I have a chair which, though designed by a famous name (Charles Eames), is also comfortable enough for me to sit in for the whole evening. But the slope of the seat and its flexible mounting make it dangerous to stand on, and its shiny surface (which facilitates necessary fidgeting) guarantees that any cats, visiting babies, boxes of colour slides or current numbers of *Nova* that are placed on it, will slide through the back and on to the floor.

This failure to make provision for any of the functions of a chair except the least important one, being sat on, shows all too clearly how cultural habit prevails over technology. If rational inquiry were to prevail, it would show that chairs are simply detached units of a commonwealth of horizontal surfaces on which any number of objects, including the human fundament, can be parked. Even in seemingly ideal situations from which real-life uses could be hermetically excluded – such as exhibitions in Heal's – the facts of the primacy of storage can still obtrude. Take the opening of Shirley Conran's *Observer* simple-girl show. No human being was allowed to sit in Verner Panton's 'living tower' (four sofas

roosting in a climbing frame, an ultimate furnicult-object), but it was already being used as a storage unit for the flowers and other goodies to be presented after the speeches.

The Finnish slouching-room in the same show was probably much closer to a rational solution of the horizontal-surface problem. But since this involved putting a mattress on the ground, it threatened to make the occupier barely recognizable as a member of the decent self-respecting human race. For if you can make this mental breakthrough, and simply sit or lie on the one universal horizontal surface we all possess – the floor – and stack your books, cooking gear and other chattels directly on the same surface, then you will be re-graded as a beatnik, your Barclaycard will be withdrawn (no bailiff's man can distrain on the floor), and the tradesmen will never speak to you again.

But you aren't likely to do it. It isn't just your bank manager who likes you to surround yourself with portable things which you believe to be beautiful and he knows to be valuable. We all like it ourselves, for we are a thing-struck culture. This must be one reason why the threatened revolution in domestic furnishings never takes place. Everyone seems to agree that furniture isn't really modern. Every six months someone invents the idea of simply upholstering the whole floor (going a stage better than the slouching-room) – and doesn't do it. Meanwhile, furniturization gallops on apace. Loudly trumpeted new inventions prove to be the same old inventions all over again, like the disposable paper chair, which will never really get disposed of, because people can't do that to furniture and it will just stand about getting dog-eared and mouldy.

Or take the Archigram/*Weekend Telegraph* room exhibition at Harrods recently. It did propose a floor 'made hard enough to dance on or soft enough to sit on'. But as you weren't allowed to walk into the room set, you couldn't tell if this too had been mocked up. You were, typically, only allowed to look, and what you saw, as ever, was a floor covered in elaborate things – marvellous things, desirable objects, believed to be useful and seen to be beautiful – but still things, still furniturization rampant. [1967]

Art Nouveau riche

Paul Barker

Whistler led a provokingly elegant life; the Spanish architect
Gaudí built in Barcelona the costliest house of the day; Tiffany
designed studios for himself 'so lavish that they were fit to
receive the court of Byzantium'. The soil in which Art Nou-
veau sprouted its languorous curves was the wealth of the
'cultured and urban middle class in the heyday of classical
capitalism'. This judgement comes from Robert Schmutzler's
newly published *Art Nouveau*. How then, in the heyday of
the mixed economy, does this style get the accolade of being
copied in every Oxford Street dress-shop window? Why has
the best ad this year been Christodoulou's Tube-station pas-
tiche of it for Elliott shoes?

The *casus belli* was as trivial as Jenkins's ear. Alphonse
Mucha doesn't squeeze a single mention out of Dr Schmutzler.
The Czech artist was a second-rate practitioner of the style,
and he practised it chiefly in advertising. In April last year his
posters for Sarah Bernhardt and Ruinart's champagne hit
London's attention with a triple bang. The Victoria and Albert
Museum put on a Mucha exhibition. The Grosvenor Gallery
had a show of Muchas for sale. Jaeger's display people got
together with the gallery, and for about three weeks used
violently-recoloured Mucha reproductions as backdrop to their
Regent Street windows. Later, in their Sloane Street shop,
they used four originals lent by the gallery. Mucha's crudity
and easy evocativeness helped the impact. His work is like-
able at first glance; boring only at a second or third. The V&A
got a steady stream of visitors; the Grosvenor Gallery did
excellent business; Jaeger were pleased.

Almost everyone in the fashion business claims now to have
been thinking about the style before the Muchas were shown.
But Mucha was the final push. One or two wholesale clothing
firms like Sambo went Art Nouveau. The dresses sold well,

The outcome was this year's deluge in every Neatawear or Marks & Spencer.

The art director of Foley-Brickley, the agency that handles Elliotts' advertising, says he saw hints of the style in foreign magazines: *Elle* or *McCall's*. 'A firm outline, details in the hair, a rounded border and fancy lettering; enough to give the feeling.' He doesn't like Art Nouveau much himself, but he thought it useful. He had the idea last November, and commissioned Paul Christodoulou to illustrate it. Christodoulou had already been doing specimen drawings in Art Nouveau style for his agent. 'It was basically a personal feeling,' he says. 'It suited my way of drawing.' He had done Art Nouveau borders for C&A, who 'suddenly warmed to it' after turning the idea down three years ago. He went along to Mucha at the V&A because a friend of his suggested it. He credits Mucha with softening up the market. But he too gained his own knowledge mainly from magazines. 'People have said: did I work under Beardsley? I didn't know anything about him, only that he was dead and that made me very old.'

Elliotts were annoyed when Christodoulou did an Art Nouveau spread in the *Observer* before their poster came out in February. But it was a sign of the gathering fashion that he had been asked to do this before he got the Elliott commission. When Foley-Brickley brought out an Art Nouveau brochure for a tanning firm a month ago, the drawings were by Barney Wan (who has made an even bigger thing of the style than Christodoulou). Nearly every page has the characteristic Mucha profane halo.

In Britain, much of the interest in Art Nouveau follows naturally from the Victorian revival that started in the thirties. But the crucial date is 1952, when Peter Floud put on the exhibition of Victorian and Edwardian decorative arts at the V&A. At that time, more connoisseurs appreciated early Victorian objects than objects from the rest of the period he covered. Afterwards, an accelerating conversion took place. The prices for original Art Nouveau and its Pre-Raphaelite forerunners started to rise. A Burne-Jones fetched 2100 guineas at Christie's last year. In 1948, Bodley Head misjudged the

market enough to publish some Beardsley reproductions. The book was still being remaindered when I bought it in 1957. Now Paul Hamlyn would have liked to reprint it if Bodley Head still had the blocks. The Maas Gallery is in its third Pre-Raphaelite show since 1961 (the Americans have caught a mania for the school). This time, Art Nouveau is included.

William Morris, the Pre-Raphaelites and Art Nouveau proper are more linked in their revival than they were when they first flourished. A William Morris Society was founded in 1955. Morris, in fact, is a main bridge between the connoisseurs' interest and the popular vogue.

The company that Morris founded didn't fold up till 1940. When it did, a Carlisle firm of calico printers bought the fabric blocks. The wallpaper blocks were already with Sanderson's who had been doing the printing for Morris & Co. Sanderson's kept half a dozen wallpapers in stock. They would also, at a price, print to order. In the early fifties, the LCC got into the habit of using Morris papers to decorate schools. The V&A arranged a travelling exhibition. Demand grew till, this year, for the first time, Sanderson's brought out a pattern book of Morris and Morris-type papers. 'The majority of our Art Nouveau designs are Morris,' the girl there told me. Which shows how, in retrospect, many people see certain colours (yellow and white, or green and blue), curved lines and floral patterns as similarities stronger than the differences that separate some very diverse artists.

In 1960, Janey Ironside at the Royal College of Art took Morris as that year's theme for the students' fashion show. 'We felt these great big bold prints were coming back,' she says simply. 'And at the college we keep trying to pick good ideas from the past.' She had blocks made of Morris wallpaper prints, and used them, with changed colours, for dress material. The William Morris Society protested at the sacrilege – without effect. The students who took part in that fashion show, which the press lapped up, have been infiltrating for four years.

Liberty's were on the same ball at the same time. Their prints clad the 1890s so thoroughly that the Italian for Art Nouveau is *Stile Liberty*. (As Dr Schmutzler remarks, the

decorative and applied arts were historically the basic concern of Art Nouveau – itself the name of a Paris shop.) Rather apprehensively, they decided to reissue some of their originals. A *Vogue* fashion editor came in to give them courage, and the new range was marketed just after the RCA fashion show. Liberty's didn't think public taste was up to the pallid colour schemes (it is now), so they brightened the tones. That was the only change. The prints went like a bomb, especially in Italy. They were taken up by Rome couturiers, then by Balmain, then in the United States. This was all at the level of high fashions. But it brings one back full circle to how *Elle* and *McCall's* could influence Elliotts' advertising, and why Sambo could be wondering when to spring.

It is not surprising that Italy is where the prints caught on. A separate current of the Art Nouveau revival was flowing strongest there: the charmingly named Neo-Liberty architecture. Pevsner was worried about this in a lecture in London three years ago. This sounds paradoxical when he gave the classic account of Art Nouveau in his *Pioneers of the Modern Movement* (first published, though not then sold much, in 1936). But, to him, Art Nouveau is a blind alley that trapped the first attempt to throw away past styles and create modern design. His history is a paean to the clean-cut structures of Gropius and Mies van der Rohe. He decried any return to the nineteenth-century habit of resurrecting the past.

The Modern Movement had been going long enough to be curious about its own biography, including its rumouredly stillborn twin. Other scholars (like Schmutzler) had come after Pevsner. And there were the exhibitions. The most important before the 1960 *Sources of the 20th Century* in Paris was Zurich, 1952: the same year as Peter Floud's at the V&A. The tortuous genius of Gaudí was recognized. Already at Ronchamp chapel, Le Corbusier had put up a building more Art Nouveau than anything. The chief credo of the modern movement was truth to materials. For Art Nouveau, form came first.

From the early 1950s Italian architects bespattered Milan, Turin and Venice with Neo-Liberty. They had two motives. With a sensitiveness to change, they registered the slight

boredom with the machine-like beauty that had triumphed nearly everywhere outside Georgian-loving England. And, among the galloping affluence of north Italy, they felt Art Nouveau was the style for a decadent bourgeois society; Turin got a Neo-Liberty Stock Exchange.

Decor also did an Art Nouveau. Pieces of expensive, white-painted furniture found their way to London, to the amazement of the natives. A huge brass sun of a lamp appeared not long ago in a Chelsea furniture shop; and quickly went. There are signs that English decor will move the same way. Portobello Road has its stalls specializing in Art Nouveau antiques (for which prices are soaring in France and America). Last month *Queen* told its readers where to find Gallé's exotic vases or original books of Beardsley. There is a man in Brighton who by now must be almost fed up of his black, white and silver flat, he was so far in the avant-garde. But others are catching up.

Wilton's fish restaurant in Bury Street was given the treatment last February: curvy brass lamp brackets and Mucha's champagne poster. Sanderson's have brought out Morris furniture fabric. A fortnight ago a student displayed the first white-painted furniture the RCA had produced. St Paul's, Bow Common, is fitted with Italian-style lights. The biggest augury is Cecil Beaton's sets for the *My Fair Lady* film: all in pastiche of Mackmurdo and Mackintosh. 'When that's out, you're off down the Tottenham Court Road before you know where you are,' says Sir Hugh Casson.

In painting, the most volatile art, what influence revived Art Nouveau had has been and passed. At the Tate exhibition of the past decade, you could trace its wake in the off-balance composition of David Hockney. Sculpture shifts slower. Students have turned out multiple-breasted women, painted in naturalistic colours. Architecture in Britain took so much converting to the modern movement that it will take time to divert it again. The Italian magazine *Casabella* is Art Nouveau's main propaganda missile. For some reason it has made the biggest crater among students at Regent Street Polytechnic. Elsewhere it's still Bauhaus, with a genuflexion for Mackintosh's sense of space. Typography, where Art Nouveau origin-

ally triumphed, remains untouched. Editors who use Wan and Christodoulou keep their drawings firmly inside quotation marks.

What happens next? In women's clothes there is no telling. But in other art forms the influence of Art Nouveau may not pass as soon as some dyed-in-the-Bauhaus writers hope. (I exclude Dr Pevsner from this group. He is a good enough critic to know his own prejudices.)

Britain as a whole is rich, if only *nouveau riche*. It should have an appropriate environment. It is hard, in the abstract, to imagine our anonymous office blocks decked out in so personal a style as Art Nouveau. But when you next pass through Barcelona, see how Gaudí treated flats. We are machine-age enough for standard components to be necessary. The new US Embassy in Dublin shows this can be reconciled with powerful decorating. Even if goods are machine-made, there is no logic in saying they have to be plain. Are these flowered machine-made textiles on every typist illogical? If so, then good for illogic. Does the idea totally appal you? Then remember the old Spanish proverb. When Art Nouveau is inevitable, lie back and enjoy it. [1964]

Power plank

Reyner Banham

Tread softly if you carry a big stick; but tread how you like if you carry a clipboard, because no one dare question your authority. Few portable artefacts pack such symbolic power as this piece of plank with a bulldog clip at its top. Sceptre, sword and crozier may lose their sway, but the man with the clipboard commands instant respect. And the reasons why are probably traceable to our old friend, the Military-Industrial Complex.

Within the established hierarchies of that complex, there are fine gradations of personal power that cannot be indicated

by brass badges, or the colour of a pay-slip – crucial slender margins, quite different from the gross differences of power enforced by, say, the police or footy referees. Those have important uniforms, and carry notebooks, but when they have taken a name or issued a caution, they *put the notebook away again*. Not so the clipboard, which must be permanently in hand and visible, and thus distinguishes the NCO in charge of stores from the equal-ranking NCO who, from a position of weakness, is trying to get something *out* of stores. Alternatively, it distinguishes 'staff' who happen to be visiting the shop floor in dirty clothes, from honest members of AUEW whose clothes are dirty because they are never *off* the shop floor.

Anyhow, when I was a member of the military-industrial complex myself, I had a marvellous ringside view of the clipboard being used to indicate crucial microgradations of power, even among upper staff. Test pilots and test observers alike wore flying overalls, leather helmets and intercom headsets, but the pilots had their notepads strapped to their thighs, so that they could jot down Observations Essential to the War Effort ('Skein of geese over Quantoxhead') without removing more than one hand from the business of flying. Observers, however, who were sitting down the back among their gauges, had nothing better to do with their hands than make notes, and so carried clipboards.

This may sound like a mere functional discrimination, but it was also an essential means of enforcing the strict social structure ordained by our chief test pilot, who had decreed that observers, like pilots, were entitled to cups of steaming black coffee when they came back frozen from the empyrean, 'as long as they don't drink it in the pilots mess, but in a standing position in the corridor outside the kitchen'. Any observer with ideas above his station who tried to sneak into the mess would be betrayed by his clipboard, and immediately ostracized by all decent people. Nor dare he abandon his clipboard, because he might then be mistaken for mere AUEW members, like myself, who were occasionally issued with flying gear in order to perform suitably menial tasks aloft.

So if you're insecure about your precise rung in the hier-

archy, the old power plank can be very reassuring, and there's no lack of functional excuses for carrying one. There are always lists to be checked, box-forms to be filled out, agenda to be worked through, scores to be ranked. Sociologists know all this stuff, of course, but keep quiet about it for obvious reasons – the clipboard is their margin of middle-class ascendancy over their subject matter. But don't think that the subjects resent this; the sight of the clipboard tells them it's Role-Playing Time, and they can get to work battering babies, vandalizing playgrounds, resenting immigrants, being influenced by violence on the box, and making up stupid rhymes for the Opies.

However, there is also an important role-ambiguity in the, as it were, bi-polar nature of the clipboard itself. The board serves to support the questionnaire that is being filled out, and the clip serves to stop it blowing away. But the clip also symbolizes the power of the board-wielder to take, and clip down, pieces of paper from those over whom dominion is given. Thus a ticket inspector will secure under the clip dubious tickets, receipts (and carbons of receipts) and other documents by which he accumulates control over his clients. Ditto the waterguards in customs sheds. And in both cases it's made worse by the fact that the rotten bleeders are in uniform and we are not, so they don't *need* to gain power over us by this modern equivalent of securing nail-parings and locks of hair.

So there's a pretty rich vein of social and psychological pay-dirt in clipboards; but where's the expertise about them? Who designs them? When did they mutate from a piece of plank with a loose clip over the top, to a snub-cornered board with a purpose-made clip riveted to it? What's the morphology? What's the bi-polar Levistrology?

I checked out our family holdings in clipboards. We have four for some reason, and the most basic is one of those nasty pieces of hardboard from Ryman's that everyone seems to own these days, with a heavily styled (horizontal ribs) clip and no means of identification, except the words 'Made in England' on the back of the clip. But we also possess the same device bound in Royal Blue PVC with a slightly different

clip (but possibly from the same stylist) bearing the unmistak-able symbol of W. H. Smith since they went 'Good Design', but – and mark this – made in Holland. In other words, the power-symbols of Euroburocracy are here before we're properly into the Common Market.

The other two are more instructive. One appears to be a vintage classic, equivalent in its field to a Red-Label Bentley or 30/98 Vauxhall. For a start, the board is genuine plywood and *varnished*. The clip is modest in form, with a simple round head to the lever. The blade, however, has the words *East-Light* in a neat rectangular border superimposed on that great period image, a sunrise, while the top right-hand corner of the board has a transfer about the size of a large postage stamp with the lapidary wording: 'EAST-LIGHT: when re-ordering specify East-Light board-clip No. 51 (mounted on polished hardwood) also give size 4to or f'cap.'

Board-clip!? Sounds a bit Purcell Room, doesn't it, like *forte-piano*? The whole thing looks as if it comes from the late twenties, but did they have clipboards then? Is it a collector's piece? Is there an East-Light Owners' Club, or an East-Light Register for locating discontinued spare parts? Perhaps other East-Light owners would care to contact me, especially the long-wheelbase f'cap model, and we could have a rally at Woburn or something as dreary.

From classic to plastic: the fourth board looks like an attempt at a radical innovation, Alex Moulton style. It came from a back-to-college display at the Ralph's Supermarket on Sunset Boulevard. It is bound in black PVC, has a very modest clip – but *two* boards. The plastic binding not only forms an envelope pocket on the face of each board, but also forms a simple hinge between the boards, which close over like the covers of a book. It's a real break from the classic format all right, only it's particularly useless. You can't handle it as a clipboard without folding the spare board right round behind the main one, which splits the plastic hinge a bit further and allows papers tucked in what is now the outer pocket to fall out unobserved.

Its only real advantages are in the area of symbolism. It obviously outranks plain clipboards, not only because it's more

complex but also because its contents are concealed when it's closed. It thus gives me a slight edge when, say, working on a television programme where practically everybody on the crew – director, director's personal assistant, studio manager, camera assistants, make-up girl even – brandishes a power plank. At tea breaks, when all the boards are on the table, so to speak, it's possible for me to get some idea how far the others have got with their To-Be-Dones, shooting schedules, footage counts and so forth, but they can't see where I have got to with proposals to mess the script about.

It looks as if the next stage in clipboard development has got to be in this direction. Special-equipment clipboards with stop-watch holders already exist in motor sporting circles, and some sociologists who are still into quantification have had hand counters mounted on theirs. But where are the clipboards with built-in lights for night observations, with Perspex canopies to keep the rain off, with slide-rules down the edge, with navigational protractors, with bulletproof backs for Queen's University, Belfast, sociologists? Yes, I expect they are all on file in the Patent Office, but until they are in Ryman's and Smith's they are not doing what they could to enrich the hierarchical symbolism of a visually egalitarian society. [1973]

The crisp at the crossroads

Reyner Banham

Among the triumphs of progressive technology that Luddites and Leavisites alike have lately been spared is the toad-in-the-hole-flavoured crisp with a hole in it! Scores of other equally nutty (literally so, in some cases) flavours for the familiar old potato crisp have been mooted lately. Don't imagine that cheese-and-onion or barbecue-bacon exhausts the ingenuity of the industry, now that flavours are sprinkled on as a dry powder before the crisp is cooked.

Not all the possibilities have got beyond idle brainstorming (blackberry-and-apple? smoked salmon? how about *crème de menthe*?), but the story about the party that was stoned right out the window at Redondo Beach by LSD crisps is true, apparently, and one memorable week in Montreal I breakfasted (for reasons beyond human belief) on Boursin, instant coffee and rainbow crisps. Rainbow? You bet; red, blue, green, white, natural, and all tasting like cardboard.

The potato crisp is at the crossroads, and to judge by the sundry aromas arising from the secret kitchens of R-and-D departments, the industry can't guess which way it will go. Whoever guesses right could make a real killing. The value of Britain's annual crop has doubled since 1964 and now stands around 62 million quid – crunch that! In the process, Smiths, with only 30-odd per cent of the market left, has had to concede victory to Golden Wonder, with over 45; and the old basic salted crisp has lost almost half the market to new fancy flavours.

It's been a real stir-up, and it has consequences for the arts of design, because the old basic crisp they still eat down at the Rovers' Return, even if it is doomed elsewhere, was unique among the works of man in being as neatly related to its pack as was the egg to its shell. Different kind of neat, but almost as instructive to look at.

For a start, it is an inherently unconformable shape. The cooking process that makes it crisp also crumples it into rigid but irregular corrugations. There is no way to make it pack closely with its neighbours, so that any quantity of crisps must also contain an even larger quantity of air. Bulk for bulk, as packed, crisps contain even less weight of food than cornflakes, and thus give conviction to the myth that they just *can't* be fattening.

This sense that there is no diet-busting substance in crisps is reinforced by their performance in the mouth. Apply tooth-pressure and you get deafening action; bite again and there's nothing left. It's a food that vanishes in the mouth, so, I mean, it can't be fattening, can it? It certainly isn't satisfying in any normal food sense; the satisfactions of crisps, over and above the sting of flavour, are audio-masticatory – lots of response

for little substance.

The pack is analogous in its performance. Keeping the crisp crisp means keeping water-vapour away from it; and until recently the only cheap, paper-type flexible materials that formed effective vapour-barriers were comparatively brittle and *in*flexible, and thus produced a lot of crinkling sound effects whenever they were handled. What with the crisps rattling about inside, and the pack crackling and rustling outside, you got an audio signal distinctive enough to be picked up by childish ears at 200 or 300 yards.

But more than this, the traditional method of sealing off the top of the pack produced a closure that could only be opened destructively and couldn't be resealed. So eating crisps was an invitation to product-sadism. You tear the pack open to get at the contents, rip it further to get at the corner-lurkers in the bottom, and then crush it crackling-flat in the fist before throwing it away. It's the first and most familiar of Total-Destructo products and probably sublimates more aggression per annum than any quantity of dramaturgical catharsis.

However you look at it, or listen to it, the total relationship of crisp to package is a deafening symbiosis that comes near to perfection. And it's the kind of perfection that not even a towering genius could have invented from scratch. The neatness of the relationship has almost a vernacular quality about it, like some survivor from a lost golden age of peasant technologies that have matured long in the wood and hand: the oar, the axe, the rolling-pin. But in the crisp's case, the golden age was recent, a threshold between two ages of industrial technology – the transitional period between the grinding poverty that nineteenth-century social moralists found so repugnant and the new affluence that twentieth-century social moralists find so repugnant.

In the history of rising genteelism, the potato crisp is a key piece of the technology that enabled a woman to go into a pub and still emerge a lady. By asking for 'a bag of crisps, instead', a lady could avoid having another drink without dropping out of a round; could participate in the social rituals of receiving goodies from the bar, or passing them on to

others, without finding herself confronted with yet another jar of ultimate senselessness – and, above all, without incurring the accusations of airs, graces and 'going all la-di-dah' that would follow if she ordered Babycham.

Now that categories like 'woman' and 'lady' are no longer distinguishable, or worth distinguishing, when any bird can share a joint or a bottle of plonk with any bloke without being mistaken for what she wishes she wasn't, the ancient function of the crisp is crumbling almost as fast as the crisp itself. For, in its new functions, the crisp just does not possess the mechanical strength it needs.

Next time you go to one of these functions, and find yourself thinking that a splodge of onion dip would go nicely with the glass of foaming Silesian sherry the dean has just pressed on you, have a good look at the contents of the bowl of dip. The chances are that you will see a surface so pocked over by the shards of wrecked crisps that it looks like the Goodwin Sands during the Battle of Britain. For every Smith or Golden Wonder that actually comes up with a scoop of dip, four or five will die the death between the fingers of the would-be dipper.

Right now, the British crisp certainly isn't keeping up with technological adventures abroad – those big, white, symmetrical ones from Holland, for instance. They may look, and taste, like foamed polystyrene, but they have the structural strength to lift a lot of dip. Even so they are a poor shape for the job, compared with current models of the American 'taco chip'.

I don't know how long the taco chip has been around. I didn't really become conscious of it until I was doing my own housekeeping in Pasadena last winter. But its mastery of the problems of a savoury-dipping culture was immediately apparent. A cheerfully synthetic product, not notably derived from sliced spud, its flavour patently sprinkled on, not bred in, the taco chip comes on in equilateral-triangle format, about two inches on the side, handsomely tanned and only slightly wrinkled.

Not only is it better-looking than the pallid old spud-based product, but it also has the mechanical strength (without being

inedibly tough) to take advantage of the excellent dipping performance it derives from its sharp, 60-degree corners. All in all, the taco chip is a classic US 'engineering solution', a worthy manifestation of the spirit that puts men on the moon and Mace in the campuses.

The surest indication of the crisp's escape from the pub-and-chara context of prole-cult is the fact that something like 40 per cent of the product is now bought as part of the weekly groceries in suitable family-economy packs, while licensed premises now handle only 10 per cent of the trade. Scotland, apparently, is still where the bulk of Britain's crisps are eaten — a surprising statistic since it is difficult to relate the crisp's low ratio of substance to side-effects with the Scots' alleged sensitivity to value for money.

For, if food value were the criterion for purchase, the crisp would be unsaleable. It isn't even an economical way of buying calories, compared with, say, porridge. Crisps, taco chips and their likes must be seen as ritual substitutes for solid food, the kind of token victuals that ancient peoples buried with their dead, the nutriment of angels rather than mortal flesh. In fact, the more I think about the comparison with porridge, the more worried I get. Could it be that the world's greatest anthropologue has got his polarities wrong, and should have written, say, *The Boiled and the Crisp*?

[1970]

Television and Theatre

Cue telecine—put on the kettle

Dennis Potter

The television play has often been scorned as neither flesh
nor fowl nor good red herring. It can be a meticulously photo-
graphed stage play, complete with the rustle of parting
curtains and little globules of sweat under the make-up. It can
be a crabbed and shrunken film made with the sort of budget
more appropriate for a fruit-gum commercial, where the
light doesn't quite match, and 'movement' in the big, wide
world can be reduced to a distant couple walking hand in
hand down a city street while a pop record yammers in the
background. Since you don't even pay your money to take
your choice, the definition is of little interest to most viewers –
which is perhaps just as well, since television plays, so plentiful
and often so unambitious, do not get and scarcely deserve the
kind of criticism which can even begin to grapple with generic
elucidation. Nobody cares very much.

Television itself, according to Nathalie Sarraute, has lifted
'the manufacture of banality out of the sphere of handicraft
and placed it in that of a major industry'. We have perfected
tremendous electronic techniques with which to dispense some-
thing designed to pass the time as painlessly as possible. Even
the most brilliant piece of television drama is of necessity
surrounded by acres of rubbish and then further bludgeoned
by the chatter and tea-making and domestic rhythms which
so happily and sensibly engulf the 19-inch grey face squatting
in the corner of the living-room. One feels that most television
critics have busy home lives, measuring out their reviews with
coffee spoons. On the little screen the women come and go,
talking of Omo.

Yet amid all the distractions at either end of the process,
we still find ourselves keeping one eye open in case we miss
something 'real'. Television brings us the Prime Minister and
a faith healer, a bruised boxer and a sinking ship, a coronation

and a funeral. The picture we see may have been bounced round the world or even off the bloody moon: it can then seem a comic sort of activity to write Act One, Scene One, rehearse in a chocolate-brown drill hall for a fortnight, remove the expletive 'Christ!' and finally sandwich yourself between Harold Wilson and somebody walking in space. As Ken Taylor, the television playwright, once found himself complaining: the trouble with TV drama is that it is shown on television.

Inevitably, perhaps, the television play – one small chunk in the whole night's edifice – began by concentrating on the type of small-scale 'naturalism' which made the panel games and the *Panorama* interviews appear not only much the same kind of experience but also of about equal value. The viewer would not jerk out of his armchair in alarm when the stiffly dignified hen-sexer from Aylsham on *What's My Line?* was followed by an interview with an unofficial strike leader and then the opening scene of a 'play' which featured the famous sauce bottle and a man in shirt sleeves saying that 'this has got to stop, Betty'. If the camera accidentally trundled into view between the cooker and the breadbin, or a desperate actor wordlessly opened and shut his mouth while waiting for a prompt, it was very much the anticipated thrill of embarrassment we got from watching Gilbert Harding lose his temper or Lady Barnett her ear-ring.

Bearded men in brown suede shoes were imported in large numbers from radio and thought it necessary to talk about something called 'the medium'. The thing which was among the least important characteristics of television drama was inflated into a doctrine, a dogma. The TV play was 'live'. Here were these people moving about before your very eyes, and anything might happen. Thus, it was not film. Whether or not it remained 'theatre' was left open to profitable discussion in the canteen: the use of close-up and the immediacy of the experience allowed some to maintain that television was on its way to creating an art form which could not exist in any other medium. The temporary technical limitations of television and lingering memories of radio – which was 'pure' – were used to define the nature rather than the boundaries

of electronic drama. And drama chiefs, stolidly faithful to an old tradition, still say, 'But you can't do that' or 'You are mixing the conventions' or, as you look in panic at the nearest door, 'The point about television is that . . .' Cue telecine, come in Moon. Only a month or so ago a BBC producer wrote an article in the *Radio Times* lauding BBC-2's *Thirty-Minute Theatre* because it was 'live' and thus somehow intrinsically 'televisual', a ludicrous way of turning what is in fact miserable cheeseparing into a respectable ideology.

At the other extreme, Troy Kennedy Martin claims that 'all drama which owes its form or substance to theatre plays is *out*'. He has demonstrated that even 'wild editing of random objects' can give us magical and liberating 'pictures in the fire'. The television dramatist can now more easily say absolutely nothing with great elaboration and, as Kennedy Martin also demonstrates, frequently does. There are now some BBC drama producers and story editors who think that the studio is insufferable, that the filmed documentary, especially with pop music and a wildtrack of real people being inarticulate about real things, is the norm, and *Up the Junction* the greatest thing since Hamlet and Mickey Mouse. Television executives, and the voluble pimps who make a good living out of interposing themselves between the writer and the director, are so conscious of the huge wodges of mediocrity on the small screen that they have an endemic tendency towards dogmatism and hysteria.

I have been indicating that, so far as television drama is concerned, almost all specific definitions are almost always premature and invariably impertinent. They also stultify. Yet for me, as a writer in television, there is always one constant by which one can most usefully approach this thing called the television 'play'.

First, television drama, slotted into sequence in a whole schedule of programming, takes its zest and colouring and technical proficiency from the news, documentaries, sports, entertainments and sermons which surround it. The people who watch it regard it simply as a television programme, like the rest. It is a series of pictures on the screen and nobody is very much bothered about artificial boundaries between

one segment of viewing and another. And secondly, television drama has a different sort of audience gathered in different sorts of groupings when compared to the cinema and the theatre. This is so obvious and so banal a distinction that it trembles on the edge of the absurd and offers little protection against the attractive excesses of dogmatism and canteen chatter of 'where we go from here'.

However, leaving aside the apologies which so afflict those who earn their living in 'television, actually', I find that the exhilaration and purpose of writing television plays owes itself almost entirely to these two simple facts.

Taking the first point: television drama does not even have to generate its own specific breath of 'experiment' or novelty. Since it takes its colouring from the programmes encasing it in the evening's viewing, the TV play can plunder at will, and even feed-in a scene bounced across oceans and continents if it wants to. The styles and mannerisms of studio interviews, the horrible confessions which the very presence of cameras seems to squeeze out of people (the legendary Vox Pop), the direct-to-camera burblings of clergymen and politicians, or the bits of old Gaumont British News: all these can give different layers of response and different patterns of dramatic conflict as and when needed. The television play is as flexible as the whole thing around it and I would rather work on the assumption that it does not exist in its own right at all.

In my TV play, *Vote, Vote, Vote for Nigel Barton*, for example, I was able to use an old Movietone newsreel of Sir Oswald Mosley as a Labour Party minister talking about unemployment, and a more recent bit of television documentary showing Nye Bevan being scornful about Suez while being heckled in Trafalgar Square. Both excerpts were used with a dramatic purpose – i.e. they revealed something about Nigel Barton, a Labour candidate under stress – and yet also added a mixture of satire and objective, historical evidence which would have been difficult to get in another way. People watching it had no reason to be surprised – it was just 'television', the entertainment which flows like water from the tap. It's an awesome sort of freedom.

Similarly, in this play, I attempted to use the convention

of the direct narrative by a big face into the camera without allowing the viewers to think that what was being said was literally 'true'. Television political broadcasts had done much of my work for me: I simply had to use the ambiguity of response that these peculiar exercises draw from the viewer to move the play along. The writer can swing between farce and tragedy, ambiguity and reportage, and still take the viewer with him. I hope.

And then, after all my deliberate efforts, television itself, quite accidentally, gave me the biggest bonus of all. On the night that it was first transmitted last year, *Vote, Vote, Vote for Nigel Barton* was immediately preceded by a party political broadcast by the Rt Hon Edward Heath. When I realized this, my joy was so boundless that I spent some time on the telephone trying to get the opening titles dropped so that we could drift straight from Ted's toothy grin of farewell into the play itself. I felt like the lance-corporal whose letter home had been prefaced by a few warm words from the General Montgomery he had been abusing. I could never have had such a gift in the theatre or the cinema.

The biggest gift of all, though, lies in the second obvious point in my platitudinous definition of television drama. Again, with a touching arrogance which has so endeared me to story editors with grey radiators in their offices, I will draw upon my own work for an example.

Stand Up, Nigel Barton, the first of a pair about this same character moving across the minefields of class and politics, was largely concerned with the stresses and adventures of a miner's son who, by accident and examination, had been dragged so far up the educational ladders of our Opportunity State that he fetched up in that medieval enclave called Oxford. In the theatre – or, at least, in the West End – the audience would have been largely on only one side of this particular fence. If it had worked at all in the cinema, the sort of tensions which any play creates in an audience might have compromised the effectiveness of the story, which attempted to use the specially English embarrassment about Class in a deliberately embarrassing series of confrontations. But with television, I knew that, in small family groupings,

both coalminers and Oxford dons would probably see this play. To know this in advance, when actually getting the dialogue down on paper, is to feel the adrenalin slopping about inside yourself. It offers a peculiar and extremely dangerous sort of excitement, and one which I believe is probably unique to television. I concede that the copywriter for television commercials might well feel the same sort of power, but such people are tainted anyway.

Many TV writers feel depressed about the fact that a crucial moment in their plays, or a fine bit of rhetoric, will be lost in a cataract of flushing cisterns, filling kettles, neighbourly gossip or scalding rows. But the obverse of this is much more encouraging. 'Thank you for letting me into your homes,' oozes the comic, and the fool doesn't realize the terrible truth of what he has just said as a public-relations cliché. The thing is, you see, he said with a little click of departing heels and a slight pinkness round his cheeks, I *do* realize the truth of it, and it would take television itself to enable me to say it in a manner which was not either insufferable or totally embarrassing. Which, to me, is QED. [1966]

Half Moon rising

Albert Hunt

The other night, at the Half Moon theatre, in Alie Street, just behind Aldgate East tube station, three young East Enders turned up to buy tickets to the theatre's show, *Female Transports*. They'd been to the theatre before; but this time, they looked round at the audience, and left. The audience consisted largely of West End theatregoers, attracted by favourable reviews. This story was told to me, wryly, by one of the Half Moon's directors. He passed it on to me completely without malice, delighted that the theatre was receiving such favourable critical attention. But the incident illustrated the contradictions in which a successful fringe theatre is inevitably going

to be caught, given the present structure of British theatre: and it illuminated the gap between the fashionable praise that's being heaped on the Half Moon, and that remarkable theatre's real achievements.

The Half Moon came into existence less than two years ago, and has, since then, become the most solidly established of all the fringe companies. The theatre came about almost by chance. A group of young actors and directors, all of them disillusioned with working in the conventional theatre, had got hold of this building in the heart of what was once Jack the Ripper country, but in an area which is still decaying and is threatened with yet further demolition and redevelopment. The building was a Jewish synagogue. In the first place, they planned to live there. Some of them still do: what would normally form the circle of a conventional theatre has been turned into a couple of flats.

But once they were inside the building, they became aware of the potentialities of the space. Together with a group of actors, who were tired of the restraints and the hierarchical structures of the established theatre, they began putting on plays that they wanted to do. The first, presented in January 1972, was a production of Brecht's *In the Jungle of the Cities*. Ironically, a local paper described this play by a refugee from Nazi Germany in terms of 'German Play in Jewish Synagogue'.

Right from the beginning, the Half Moon differed in many ways from the usual fringe companies. Most such companies have come together, either because, like the Beatles, they emerged from a common background; or because they share a particular set of political commitments; or because they're devoted, like the company called the Welfare State, to a particular fine-art philosophy. What seems to attract the people who work in the Half Moon is the building itself, and the location of the theatre: and also, quite simply, the possibility of doing work they like doing, with people they like working with. There's no permanent company. Actors have to go off from time to time to earn money elsewhere. But, on the other hand, there is increasingly a group of actors whose primary commitment is to the Half Moon, and who form a central core. With the hope of an increased Arts Council grant

next year, there's also the hope that it will be possible to give this group of actors a living wage. In the meantime, the Half Moon has survived on the actors' goodwill, and their belief in the working situation that has been created.

This situation reflects the attitudes of the people who run the Half Moon. There are, in effect, three of them – Michael Irving, Maurice Colbourne (formerly with the Freehold Company), and a young Canadian, Guy Sprung. They're helped by an American, Jeffrey Hooper, a student who worked with the theatre fifteen months ago, went back to the United States to finish his studies, and has recently come back to help in the direction. What's interesting about these people is that they're all individuals, with apparently separate approaches to theatre. These approaches come together in a collective commitment to the Half Moon: but in practice the choice of plays seems to operate very much on a give-and-take basis.

Maurice Colbourne's productions, for example, have been mainly of solidly established plays. In 1972, he directed Euripides's *Alcestis* and O'Casey's *The Silver Tassie*. His interest seems to be in the putting on of crystal-clear productions of classic plays, in such a way as to make sense to the East End audience.

Michael Irving is very clearly turned on by the building itself, and the relationships that can be created inside the synagogue space. He talks enthusiastically about how, in *Dan Dare*, he turned the whole auditorium into a spacecraft, with stars flying past. And the way he's taken the three-dimensional playing area, and has set it off against two-dimensional cut-outs, making popular gags out of the physical situation. This isn't in any way an abstract aesthetic concern: he's committed to using the space to build up relationships with a local audience. But talking to him, you feel that it was the space itself that gave the impetus to turn an idea of popular theatre into a practical reality.

Guy Sprung's commitment is more openly political – although, undoubtedly, his ultimate aims are shared by the rest of the group. To him, the Half Moon is a concrete expression of a political struggle, and his intention is to identify the theatre with that struggle. So he has directed plays

about local interests – a collage play about Wat Tyler; a version of Jack the Ripper, which puts the emphasis on the social conditions which produced the Ripper's crimes; and a play about dockland, intended to demonstrate what's happening – short and clear, and made for local festivals, and meetings of trades councils and action committees.

But what is most striking about the Half Moon is the way in which, over the past eighteen months, its very existence has proved to be the starting point for a number of projects involving local people. The Half Moon has opened up imaginative possibilities which, without the presence of the theatre, would never have existed.

For example, a young photographer, Ron McCormick, who lives in the area, took on the job of organizing a gallery in the theatre. His aim was to offer an alternative to the more fashionable galleries, which tend to see photography as a branch of avant-garde art, and in which young people who take photographs find it difficult to get exhibited. He intended to produce exhibitions which complemented the work of the theatre. But since he had to plan his own exhibitions three months in advance, and since the theatre schedules tended to change more frequently than that, he eventually tried to make the gallery a place where local people would go and see pictures which interested them. So he presented an exhibition of photographs of the East End between 1896 and 1912; and his own documentation of the area, *Neighbours*; and an exhibition about Dalston by an eighteen-year-old black photoprapher called Dennis Morris. Perhaps his most successful attempt at integration with the theatre itself came when, alongside the show about dockland, he presented the photographs of a steel-fixer, called Ray Rising, who had been taking photographs of the river for many years. Rising also made the slides for the dockland show – an example of the way the Half Moon has involved local people in the theatre work. The slides, and the exhibition, attracted a lot of local people to the show itself.

Perhaps an even more striking example of the way a theatre like the Half Moon can act as a catalyst in a local situation was provided by a play Guy Sprung directed last summer,

Fall in and Follow Me. The production brought together a number of disparate creative elements. There happened to be living in the locality a history lecturer, Raphael Samuel, who teaches at Ruskin College, Oxford. His method of teaching (he calls it History Workshop) is to encourage his students to become practical historians themselves: to collect documents and materials, and create, in pamphlets, their own response to the subjects they're dealing with. One of his students, Dave Marson, a docker from Hull, stumbled on the fact that a number of schoolboy strikes took place in 1911: and that one of these strikes took place in Stepney. Dave Marson collaborated with a young writer from the locality – an eighteen-year-old called Billy Colvill, who's now a permanent actor in the company, to put together a play set in and around the Ben Jonson junior school.

And the local involvement didn't stop there. Guy Sprung went along to a local school and, in a series of workshops, recruited a group of thirteen- and fourteen-year-old children to take part in the play. At first, a lot of them came along out of curiosity: but, gradually, six emerged who were fully committed to the production. They themselves created much of the show's dialogue. The production was a demonstration of how 'theatre in education' really can work in a community – not by having professional actors go and perform in schools, but by involving young people in the imaginative activity itself.

The Half Moon has, in fact, in less than two years, demonstrated that it's possible, without being patronizing, to locate a theatre in a community, to involve that community in the activities of the theatre – and yet to maintain a totally uncompromising standard. There's no thought in the Half Moon of 'getting down' to a popular standard: simply an assumption that Euripides, Middleton, Brecht, O'Casey, or a group of schoolboys from down the road, will all have something to say to a local audience, as long as the performance itself is strong enough.

Only two factors seem to me to be working against the intentions of the Half Moon. The first is the devastation of the area itself. Until recently, for example, there was a house next door to the theatre in which several children lived. They

were the only children left in the street. They used the theatre as a playground. At first, they nicked the ticket money and stole from the gallery donation box. But gradually they became a part of the theatre. They were always there – until they were moved out to a new housing estate. Now, one of the theatre directors lives in the house: but the disappearance of the family is symptomatic of what is happening in the whole area – a process that could leave the Half Moon as the only centre of life in a community that has ceased to exist.

The other threat comes from those who want to help the Half Moon: the critics who, from the best of intentions, are making the Half Moon fashionable, and so bringing in an entirely new audience, which, potentially, could frighten the local audience away. The irony is that the Half Moon needs the support of the critics: and yet that support (including even this account?) threatens to undermine the basis on which the Half Moon works. The critical response to *Female Transports*, the show which finished a fortnight ago, seemed to me to be very over-done. It's as if everybody decided the Half Moon was 'in', and so had to be extravagantly praised. The play was praised as demonstrating the best virtues of the fringe. In fact, *Female Transports* was an interesting enough play – effectively, though not outstandingly, performed, with a predictable, and fairly naïve, political message. It's the sort of play that any self-respecting rep theatre ought to be able to present from time to time. But where is anybody to find a self-respecting rep theatre? I wouldn't describe it as a fringe play at all. The fringe, at worst, can be silly and irritating and self-indulgent. But at its best, it has moved way beyond twentieth-century actresses trying solemnly, for two hours, to persuade people they're really eighteenth-century women on a transport ship bound for Australia.

Fortunately, there's always the other side to any contradiction. One group of teenagers didn't come to *Female Transports* because of the audience. But another group, of young children, came to one of its first performances and kept coming back afterwards. The play certainly wasn't intended as a children's entertainment; but these children clearly enjoyed being there.

Perhaps they liked the swear words: or Billy Colvill. Or
perhaps it was warmer than at home. It's around such contacts
that the future of the Half Moon is going to be built. A future
which, in spite of the difficulties, seems to me to be potentially
one of the brightest in British theatre.　　　　　　　　[1973]

A theatre of ideas

Albert Hunt

In recent months, a large number of people have been able
to see two plays by Trevor Griffiths. *The Party* – first produced
at the Old Vic in December 1973 – has been toured in a
concise version as a National Theatre Mobile production. And
Occupations, after productions in Manchester and by the
Royal Shakespeare Company, has been put out on BBC TV.
Both plays show Griffiths to be a writer who, for a number
of reasons, is unusual in British theatre.

In the first place, Griffiths is passionately committed to an
exploration of ideas. This runs counter to a general tendency
in our theatre to see ideas and theatricality as opposites
which are mutually incompatible. Griffiths himself comments
obliquely on this in *The Party* when he presents an agit-prop
theatre anarchist as someone who separates thinking from
doing. ('It's just books . . . It's not bloody *relevant*. None of it
answers the question: what are we going to *do*?') Griffiths
sees ideas as dramatic events.

Secondly, the nature of the ideas to which Griffiths is
committed is unusual, not just in our theatre, but in the
English intellectual tradition. Griffiths is concerned with
Marxist thought as a basis for action. He uses the theatre to
examine the apparent contradictions in the way Marxist ideas
have been used; and in doing so, he examines the way those
contradictions are reflected in himself as an individual. But
there is no central tradition of Marxist thought in Britain.
Griffiths is aware of a hole in our culture where Karl Marx

ought to be. His plays are a conscious attempt to fill in the hole.

Thirdly, Griffiths is unusual – particularly among left-wing playwrights – in being committed to the content of what he is saying, rather than to the kind of people he is saying it to. Since the days of Wesker and Centre 42, and of Littlewood's early Theatre Workshop, the emphasis, amongst writers and groups on the left, has been not merely on presenting plays with political content, but on reaching new 'popular' audiences. The established theatre is dismissed as 'bourgeois'. Griffiths accepts that he writes for a 'bourgeois' theatre: but he argues that this is an important thing to do. He draws an analogy with E. P. Thompson's book, *The Making of the English Working Class*, which, he points out, has helped to shape our sense of history, but isn't primarily read by workers. Griffiths believes that the most effective way he can make an impact on the current intellectual climate is by taking on the bourgeois theatre, using the theatre's conventions and language. (Like Thompson, Griffiths has himself been very involved with further education: after teaching at Stockport Tech, he became further education adviser at BBC Leeds in 1965 – which was when, at age thirty, he began writing for the theatre.)

This point about conventions relates to a fourth quality which makes Griffiths unusual. Nearly all the writers or groups with claims to seriousness in our theatre are consciously struggling, for the most part unsuccessfully, to break away from naturalistic forms. Griffiths, on the other hand, asserts that naturalism is the form he wants to start from – because he's introducing unfamiliar ideas and therefore wants the form, at least, to be familiar; and because, as he sees it, naturalism has a powerful hold on people's imaginations.

I believe, however, that there is another reason for Griffiths's commitment to naturalism. Naturalism is basically about the observed details of everyday life. One of Griffiths's central themes is the connexion – and sometimes collision – between political ideas and the texture of lived experience. In his three major plays to date – *Occupations*, *The Party* and *Sam Sam* (written before *Occupations* but only produced in 1972) – Griffiths draws on naturalist conventions to create such a

texture of lived experience. But his originality lies in the way he injects into naturalist conventions a debate about political ideas, which becomes a dramatic element in its own right.

In each of the plays there's a different mix. In *Sam Sam*, the experience is central, the debate implicit. In *Occupations*, the situation is reversed: interest is focused on the political debate, with the personal element becoming marginal. In *The Party*, the political and the personal are put together into a highly complex and shifting structure.

Sam Sam is, to me, the most derivative of the three plays, and the one that is closest to what is normally thought of as 'avant-garde' theatre. (It's currently having a success on the continent as an alleged example of English pornography.) The play could well be subtitled *Friday Night and Sunday Afternoon*: it has echoes both of Alan Sillitoe and the early John Osborne. The play is in two parts, and is about two brothers, Sam One and Sam Two, who are played by the same actor. The first part shows Sam One on a Friday night. He's an unskilled, unemployed labourer, and we see him living and rowing in a cramped house with his wife and his mother, and thinking with sentimental anger of the wasted life of his dead father: 'Trot trot click he went all his bloody miserable exploited life and I fill up with snot and tears and shame and anger whenever I remember the way he was.' The second part shows Sam Two on a Sunday afternoon. He's declassed, a schoolteacher, and left-wing Labourite, rehearsing a speech for the party conference and on the point, apparently, of being offered a safe seat. He's married an upper-middle-class girl, with whom he has an 'agreement' to sleep around. She's preparing to receive her parents for Sunday tea when Sam's mother arrives to ask Sam Two for help. The wife virtually hurries the mother out of the house. Sam Two retaliates by spitting whisky into the face of her father.

Both parts end with music. Sam One plays the Choral Movement of Beethoven's *Ninth Symphony* ('Let's hear it big and clear . . . With me now'); Sam Two plays the Brighouse and Raistrick colliery band version of a popular hymn tune. Sam One sounds at times a good deal like Sillitoe's Arthus Seaton;

while Sam Two, like Jimmy Porter, fights the class war through his relationship with his wife. But Griffiths creates one astonishing theatrical image at the end of part one, when Sam One, putting on Sam Two's 'immaculate dress suit', talks ironically about 'HISTORICAL INEVITABILITY' – 'sounds a bit like a terminal illness'. It's an image in which Griffiths brings together the personal and the political in a startling way.

Griffiths himself says, in an introductory note, that the play in part describes 'the pyrrhic victory of environment over genes'. In other words, to the extent that the play involves Marxism, it's because Griffiths himself is offering a description from a Marxist point of view, and not because Marxist ideas are explored and discussed in the play itself. The precise opposite is true in *Occupations*, in which Griffiths himself refuses to take up any definitive position at all, and contents himself with presenting two sides of a contradiction.

Occupations was first put on in Manchester (before the RSC production) in 1970. It takes place in Turin in 1920. The word refers partly to the occupation by half a million workers of factories all over northern Italy, and partly to the professional occupation of a man named Kabak, whose job it is to be a revolutionary, and who arrives in Turin as the representative of the Moscow-led Communist International. The play centres round the relationship between Kabak and the Italian Marxist thinker and activist, Gramsci: not the least of the play's virtues is that it introduces this comparatively little-known figure to English audiences. Gramsci, a hunchback and an intellectual, has found it difficult to make contact with the working classes, but he has *thought* his way through and is now guiding the occupation alongside the working-class leaders.

Kabak represents two contradictory strands in Lenin's 1920 policy. Lenin has given the order to encourage world-wide revolutions; but he has also given the order to safeguard first the security of the already achieved revolution in Russia. Kabak lives out these contradictions. At the very beginning of the play, he encourages Gramsci to take risks and to turn the occupation into an insurrection. But when it becomes clear that the national leaders of the movement aren't going to

support a revolution, Kabak does a deal with the industrialist whom Gramsci has been trying to defeat, a deal which will bring economic benefits to Russia.

Gramsci, on the other hand, is hesitant in the early stages. He doesn't believe that the workers are ready for insurrection. The need, he says, is to educate. Will there be time – events are carrying him away. But towards the end of the play, Gramsci abandons his belief in education; and urges instead a revolutionary vanguard, to take the decisions and drag the workers along.

The strength of the play lies in the way Griffiths presents each of these contradictions with great conviction. He never sets up an Aunt Sally, but he writes each argument from the point of view of the character who is propounding it. The audience is left in the position of being forced to think the contradictions through.

There is, however, one other way in which Griffiths differentiates between Kabak and Gramsci. Gramsci argues that what motivates a revolutionary is love, and insists that you can't love mankind unless you love individuals. Kabak asserts that a professional revolutionary is a general, and that if a general loves his army, he will never be capable of action. Kabak's last words to Gramsci are, 'You still love them too much, comrade.' Once again Griffiths refuses to offer a judgement. But he demonstrates Kabak's refusal to love by showing his relationship with his dying mistress, who is on the stage throughout, and to her maid Polya, whom he uses sexually as if she were his own property. But compared with the complexity of the political discussion, this personal relationship seems rather conventional; and by the end of the play, the mistress, a former countess, becomes not an element of lived experience so much as a symbol of the old Russia that is passing away.

This scarcely detracts from the power of a play in which the political debate is dramatized in such concrete terms. But it does contrast with what happens in *The Party*, in which the personal and the political interact from the play's start.

The Party takes place in the house of a successful TV producer, Joe Shawcross, on the night of 10-11 May 1968,

during which French students fight it out with the police in the Latin Quarter. Joe has invited a group of people to meet and try and formulate a common revolutionary attitude – or at least to begin a dialogue. Present are a successful northern writer turned drunk, called Sloman; an International Socialist girl; an anarchist from agit-prop theatre; a fashionable left-wing literary agent; Joe's former wife, Kara (now a columnist with the *Guardian*); and a lecturer from LSE, Andrew Ford. Joe has called them together to meet the veteran Trotskyist leader, John Tagg (played in the original production by Olivier).

The early sequence of the play is in the style of a sophisti-cated comedy, and works like a funny 'well-made' play. The best lines are given to Sloman, and we think we know where we are, in the territory in which a rude but commonsense and down-to-earth drunk deflates the pretensions of a group of intellectual pseuds. But, suddenly, Griffiths shifts gear. He presents us with a long statement by the LSE lecturer, in which he argues, without interruption, for revision of Marxist theory. The advanced industrial proletariat has merged its interests, he states, with those of the bourgeois state. The centre of the revolution has moved to the Third World. All disaffected western groups, blacks, students, can do is demon-strate their support for the revolutions elsewhere.

At the end of the lecture, there's an interlude from politics, during which Sloman accuses Ford of not feeling it where it hurts. Dramatically, Sloman breaks a window and wanders into the garden. There follows a long answer to Ford by Tagg, who begins, surprisingly, by agreeing with the call for personal involvement by Sloman, whom he has just accused of being a 'salon drunk'. Tagg argues that if the European proletariat has lost its revolutionary energy, this is because the energy has been deliberately suppressed by the Communist Party acting in the interests of Stalin – an echo of the theme of *Occupations*. The Third World won't win without a revolu-tionary proletariat. Tagg's message is 'Build the revolutionary party'.

As in *Occupations*, Griffiths has presented both these argu-ments with equal seriousness and equal conviction. He leaves

us to argue them out for ourselves. But after the interval, he produces yet another twist.

The statements of the first act have taken place against the background of the events in Paris. Now we see the revolutionary Tagg talking to his contingent on the Left Bank, by phone. He reveals that, in this apparently revolutionary situation, his revolutionary party is not fighting. What is more, he argues that this is correct: the workers, if they join in, will be led and betrayed again by the communists, and the cause of revolution will have been set back. Again, we have to accept the logic of the argument. But Tagg now exists as an image of a man who has given his life to building the revolution, who wishes, as he dies of cancer, to take root in other people, and whose logic has led him into isolation from a revolutionary happening.

After he's gone, Griffiths largely gives the stage to Sloman. Played strongly by Jack Shepherd in David Hare's clean and simple Mobile production, Sloman emerges from caricature. He argues that the revolution will come, not from 'a tiny Bolshevik party in south London', or 'the authentic voice of Trotsky', but because the 'germ' is still there, inside people like his father, 'a model worker, chapel every Sunday', who, on the day he was given a fortnight's notice, said, 'I could kill the bastards'.

And this argument, too, is convincing; only it comes from a man whom we've seen to be virtually incapable of writing any longer a processed play for a Marxist producer, who is completely impotent to change the situation in which he himself works.

Joe's impotence had been a central image of the original production at the National, having almost the symbolic dead weight of the dying Countess in *Occupations*. The play had opened and closed with scenes showing his incapability of making it with his second wife. In the Mobile production, there's a significant change. The wife has disappeared, and the play opens and closes with scenes with Joe's brother which relate directly back to *Sam Sam*. As in *Sam Sam*, one brother is successful, the other brother remains a worker. This time, the brother Eddie is up for a job. But in the

opening scene, it's revealed that he's asking Joe to lend him
£300 to set up his own business. The money's no problem:
but Joe can't bear the thought of setting up his own brother
to become a capitalist and exploit other people. 'So why the
unease now?' asks Sloman. 'If it's that clear cut, say no and
have done with it.' By the end of the play it's become obvious
that it's not 'that clear cut'. The new version ends with Joe
giving Eddie the money – taking a positive action in a lived
experience, even though the action collides with his political
ideas.

It would be possible to interpret *The Party* as an entertain-
ing, if malicious, in-joke about recognizable SW pinkos. It
would also be possible to see it as a lament for the impotence
of armchair revolutionaries in a non-revolutionary situation.
But to offer these interpretations seems to me to ignore the
strength and force of the arguments at the centre of the
play, and the way these relate to experience. Griffiths has
put together a jigsaw of contradictory bits and pieces, all of
which seem to have some validity in their own right. And
he has done so, I believe, not in order to allow us to wallow
in our own impotence, but to stimulate us into trying to over-
come the contradictions, like Gramsci, by an effort of mind.

In the end, confrontation plays an important part in all
Griffiths's work. He confronts the 'bourgeois' audience with
a need for revolution; confronts the revolutionaries with the
implications of their own contradictions; and confronts him-
self with honest, self-critical questions about his own effective-
ness. But what makes the confrontations interesting is the
quality of mind and respect for ideas that Griffiths brings to
his work. And an increasing technical range which lets him
present those ideas in an entertaining and varied dramatic
form. [1975]

Crime wave

Andrew Weiner

1973 was American TV's Year of the Cop. The networks moved from an extraordinary infatuation with law enforcement, all the way through into total obsession. Thirteen out of twenty-four new shows introduced in the 1973 television season were crime shows of one variety or another. And at the very peak of the boom there were twenty-nine different cop shows, making up more than one-third of all prime-time programming.

This year the boom has tapered off a little. American programmers seem more interested in situation comedies and nostalgic nuclear families. Even so, it is still nearly impossible to switch on a set anywhere in North America without being confronted with some kind of cop show. And the crest of this astonishing crime wave is even now spilling over into English television schedules.

American television programming has always moved in discernible cycles. One year it's doctors, the next it's lawyers, or spies, or quiz shows. And while it may not be easy to see how a particular cycle gets started, it's easy enough to see how it continues. Imitation is the name of the game. *Dr Kildare* meets *Ben Casey*. *Kojak* breeds *Kolchak* and *Kodiak*; and these days, even the names are nearly the same, for the benefit of careless or near-sighted readers of the TV guide.

This frantic unoriginality derives from the primary law of American programming: the law of numbers. All three networks strive to deliver the largest possible audience to their advertisers, and so wring out the maximum possible revenue from the prescribed air-time. If one cop show is pulling the crowds, another will quite likely do the same. And still another, piling one on top of the next until the audience screams for mercy, or signals its displeasure by exhibiting a

new preference – perhaps for those nostalgic nuclear families, instead. It is not quite this simple, however. Secondary laws of scientific marketing may enter the picture. The atrocious *Beverley Hillbillies* was still high in the ratings when the advertisers pulled the plug. The problem here was not the size but the composition of the audience: primarily geriatric, low in income and consumption needs. The cop shows have performed miraculously in both quality and quantity. They have attracted the most desirable demographics of all, the young adult audience with high income and high consumption needs. A minute of prime-time advertising on the averagely successful cop show sells for around $60,000.

Why, though, would people want to watch so many cop shows? And why did they watch them in preference to, and eventually to the exclusion of, the other stock action-adventure genres, the spy shows and westerns? Spy shows have disappeared completely now and westerns are down to an all-time low of one (*Gunsmoke*) from a peak of nearly thirty in the days of Kennedy's New Frontier. Cop shows started to overtake the rest of the action-adventure field around 1968, also the year of Richard Nixon's accession. And the cop boom, like Nixon's victory, owed more than a little to the average American citizen's increasing preoccupation with law and order. There was chaos in the streets: demonstrations, race riots, looting, mugging, murder. And there was chaos across the face of the earth.

There were cop shows before 1968, of course; but they were much fewer and farther between. The cop had never been a really major figure in modern American mythology. Gangsters, yes, and private eyes, but not cops. In the private-eye and crusading-lawyer series of the early sixties, cops were consistently shown up as stupid, incompetent, even actively corrupt. After 1968, it seemed that American television audiences didn't want to think of cops as stupid or incompetent or corrupt. They didn't fear the cops. They feared, instead, that the cops might be losing their grip, that the situation might be getting out of control; the crime situation, and the world situation, and their own personal situations, but crime first of all. And so the ratings came to be dominated by shows like

Hawaii-Five O, with its relentless and very reassuring emphasis on the implacable power of scientific police procedure. Or on a more complex level, a show like *Kojak*, with its cynical yet idealistic hero, facing the absolute chaos of New York and somehow rolling it back just a little, holding that line between them and us, between the people with some property and the people with no property; that steadily eroding line.

A simultaneous cop boom took place in the American cinema: *The French Connection, Dirty Harry, The New Centurions, Serpico.* Fascist cops and liberal cops and Angst-ridden cops; all kinds of cops. Yet the most successful and significant movie of this whole period – the Nixon law-and-order period – turned out to be a movie about gangsters, *The Godfather*.

The contradiction is more apparent than real. Like all the cop movies of this period, *The Godfather* must be viewed as a power fantasy, peddling an idealized line in masculine power to a dispossessed and emasculated audience. But from all the cop movies, *The Godfather* stands out as the ultimate power fantasy, a speculation on the possibilities of human omnipotence. The movie did have other attractions. It gloried in the continuity and strength of an extended family for a nation rapidly shrinking past the nuclear unit to the one-parent consumption model, a nation baffled and frightened by all kinds of far-reaching disruptions in traditional sex roles and patterns of sexual behaviour. And it played to favourite old emotions like pride and loyalty and revenge, the kind of noble and uplifting emotions that make a man feel important and strong as he dreams about shooting to kill. Finally, though, *The Godfather* was about power. Lyndon Johnson couldn't deal with that mob across the ocean, but Al Pacino certainly could wipe out the mob across town. And Americans yearned to identify with that kind of power.

None of this is without precedent. The western has always provided Americans with idealized fantasies of masculinity and strength and domination. This even in periods of domestic tranquillity and civic order. But in recent years, as the chaos in the world outside has seemed to escalate, the venue for such fantasies has changed, and has moved into present time

and an urban context. The overtones of paranoia have become that much more strident.

The meeting point between the genres of the western and the cop movie is nowhere more clear than in such straightforward urban westerns as *Dirty Harry*, with the cowboy star, Clint Eastwood, masquerading as a cop, and the more recent *Death Wish*. American movie critics have been very distressed about *Death Wish*, in which Charles Bronson, another ex-cowboy, systematically tracks down and exterminates nearly every mugger in New York, to the enthusiastic cheering of the audience.

With material like this, it's usual to reach for analogies between violence and sex, the gun and the phallus. But the audience for movies like *Death Wish* aren't immediately concerned with questions about their own potency. They genuinely want to see all those muggers and hijackers and psychopaths and obvious human trash, get exactly what they have coming to them. The threat here isn't just sexual. It's physical, it's social, it's economic, it's absolutely total. Gunplay is the total solution. Identify the enemies, the people making your life a misery (because somebody is doing just that), and then wipe them out. Wipe out all the muggers and outlaws who make you scared just to walk down the streets. Just don't let them bother us any more.

Still, on a not much deeper level, sex does enter into it. There is a deep confusion about male sex roles in American society right now; a confusion in its own way nearly as worrying as inflation or crime in the streets, even if the average citizen wouldn't necessarily articulate it to the man from Gallup. There's a great deal of barely hidden doubt and anxiety and paranoia that consistently shows up in the TV cop shows in the most peculiar ways. In their relentless search for new angles and new situations, the networks have been turning up some very curious new images of American manhood. There was, for example, a flush of handicapped cops: the gross, food-obsessed Cannon, the blind and utterly defenceless Longstreet, the brooding paraplegic Ironside.

Ironside, in particular, provides almost an embarrassment of symbolic riches. The man in the wheelchair is at once the

most powerless and most powerful man on television. Cannon may be too fat to run properly, but he can still shoot straight, and he does, with monotonous regularity. Ironside is completely unable to defend himself, let alone assert his identity through the usual kind of ritualized violence. Instead, he commands the unquestioned obedience of his team of stooges, his *legmen*, creatures of inferior intelligence and moral substance. As power fantasy, the show runs very deep. It appeals, on the one hand, to ancestral American memories of the saintly, blessed FDR. And, on the other, it approaches theological import. Ironside is massive, ponderous, sexless, a creature of pure mind, absolutely omnipotent. His handicap is not a weakness but a strength, for he has transcended the flesh. What, then, is Ironside if he is not a WASP vision of divinity?

Columbo, probably the most consistently entertaining of all the cop shows, is similarly far removed from traditional male power fantasies. Columbo never uses violence. He is small, unprepossessing. All the show's excitement derives from his processes of deduction and methods of entrapment. Characterization in most cop shows is utterly perfunctory, but Columbo is characterized up to and beyond the point of caricature, by an enormous range of trade-marks and mannerisms: the greasy coat, unlit cigar, cold coffee, dog, invisible wife, the arm-waving routine and the one-more-thing gambit. Columbo deploys this whole range of characteristics to his advantage. He uses his own apparent untidiness, dumbness, creepiness, lack of power or wealth or class, as weapons against his victim. The victim, the murderer, will always be rich or famous or powerful; will consistently underestimate and patronize Columbo; and will finally walk right into his trap.

On the surface, this is all quite familiar stuff, a little guy making good, bringing down the mighty. The show plays very cleverly on our resentment and envy. We identify with Columbo against our oppressors, just as we might identify with the snobbish *MacMillan and Wife* in their struggle against the lower elements. More interesting, though, is the way in which Columbo defeats his opponents. What he does is to

draw them into a relationship. He acts as a kind of *femme fatale*, playing on their very worst instincts, their vanity and cruelty and arrogance, using their faults to ensure their defeat. He starts out as the adulatory fan of the famous photographer or singer or politician. He flatters them by asking their help in solving little details of the crime. Then, with this relationship established, he proceeds to abuse it, to nag and badger them towards their final submission. Metaphorically, Columbo is most like a spider, spinning out a web of his victim's lies and finally strangling him in it. The image of the spider is traditionally female. Columbo is a male hero using female game-plans. And it's not accidental that the show should have achieved a great deal of popularity with women as well as men.

The traditional male stereotypes still show up. *Kojak* is very straightforwardly masculine – if also ethnically chic, impeccably hip and politically liberal. But even *Kojak* falls far short of total wish-fulfilment. The show really does hint at the reality of the streets, and swarming confusion and desperation and brutality and terror of police work. Cops are not seen as perfect. But they try, most of them, they really try. Which is as much as you could really ask these days.

So much for the cops. What has happened to the traditional private eye? If the cop represents power, and then order, the private eye has traditionally been concerned with *justice*. The private eye of literature and old movies and even old television shows was a solitary man, waging a lonely crusade for justice, a quality often overlooked by the cops in their service of order and power. Today's private eyes have, on the whole, failed miserably in their attempts to carry that flame. *Mannix*, *Cannon*, *Barnaby Jones* – they all work hand in hand with the police; they never step one inch outside the law. Their aims and methods hardly ever conflict with those of the established order. They act alone, but they might just as well act alone from the station house.

The one, marginal, exception is *Harry-O*, a show made in almost slavish imitation of the great private-eye movies of the 1940s, very selfconsciously in the tradition of Chandler and Hammett and Ross Macdonald. Harry-O lives, literally, on

the edge of town, by the ocean. He owns a boat called The Answer, hates the city, dislikes guns, and usually travels by bus. He is much given to philosophical voice-overs in the style of Chandler's Philip Marlowe, though the content is often dubious, if not meaningless. The cinematography is a grab-bag of private-eye movie clichés: bizarre angles, pools of darkness, mists of confusion. *Harry-O* has great pretentions which it only rarely fulfils. But David Jannsen as the private eye is consistently good, and sometimes the script will mesh with the elaborate camerawork and briefly live up to the myth of the private eye, the last American hero – the man who sees things too clearly, sees all the way through the corruptions of money and power and sex. The show isn't great by any means. But even at its worst, it is miles ahead of the other private-eye vehicles. And it is a lot better than we have any right to expect.

The cop cycle is in slow decline now. Inflation has replaced crime as the average American's No. 1 concern. The new inflation programming is heavy on quiz shows, warm-hearted impoverished families, and socially relevant situation comedy. And for those anticipating world depression and the collapse of society as we know it, there's a definite spate of survival shows, with cavemen and apemen battling the elements.

Meanwhile the cops, in somewhat reduced numbers, struggle on, beating off the twin threats of chaos in the streets and mid-season cancellation. The network programmers nervously shuffle their cards, but police recruitment continues to soar. Americans have gained a new and unlikely hero. And it looks as if he'll be around for some time to come. [1974]

Shadows of reality

Albert Hunt

Once I worked for a couple of years as a clerk in a British Road Services office. I wasn't in one of the depots, but at a place called 'group', so I never saw any wagons, and the only time I met the drivers was when they came to fill in accident-report forms. 'I was driving down a narrow street when a building leaned over and hit the top of my load,' one of them wrote.

After I'd been there for about a year, the Tories won an election and started to de-nationalize. Everybody was busy fighting over the pickings. Our most efficient depot superintendent bought a fleet of wagons, in his son's name, and ran them in competition with himself. Nobody complained, because he was still making 40 per cent profit every month for the depot by breaking all the rules in the business.

The girls in group office had permission to leave at quarter past five, to avoid the rush hour. When I started there, the group manager used to come out of his inner office at five past five, scowl round at the empty desks, then put up stern notices that nobody ever read. Then I taught him to play pushpenny – a game of table football using two pennies and a sixpence. One of the invoice typists kept the top of her desk highly polished, and so it was the best playing surface in the office. After I taught him this game, the manager used to come out of his office at five to five every night and mutter, 'Haven't those bloody girls gone yet?' Sometimes, for a change, we played shooting-in with a matchbox in the lavatory.

You can't imagine anybody in *The Brothers* – the BBC's current television series about road transport – doing anything as entertaining as playing pushpenny in the office. Edward Hammond, the chairman of the board, will, in a twitchy moment – and there are many of them – get out the office whisky. His unmarried brother, David, will go in for an

occasional evening's joyless lechery, in the interests of the business. Otherwise, the heights of frivolity are reached only in those business lunches – is it called the Swan? – where what gets probed is the other fellow's bank account. In this series, wives and mistresses are strictly for the leaving.

The Brothers belongs in that area of twentieth-century popular drama which has descended from nineteenth-century naturalism. The naturalists believed that life was what you saw. The appearance, as observed objectively by the artist, was the reality. So the aim of art was to reproduce a faithful representation of real life. In terms of theatre, this meant the creation of a total illusion. What happened on the stage had, above all, to be convincing. And this, in turn, meant that all characters and events had to be plausible. (When Zola, the arch-naturalist, had two characters who'd been trapped and starving in a coalmine for days suddenly make love, his novel momentarily collapsed into absurdity.) The trouble is that real life isn't plausible. It's not plausible for a responsible group manager to play pushpenny on an invoice typist's desk with a grade-four clerical assistant. He should be in his office, twitching over a bottle of whisky, or ringing up to explain to his mistress why he's going to have to give her up.

Faced with a contradiction between 'reality' and 'plausibility', the answer of naturalism is to leave out of the objective picture of real life any details that are implausible, that might threaten to make the picture less 'convincing'. And so there's a tendency in this kind of art for experience to be narrowed down to what artists and audience alike will accept as normal. Certain patterns of behaviour are more convincing than others, and so all life has to be forced into these patterns. What began as an attempt at objective observation ends with the creation of a new set of conventions – and the twentieth-century soap opera is born.

The hall-mark of soap opera is that it's completely conventional, but uses every artistic device to convince the audience that it's real. So, in *The Brothers*, the basic set-up is as tight and artificial as that in any classic tragedy. Father has died and has left his road haulage firm to his three sons, whom he has named as directors. Edward is in the chair, with

a casting vote. But there's a fourth director, a woman, Jennifer Kingsley, who used to be father's mistress, and who is, in fact, the mother of the father's illegitimate daughter. She has a liaison of sorts with Edward, which gives the two of them a permanent majority. But this means that if ever she quarrels with Edward, the firm's policy is in doubt. Such quarrels are constantly stirred up by the brothers' jealous mother – with the result that the haulage business is always inextricably tangled up with the private emotions of those involved.

The strength of the plot lies in its artificiality. Endless changes can be rung around this basic situation – which is complicated by the strained marital relationship of the third brother, Brian, which often distracts him from business matters. But whereas in a classical tragedy the artificiality of the situation is heightened by the artificiality of the style, in soap opera every attempt is made to disguise this artificiality, to make the audience say, 'That's just what running a transport business must be like.'

This appeal to recognition is important in soap opera. Yes, we say to ourselves, that's exactly how we'd expect such a family to behave. *The Archers* offers city dwellers a picture of the way they, the townsmen, expect country people to behave. What's more, these fictionalized characters behave in the way country people imagine *themselves* to behave. And the same applies to *Coronation Street*. 'That's exactly what it must be like,' says the green-belt suburbanite. 'That's what it *used* to be like,' says the viewer in the new Manchester high-rise flats. And the dwindling numbers of people who still live in *Coronation Street* see themselves as quaint and interesting – rough, but with hearts of gold.

What is remarkable about *The Brothers* is the extent to which, like *The Archers*, it gets tangled with real events. Every parody of *The Archers* over several decades has included the bit where the characters suddenly stop behaving like characters and start giving hints on modern farming or on the function of the Women's Institute. Reminders of a different kind of reality are slipped in. Chunks of popular education are fed into the daily gossip.

This different kind of reality also breaks into *The Brothers*,

but in rather a more sophisticated form. For if the personal relationships are artificial, there are constant reminders of the 'real world' outside when it comes to the actual management of the business. There was, for example, an episode in last year's series when the brothers were caught up in a dock strike. One of their lorries was trapped by the pickets in Liverpool docks. Both Edward and his foreman sympathize with the strike – but the firm is economically in a very precarious position. Unless they can get the lorry out, the firm might be forced to lay off some of its drivers. Edward and his foreman themselves drive through the picket line. (They feel badly about it, but recognize it as something that has to be done.)

The current series is about merging with an Australian called Carter. Carter is buying some land next to the Hammonds' business. They need the land, but the only way they can get hold of it now is to take Carter over. This means giving Carter a seat on the board – with a resulting shift in the balance of power, and a new stirring up of the family intrigues. But as well as the personal problems, there's a wider social obstacle. When all the agreements to merge have been made, it turns out that Carter's drivers aren't union men. The Hammonds are suddenly faced with a labour crisis which relates to *real* labour crises the audience is familiar with as 'reality' – reality, that is, as shown on the newsreels and documentaries. The world of documentary begins to impinge on the soap-opera screen.

Except that, in the 'real world', the events shown are outside the viewers' control. That picture of the picket line in the early-evening news may mean that later the lights will go out and there'll be no picture at all. Whereas in *The Brothers*, the sense of plausibility leads also to a sense that life isn't really anarchic, that human behaviour is reasonably predictable, and that, therefore, the lights won't go out. There may be tears and heartaches, but everything will work out somehow in the end. The world *The Brothers* presents is real enough to be recognizable. But not quite real enough to be disturbing. [1973]

What Joe Orton saw

Albert Hunt

During a CND demonstration in the early 1960s – about the time that one London bobby was putting bricks into the overcoat pockets of arrested pacifists in order to be able to charge them with violent behaviour – the police picked out and arrested a leading member of the Committee of 100. When he was brought to court, the policeman went through the usual mumbo jumbo about 'I cautioned him and warned him that anything he said . . .' But the prisoner objected that this was not a strictly accurate account of what had happened. What, then, asked the presiding magistrate, had the constable said in making the arrest? 'He said,' replied the prisoner, ' "You're fucking nicked, my old beauty." '

The phrase is quoted by Joe Orton at the climax of his play, *Loot*. Truscott, the detective who has just accepted a bribe to overlook the activities of two bank robbers and a mass murderer, uses the words in arresting the only comparatively innocent person in the play. In 1966, when the play was first produced, the Lord Chamberlain instructed, 'For "fucking" substitute "bleeding".' In the season of Orton plays starting tonight at the Royal Court, the phrase will be restored in its original accuracy.

That Orton should use a documentary quotation at the climax of a rock whodunnit is entirely typical of his way of working. Ronald Bryden has described Orton as 'the Oscar Wilde of Welfare State gentility'; and it's true that there's an echo of Wilde in his epigrammatic turns of phrase: 'My mate Dennis done you. He speaks of it with relish'; 'Young men pepper their conversation with tales of rape. It creates a good impression.' But Orton himself prefaces *Loot* with a quotation, not from Wilde but from Shaw: 'Anarchism is a game at which the police can beat you.' In his most original plays, it's early Shaw he resembles, in method and in attitude.

Shaw, in his early plays, took the popular theatre forms of his day and used them to present what he once described as his own entirely 'normal' vision of social reality. His optician had told him that he had perfectly 'normal' eyesight, a faculty he shared, according to the optician, with only 10 per cent of the population. So, said Shaw, he wrote down what he saw, and everybody praised him for being witty and paradoxical. When in *Arms and the Man* he quoted directly from contemporary military memoirs, the critics spoke of his powers of invention and of his imagination.

In the same way, Orton takes two of the most popular forms of contemporary commercial theatre – the whodunnit and the bedroom farce – and uses them to present *his* view of *our* social reality. From a conventional viewpoint, the visions of both Shaw and Orton are extremely anarchic – which is why, perhaps, since the night in August 1967 when Orton had his brains beaten out by a man he'd lived with, to whom he'd dedicated his first play, and who committed suicide immediately after the murder, some critics have tried to bring him back inside conventional boundaries. John Russell Taylor, for example, in his book, *The Second Wave*, praises Orton's first play, *Entertaining Mr Sloane*, for 'the degree of human believability accorded to the characters' and approves of his conventional TV play, *The Good and Faithful Servant*. But he writes of *Loot* that it is 'a little arid, a play about plays and play conventions rather than a play which is, however remotely, about (if you will pardon the word) life'. He adds that *Loot* lacks a dimension because it fails 'to relate the words and actions of its characters to some recognizable external reality'.

In fact, like *Entertaining Mr Sloane*, which wades into the idea of the family, *Loot* and *What the Butler Saw* are about the criminal lunacy of social institutions that are generally accepted as reasonable and beneficial. *Loot*'s targets are the Church and the law; in *What the Butler Saw*, authority itself in the shape of two psychiatrists.

The nurse, Fay, in *Loot* has murdered seven husbands and the wife of her present employer. But like the manservant in Buñuel's *Diary of a Chambermaid* (who rapes and murders a

child but has great respect for the Church, for the French army and for the police chief who censored one of Buñuel's earlier films), Fay is a devout Catholic. She puts a text of the Ten Commandments on her latest victim's coffin; objects that the large wreath which decorates the motor has been sent by the landlord of the King of Denmark – 'I don't think a publican's tribute should be given pride of place'; and when she gets 'knocked off' by Dennis, the undertaker, it's beneath a picture of the Sacred Heart. (The Lord Chamberlain ordered this to be changed to the Infant Samuel.) After she has confessed ('Mrs McLeavy was dying. Had euthanasia not been against my religion I would have practised it. Instead I decided to murder her'), Truscott handcuffs Fay McMahon and comments, 'Nothing but a miracle can save her now.' So Dennis informs him that the casket containing the vital evidence, Mrs McLeavy's stomach, has been forced open in a violent explosion and 'the contents dispersed'. 'What an amazing woman McMahon is . . . She must have influence with Heaven,' exclaims Truscott. 'God is a gentleman,' says Hal, Dennis's mate. 'He prefers blondes.'

Orton's other target, the law, is represented in *Loot* by Truscott himself. Truscott introduces himself as being 'attached to the Metropolitan Water Board' – to Orton one social institution is as absurd as another – and demands to inspect the mains supply. Later, he presents himself as 'Truscott of the Yard. The man who tracked down the limbless-girl killer.' He has a completely rational explanation for his behaviour. 'The process by which the police arrive at the solution to a mystery is, in itself, a mystery. We've reason to believe that a number of crimes have been committed under your roof. There was no legal excuse for a warrant. We had no proof. However, the water board doesn't need a warrant to enter private houses . . . It's for your own good that Authority behaves in this seemingly alarming way.' Throughout, Truscott acts like a parody of a stage detective. 'When I shook your hand, I felt a roughness on one of your wedding rings. A roughness I associate with powder burns and salt. The two together spell gun and sea air. When found on a wedding ring, only one solution is possible.'

A.S. H

But when he's unmasked the criminals at the end, instead of handing them over to justice he accepts a bribe and arrests the innocent McLeary instead. And when McLeary threatens to 'denounce the lot of you', Truscott begs him, 'Now, then, sir, be reasonable. What has just taken place is perfectly scandalous and had better go no further than these three walls. It's not expedient for the general public to have its confidence in the police force undermined. You'd be doing the community a grave disservice by revealing the full frightening facts of this case.' Orton has used a familiar set of theatre conventions – the murder, the body, the clues by which an infallible detective brings a criminal to justice – gleefully to demolish the social and moral conventions on which the play conventions are based.

In *Loot*, as in his radio play, *The Ruffian on the Stair*, Orton uses the conventions of the whodunnit. In *What the Butler Saw* (which was only produced after his death, and which would, presumably, have been revised and tightened had he lived), he uses the conventions of the bedroom farce. He uses them not simply to destroy the sexual stability on which the mechanics of bedroom farce depend (if there's no outraged wife, then there's no reason to hide the girl in the bathroom and hide her dress under your pyjamas), but also to question the basic sanity of organized society.

The plot depends on the joke about the man who persuades a girl to take her clothes off, but is interrupted by the arrival of his wife at the crucial moment. The man – a psychiatrist called Dr Prentice – hides the girl, his secretary, behind a screen. It's accepted by the audience that the worst thing that can happen is for her to be discovered. From this starting point, as in ordinary farce, more and more complexities arise. The girl rushes out, to be replaced by a boy, who is ordered to dress as a girl. The man is caught constantly by his wife trying to hide bits of female clothing. All the trappings of farce – the running in and out of doors, the disguises, the mistaken identities, the coincidences – are there. But what's entirely absent is the shared moral code which makes the conventional farcical machinery work.

The wife who interrupts the opening seduction is no respect-

able pillar of the marriage institution. We've already been told that she's a nymphomaniac. We quickly learn, too, that after expelling from a lesbian meeting a woman who's fallen in love with a man, she's just spent the night at the Station Hotel failing to be raped in a linen cupboard by a pageboy who has taken her dress and some dirty photographs of her and is wanted by the police for seducing a whole dormitory of schoolgirls. In this sea of moral confusion, Orton unblinkingly maintains the convention that the one fact this woman must never, never discover is that there's a naked girl behind the screen.

Russell Taylor rebukes Orton for a failure of logic. Why should a woman so sexually 'sophisticated', he asks, worry about the peccadillo behind a screen? Why should Prentice be so determined to keep the story from his superior, Dr Rance, when Rance himself assumes that a secretary is there to be slept with? But this dislocation between what society accepts and what it pretends to reject – and the absurd posturing that springs from the dislocation – is precisely one of Orton's main points. And if there's no conventional logic, there's another mad, frightening logic that takes over as the play develops.

When Rance decides that the naked girl on the couch is a patient who has been trying to seduce Dr Prentice, then everything she does and says is re-interpreted in terms of the pop psychiatry bestseller Rance is writing in his mind:

'Who was the first man in your life?'

'My father.'

'Did he assault you?'

'No.'

'She may mean "Yes" when she says "No". It's elementary feminine psychology. Was your stepmother aware of your love for your father?'

'I lived in a normal family. I had no love for my father.' . . .

'Did your father have any religious beliefs?'

'I'm sure he did.'

'Yet she claims to have lived in a normal family . . . Was there a church service before you were assaulted? . . . Were you molested by your father?'

'No, no, no!'

'The vehemence of her denials is proof positive of her guilt. It's a textbook case.'

Later, when Mrs Prentice suggests to Rance that her husband is insane, Rance re-interprets all Prentice's actions (which we know to be connected with hiding the girl) as evidence of lunacy:

'I've just seen my husband carrying a woman into the shrubbery.' . . .

'Then a new and frightening possibility suggests itself. The drugs in this box may not have been used for suicide but for murder. Your husband has made away with his secretary.'

'Isn't that a little melodramatic?'

'Lunatics *are* melodramatic. The subtleties of drama are wasted on them.'

As in Truscott's gag about 'these three walls', Orton is openly joking about the conventions he's handling in order to use those conventions against the representative of authority in his play. At the climax, Mrs Prentice rushes in, her hands smeared with tomato juice. 'Is this blood real?' she cries. 'No,' says Dr Rance. 'Can you see it?' 'Yes.' 'Then what explanation is there?' 'I'm a scientist, I state facts. I cannot be expected to provide explanations. Reject any paranormal phenomena. It's the only way to remain sane.'

Orton has deliberately used a comic gag to demolish a whole way of looking at 'recognizable reality'. It's a way of looking that is normally accepted as the only rational way: 'I'm a scientist. I state facts . . .' But the scientists in *What the Butler Saw* can't even agree on the facts they state – or on the meaning of the word 'sanity'. 'I'm going to certify you,' cries Prentice to Rance, waving a gun. 'No, I'm going to certify you,' Rance replies. 'I have the weapon,' says Prentice: 'You have the choice . . . Either madness or death.'

Far from creating a world which is not recognizably real, it seems to me that Orton has, in these two plays especially, offered us an entirely recognizable picture of our social situation. The problem is that we've become so familiar with institutions and processes that are basically mad that we accept them as reasonable. It takes a man with 'normal' vision

to find a way of making us look at the absurdities and move towards demolishing them, through laughter.

From the point of view of naturalist theatre conventions, Orton's characters may lack 'human believability'. But then, so does John Stonehouse. And Henry Kissinger. [1975]

Give me laughter

Albert Hunt

By a strange irony, the current series of Morecambe and Wise shows put out on BBC-2 conflicts with the Wednesday Play on BBC-1. There, on the popular channel, is the corporation's weekly homage to the live theatre; and there, for the eggheads on BBC-2, is Eric Morecambe making up poems with words that rhyme with knickers. It somehow seems to be a surprising reversal of roles.

The irony has been even more marked in the last few weeks by the fact that the Wednesday Play has consisted of a trilogy by Alan Plater. Plater is a northern writer, rooted in Hull. He draws on popular traditions in his work for the theatre— on song, dance, even on football.

I've only seen the middle play of the Plater trilogy (Morecambe and Wise are on every other week). It was about a PRO man called Donkin, who was trying to promote sales of cardboard boxes. He looks and talks like a rake, but fails with all the women he meets, and ends by admitting that what he'd like to do is take a girl for a walk in the rain (he fails, of course – her muscular boy-friend turns up). It could have made a good ten-minute sketch, but it lasted an hour and a quarter, and one felt that in spite of the surface comedy, Plater was reaching towards a self-conscious seriousness: we were, in fact, gradually supposed to be confronted with the total emptiness of this man's life.

This mixture of solemnity and smallness seems to me to be typical of TV drama. The companies are conscious of their

duty to drama, but they have a narrow idea of what drama is. It's nothing, for example, as crude as *The Untouchables*, that raucous, fast-moving American crime series that holds, simply through its pace and its action. And it's nothing as coldly calculating as *The Power Game*, which assumed that political manœuvring could be interesting in itself. It's concerned, in general, with mood and with psychology, and above all with being believable. So, in *Till Death Us Do Part*, Alf Garnett can explore the wilder reaches of primitive fantasy; and in his comedy series, Marty Feldman can be expected to explode into total anarchy. But put them together in a 'play', as happened last year, and the result is a pedestrian meeting between two closely studied but harmless eccentrics.

Television drama is, in general, married to the central tradition of bourgeois theatre over the past 150 years. During that time, the stage itself has been narrowed down until the overriding aim became the representation of what was conceived of as 'real life'. It's a tradition that is breaking up, though very slowly, in the theatre – but in TV drama it's been intensified. For in this kind of naturalist theatre, the actor's face is often assumed to carry complexities of thought and feeling that can't be expressed by the deliberately everyday language. And on television, the actor's face can itself be emphasized in close-up. And so 'serious' television drama has tended to concentrate more and more on these inner feelings, as if this were the stuff of theatre itself.

Morecambe and Wise also use close-up. Wise asks Morecambe a question. He shakes his head – there's the sound of loose screws rattling. Wise thereupon repeats the question. Morecambe shakes his head again – same rattle. The camera pulls back to reveal that Morecambe holds in his hand a pair of maracas. ('Maracas! Please. No words like that in front of ladies.') Again, Morecambe is playing the part of Robert Browning. He recites a poem:

> I sit beside you in the room,
> The firelight glows and flickers . . .

Then he pauses, and looks straight into the camera. The camera scrutinizes the impassive face, with the balding head and the huge, owl-like spectacles.

It's worlds away from the psychological intimacies of the 'serious' TV play – but it's very close to a different kind of theatre altogether. And in fact the trappings of a Morecambe and Wise show are deliberately theatrical: they play in front of a curtain, perform 'dramas' that are supposedly written by Ernie Wise, and take a call at the end, in which a huge woman who appears nowhere else in the show accepts the applause and is given a bouquet.

These theatrical trappings may simply have grown out of the fact that Morecambe and Wise have played music hall. But in the television shows they're used as a basic element to be exploited.

So, Wise stands in front of the curtains, waiting to announce a turn. Morecambe appears. Behind that curtain, he tells Wise, he has a great new ventriloquist act which he's waiting to show. Wise agrees and Morecambe disappears. There's a fluttering behind the curtain, and suddenly a huge leg appears, about six feet high. Then another. Then Morecambe staggers out, struggling with an enormous version of Archie Andrews. He sways backwards and forwards. 'Here, hold it a minute,' he says to Wise, and Wise nearly falls beneath the weight. 'Solid oak,' Morecambe explains. 'You know that clearing in Epping Forest? This is him.' Wise wants to know how Morecambe makes it work. 'You mean how do I reach his thing?' Morecambe asks. He can't. Wise suggests steps, and he then places them for Morecambe. Morecambe climbs up the steps, works the mouth and says something through his teeth. 'What did you say?' asks Wise. 'I couldn't hear you.' 'What's that?' asks Morecambe. 'I can't hear you up here.' He comes down to listen to Wise, but the dummy falls on Wise, knocking him flat on the floor. The scene ends with Wise struggling underneath the dummy.

Here Morecambe and Wise are starting from a simple music-hall convention – a ventriloquist's act. But they've taken the convention, twisted it round and juggled with it until it's something wild and absurd.

At a later spot in the programme – in the part where, with the help of a guest star, they act out one of Wise's plays – they treat the conventions of drama in a similar way. So, in

their version of *The Barretts of Wimpole Street*, we're given all the surface trappings of the drama – the naturalistic Victorian set, and the cliché acting – but Morecambe demolishes it from the inside. He's only playing the part anyway, it's explained, because they couldn't get Rock Hudson. He hides from Elizabeth's father by throwing himself on a tiger rug and pretending to be a tiger – but looks up to make a personal crack to Wise in the middle of the scene. He is thrown out of the room. 'If only he were a vicar,' says Elizabeth Barrett's father – and Morecambe instantly reappears with his collar the wrong way round. He's thrown out again. 'If only he were a painter' – and he appears with boots on his knees as Toulouse-Lautrec. All the time, Wise fusses round worrying about the script and the acting and apologizing to the guest star.

In another 'play', Wise is determined to play Nelson. And Fenella Fielding is Lady Hamilton – she explains that she can't resist any man who utters the words, 'Haydock Park, Oldham Athletic'. Morecambe also wants to play Nelson. For a time, there are two one-armed, one-eyed Nelsons in the scene. Morecambe is at last persuaded to play Hardy. He goes off and returns as Robert Newton in *Treasure Island*, only he keeps forgetting which leg is crippled, and uses his crutch in a dance.

In yet another drama, Wise has to play the heroine. He puts on a dress, and plays the part dead straight – except that he's always clearly Ernie Wise. The comedy springs from the incongruity – he's so seriously feminine but so obviously masculine. (Compare Danny La Rue, whose success, in spite of the masculine asides, depends primarily on how far he is a *convincing* woman.)

In all these scenes, Morecambe and Wise are demolishing, incidentally, the theatre conventions which dominate the drama on the other channel. But this demolition isn't their main aim. What they're doing in fact is simply using the conventions of theatre as a jumping-off point.

The leap takes them into a world which has its own sardonic logic. It's a world in which two monks kneel reverently in front of an altar in order to take out huge cigars which they then

light from the candles; or graciously throw crumbs to the
ducks while selecting the one they're going to kill with a big,
hard loaf; or pull out the stops on an organ to make a stained-
glass window light up like a pin-table machine. It sometimes
seems to be cosy – a repeated episode in which the two of
them relax in a flat has the surface security of *Coronation
Street*. But the sting's never far away. 'I watch the Epilogue
just in case there's a couple of good gags,' Morecambe will
remark, and then tell a story about somebody who 'should
have gone to Torquay but the driver put the wrong glasses
on'. When assured that somebody is as innocent as a new-
born babe, he comments, 'A new-born babe is an apprentice
old-age pensioner.' At the end of each programme they sing,
'Give me sunshine. And a smile. Give me laughter. All the
while . . .' but the laughter is built on a scepticism that's as
tough as it's gay. [1970]

Buildings and Towns

On a distant prospect . . .

Reyner Banham

. . . of three perfectly regular spheres in the middle of nowhere. Everyone knows vaguely that they are somewhere up in that part of Yorkshire, but no one seems quite to expect them to appear at that moment on that particular piece of road. The A169 has been climbing into true (though fenced) moorland for some miles out of Pickering, and just after it turns and plunges down at Gallows Dyke you see the huge square dishes of the forward-scatter antennae on the skyline, and the three white domes of the early-warning radar setting like paper suns behind the ridge as your viewpoint drops with the dropping road.

Your next view of Fylingdales, half a mile further along, will be more complete though still distant, but it won't have the impact of the first encounter, which is a visual happening of the first order and a textbook demonstration of the downright *unfairness* of our aesthetic responses. Unfair, because however much you may disapprove of lunatic foreign policies that make the construction of such things necessary, however much you may disapprove their construction in the teeth of National Parks legislation and local protests, I can pretty well guarantee your helplessness to do anything but approve when you see them in that setting.

Nor does the availability of at least partial explanations of their power exorcise their impact on second or third viewing. Attempts at explanation tend, rather, to explain why their effect is sustained. Simple they may be in geometrical form, but even their verbally accessible meanings are of a complexity that goes far beyond the 'absolute' beauty that Plato supposed to lie in elementary geometrical solids. For instance, our first sight of them was greeted by a scholarly query on Paul Nash in the front passenger seat, and a delighted shout of 'They've landed!' from the younger generation in the back.

Both responses check out as equally valid. For people who survived the progressive aesthetics of the thirties and were later readmitted to the human race, Paul Nash's vision of Plato's regular solids standing in for megaliths against a background of Wiltshire wilderness . . . these, almost alone of the abstract aesthetic remain real. And to see Nash's precise geometry given physical existence, even if the background is the empurpled moors, not Wiltshire, can still set ancient atavisms jangling.

The Thunderbirds-are-go response of the kids may appear more superficial, but is probably much more complicated and lavish. It does not depend on a simple contrast between the poverty of platonic aesthetics and the riches of untamed nature. It is rich in itself; in relations between objects of opposite curvature, for in this vision the concavities of the square antenna-dishes are as important as the convexities of the domes, not just as a contrast of abstract shapes, but because they express, however obtusely, the differing functions of communications and surveillance. A high monument of their world-around culture of electronic contact, but not solemn because the Ministry of Defence has unwittingly joked up the whole scene with No Entry signs headed MOD PROPERTY.

Further, and irrespective of generation, the objects themselves are visually rich, whoever the observer. This is partly due to their setting in a well-creased landscape that reveals them unexpectedly in many distant prospects across the moors, so that there is a constant element of surprise in one's perception of them, but much more due to the material of which they are made. Any old-time snob who insists that plastics are 'lifeless, soul-less' materials had better avoid Fylingdales if he treasures his illusions, for the three domes are bafflingly responsive to incident light.

They take, at all times, slight reflected colour from the sky and the heather, so that they are a cooler tint above than below; in strong sunlight they jump up in crisp modelling, lurk in grey obscurity when the clouds are zapped in solid; appear to glow with an internal radiance (maybe there were actual lights on inside) when the sun is low and the air misty.

Picture postcards by three different publishers, bought in Whitby, show the radomes as three different shades of pale. None of the shades is any more convincing than any colours on picture postcards, but the variation is entirely justified.

Also, the heather deserves a word of congratulation. It is a marvellous background for geometrical effects of any sort. Not because it is untamed nature; it isn't anything of the sort. The local shootocracy keep it under very careful control both as grouse moor and sheep ranch; it is a managed ecology if not an artificial environment, and should be regarded less as a shallow jungle than as a deep pile carpet, in whose purple fuzz the eye falls, unfocusable, away from any hard-edged forms (distance judgement can be very difficult, for instance). It's like the velvet behind the pearl, exaggerating whatever virtue is there.

At one distant viewpoint for Fylingdales, rejoicing in the name of Murk Mire Moor, there is a shooting lodge: two large rooms under a common roof, a stable sticking out the back, and an unroofed stable yard wrapped in an L-shaped wall. At its exposed end, the wall reveals that it has been built with a slight but precise batter (upward taper) that reduces its thickness by about three inches in a height of eight feet.

Now, that batter is not there for the giggle or by accident. It is a very sound usage in an un-buttressed wall, giving it an inherent stability that is probably a necessity in such an exposed location. It's an easily comprehended necessity, a self-explanatory form. But the necessity adds authority to the form; and quite often the mere knowledge of the necessity, however difficult to comprehend, can still confer that kind of authority to forms. One knows that the radomes are there for a reason; some military necessity determines their location, function and form. The function may be repugnant, their internal workings incomprehensible, but the authority persists.

No such authority subsists in most works of art that are supposed to have it, like Henry Moore sculptures. Dragged out of the art gallery or Battersea Park, and located in landscape, they dwindle. They lack the authority of necessity because they exist only at the whim (however profound) of one man

and have nothing to do beyond the gratification of that whim. Even the 'necessities' of the material have become pretty inoperative in Henry Moore's recent work. But the existence of such necessity, however ill comprehended, adds another dimension of richness to the aesthetic of Fylingdales, another grain of explanation of their durability as affective images. In the Harvardese of one of my students, they are 'resilient to repeated interrogation' – a singularly apt phrase because 'interrogate' is what you do to stray satellites – and even well-behaved ones, if they are the sort that only deliver information on demand. Fylingdales can't be caught out; however you sneak up on them, the radomes have something new to tell.

And they tell it to everybody. The most sensational piece of information about them as aesthetic objects appears five paragraphs above – the words 'picture postcards'. It has been granted to few monuments of technology to get into that league recently, or so quickly. The Post Office Tower is the only one that comes handily to mind, and that has certain obvious margins as a symbol of swinging London and something you can go inside. But Fylingdales is a purely visual experience, you can't go inside, because it's MoD property, and it doesn't symbolize anything. NATO is too remote and moribund a concept to give the equivalent of, say, Union Jack or Spitfire status. Any symbolism that Fylingdales carries is something that people have wished on it privately, perhaps even below the threshold of consciously knowing what they symbolize by it.

But the long-term consequences are pretty alarming-looking. If it has already achieved pop-postcard status at sufficiently profitable level for three different publishers to put out their own versions, then it must be in the same league as Anne Hathaway's cottage or Buckingham Palace. And you realize what that means? It means that there will be an outcry against any attempt to pull it down. From unwanted intrusion to ancient monument in four years flat! Don't ask me to form a preservation group, however. I *want* to see it fall down, because it will be our first major plastic ruin, and for that I can't wait. [1967]

Cathedrals city

Paul Barker

Why a cathedral at all? 'Well,' the priest said, 'the pennies of the poor have been collected for it for years; it is an obligation you have to honour.' Back in the thirties, for example, rock was sold to the children of Liverpool by the hundredweight, with the name of the cathedral-to-be running through the middle of it.

That, though was for a different cathedral – not Frederick Gibberd's papist spaceship (to be consecrated on Whit Sunday), but the vast Wrenaissance pile (architect, Sir Edwin Lutyens) which the archdiocese had then just commissioned. Lutyens had designed them the largest church in Christendom, after St Peter's, Rome. It was like something out of Brobdingnag. Even the wooden model of it was 17 feet high and 20 feet long. You could walk about in it, like Gulliver being carried in a box by the giant to the king, only this time (presumably) your destination was God.

It was to have the largest dome in the world (168 feet across), and be longer than Winchester cathedral (560 feet to Lutyens's 676). The entrance porch would be open day and night, warmed, lit and provided with benches for the destitute to sit on. Even at the start, in 1931, the likely cost was put at £3 million. But Lutyens, who built New Delhi for the British Raj and Central Square, Hampstead Garden Suburb, for the British intelligentsia, didn't mind spending money in a monumental cause, undisturbed by the poverty down the road.

But still, why a cathedral? There were 'utilitarian' reasons, Dr Downey, then the archbishop of Liverpool, said. 'When we celebrated the centenary of Catholic Emancipation, there were a quarter of a million people present, so you see we need a large cathedral.' And Lutyens's plan went ahead on Brownlow Hill, next to Alfred Waterhouse's redbrick university tower and on the ex-site of a Poor Law Institution. Three

hundred children collapsed on a hot Whit Monday in 1933, crowding to hear the Papal Legate call the hatching monument a 'resounding answer' to unbelief. By September 1939, the work of building this answer was down to one fourteen-year-old bricklayer's apprentice. Only three chapels of the crypt were ever finished. To walk through them is like being in a very sophisticated catacomb. Lutyens shares with that earlier follower of Wren, Nicholas Hawksmoor, the knack of combining the absurd and the deadly serious.

By 1955, the local hierarchy saw that it would cost at least £27 million (because of the swelling cost of building) and take hundreds of years to go the whole Lutyens. An attempt to cut his price, size and time span was quickly dropped (you can't build *half* of a Great Pyramid). In 1960, Frederick Gibberd won a new competition to add a wholly different crown to the crypt. It was a condition that the cost shouldn't go over £1 million. (In fact, by now, it will be £1,500,000 for the building alone, quite apart from artwork and fittings.)

So: why a cathedral? Because the idea – and a crypt – was there. Besides, a quarter of the city are Roman Catholic. They needed to match the Anglican opposition at the other end of Hope Street, where Giles Scott's pink-sandstone elephant had been building since 1904. In his design, Gibberd deliberately made the top of his tower correlate with that of Scott's cathedral, less than a mile away. The two of them together make a fine Parkinsonian sight, like the Admiralty proliferating yet more cliffs of offices just when the navy was most in decline. Even the architects seem to have got bureaucratically cross-posted somehow: Gibberd is a Protestant; Scott was a Roman Catholic.

Churches are, outdoors, what armchairs are indoors: a licit object to be sumptuous and/or artistic about (see Reyner Banham, page 170). And cathedrals – being where the bishop keeps his *cathedra* – get it both ways. For the architects who build them and for the other artists who decorate them, they have one other great attraction besides this. They are as near to a permanent site as you are likely to get. They are the very opposite of Expo 67 or the New York World's Fair or the Festival of Britain, where all that labour leaves naught

but a concert hall or a bit of urban transportation behind. The wind-tunnel tests on a model of Gibberd's cathedral simulated the next *500 years'* strain.

What, this time, is being made into permanent public art? Gibberd's cathedral shows how rooted in the English mind Gothic architecture is. As you walk up Mount Pleasant from Lime Street station, the interlaced spikes on his tower rise above the houses like a Victorian gasholder. The cathedral structure depends on sixteen flying buttresses. The whole motion is upward and aspiring, not seeking the completeness and calm of classicism. Gibberd wants the attenuated top to 'dissolve the silhouette into the northern atmosphere'.

In other ways, he pays less attention to the atmosphere. His method of tying Lutyens's crypt into the new building is to roof the crypt over with an enormous piazza, meant for outside services. During the opening celebrations, this will be cold but jolly. Brass bands are giving concerts on the piazza and may tempt people to stay on for the al fresco mass. After that, life will be dourer: the public weather forecaster outside the *Echo* building only has three positions, Rain, Unsettled and Fair; sunny doesn't come in.

The cathedral is circular inside, with the altar in the middle. No one sits more than 60 feet from the priest. (That's as Early Christian as you can get in a building this size.) Side chapels are set around the edge of the circle, all separate and cut off from each other and the roof by coloured glass: they are the only wall the cathedral has. A circle this big rather disorients you: it's like being in the middle of a circus ring or a Roman (Catholic) arena; your eye has nowhere precise to rest, and moves around looking for a focus. Gibberd originally meant the floor to curve down like a saucer: this would have made the altar more of an eye-rest than it now is. Probably the cathedral's two main virtues are that it was finished quickly (work only started in September 1962) and, for a cathedral, cheaply. Unfortunately, in a cathedral, these virtues are vices.

For a building so large and durable as this, the architect needs time and money to be able to hone down his conception as he goes along. When Lutyens, for example, wanted to check what stone would weather best, he simply left various

samples on site for a few years. And with the Anglican cathedral, Scott jettisoned almost the whole of his first design five years after the foundation stone was laid: he gave it one tower instead of two, made the outline less fiddly, and borrowed heavily from a runner-up design by the Art Nouveau architect, Charles Rennie Mackintosh. The result may be the last gasp of the Gothic revival proper, and perhaps the last stone-built cathedral ever, but it is indisputably imposing. Rather too self-consciously so, for my liking. Scott was altogether too tasteful.

This is yet more of a drawback in the interior. In many Anglican churches, the genteel 'furnishings' seem more prominent and more important than the architecture. Here, the 107 foot Gothic arches can't compete with a bronze Earl of Derby in his robes, a very polite font, emasculated symbols of Faith, Hope, Charity, and so on, and so on. The tower doesn't crown the altar (as in Gibberd's cathedral) but empty space; and somehow this is appropriate. The tower itself was paid for 'In thankfulness to Almighty God and in memory of Samuel Vestey, provision merchant of this city': not necessarily, one feels, in that order, and it's suddenly hard to be as worried as the cathedral chapter is that Liverpool's inner-ring motorway will go past the cathedral front door.

It's not a time for cathedrals. The Catholics' turn of speed hurried the Anglicans last month into announcing a pared-down version of Scott's unfinished nave. This will save £1 million and get the cathedral finished (they hope) by 1975. If we were still – in the mid-twentieth century – true cathedral builders, we wouldn't mind living with a building that seemed in almost permanent growth: that would be part of the point.

Cathedrals – like churches but more so – used to be genuine meeting points of the entire community. Now *Meeting Point* is the name of a television programme. In medieval Europe, a city was a machine for living the Christian life, and the church was its engine. The Victorian English tried to revive the church and its buildings as *rival* engines to the industrial engine that had become the real centre of their cities; and they failed.

We live in the aftermath. Christian belief is now back again

where it started: as a kind of underground. If it wants churches built in the shape of Early Christian cells, they should have the smallness and plainness of the chapel at Queen Mary College, London. Perhaps they should literally go underground again. Perhaps, in that catacomb crypt, Lutyens already has the best kind of cathedral for today's Christianity. [1967]

Industry as artwork

Angela Carter

At times, Bradford hardly seems an English city at all, since it is inhabited, in the main, by (to all appearances) extras from the Gorky trilogy, huddled in shapeless coats – the men in caps and mufflers, the women in boots and headscarves. It comes as no surprise to hear so much Polish spoken or to see so much vodka in the windows of the off-licences, next to the British sherry, brown ale and dandelion-and-burdock. Though, again, it might be a city in a time machine. Those low, steep terraces – where, at nights, gas lamps secrete a mean, lemon-coloured light which seems to intensify rather than diminish the surrounding darkness – and the skyline, intermittently punctuated by mill chimneys, create so consistent an image of a typical Victorian industrial town everything teeters on the brink of self-parody and the public statuary goes right over the edge.

Like monstrous *genii loci*, petrifications of stern industrialists pose in squares and on road islands, clasping technological devices or depicted in the act of raising the weeping orphan. There is something inherently risible in a monumental statue showing a man in full mid-Victorian rig, watch chain and all, shoving one hand in his waistcoat *à la* Napoleon and, with the other, exhorting the masses to, presumably, greater and yet greater productiveness.

The same impulse to ennoble commerce must have dictated

the choice of the Gothic-revival architectural style, that of
the instant sublime, for which the city is famous. The Wool
Exchange pretends to be a far more impressive cathedral than
the cathedral itself, and most of the public buildings strive in
their appearance to transcend their origins, becoming in the
process authentic chapels to mammon. Mysteriously enough,
the city museum is housed in a mansion imitating another
kind of grandeur; it and the formal gardens surrounding it
are just like the hotel and grounds in *Last Year at Marienbad*,
a curiously wistful palace of culture set in a rather romantic
public park. The building is guarded by a statue of Diana the
huntress. All this is irrelevantly gracious and unnervingly out
of context, reflecting, presumably, the place of the arts in
the context of the culture which produced it. The mills, how-
ever – reflecting, perhaps, a more honest respect for the muck
which signifies brass – are built on heroic proportions.

Their chimneys are monumental in size and design, like
giant triumphal columns or pediments for Brobdingnagian
equestrian statues. On some days of Nordic winter sunshine,
the polluted atmosphere blurs and transfigures the light, so
that the hitherto sufficiently dark, satanic mills take on a post-
apocalyptic, Blakean dazzle, as if the New Jerusalem had come
at last, and the sky above is the colour and texture of ripe
apricots. A russet mist shrouds the surrounding moorland,
which is visible from almost every street, however mean. On
such mornings, it is impossible to deny that the scene is
beautiful.

Snow, however, brings out the essential colours of the city.
Everything is delicately veiled in soot which fortuitously unifies
the eclectic urban scene to such a degree that those public
buildings which have been scrubbed back down to their native
stone look ill at ease, as though they no longer belonged here,
like mill-hands' sons who have gone to Oxford. But the soot,
although it paints in monochrome, does not create a mono-
tonous scene, for here one may appreciate and enjoy an
infinitely rich collection of blacks, from the deepest and most
opaque to the palest and most exquisitely subtle, through an
entire spectrum – brownish black, greenish black, yellowish
black and a cosy, warm, reddish black. The air, which often

has the metallic chill of freezing metal, is full of the sweetish smell of coal smoke. Snot is black.

The weather is brutish. The cold has moulded the stoicism of the inhabitants and, perhaps, helped to determine their diet, rich as it is in heat-supplying fats and carbohydrates — so rich in fat, indeed, that persistent local folklore relates how Bradford Royal Infirmary is forced to discard pints of donated blood due to the high fat content it contains.

Fish and chips; pie and a spoonful of reconstituted dried peas the colour of mistletoe, swimming in grey juice; the odorous range of Yorkshire charcuterie, haslet, sausage, tomato sausage, black pudding, roast pork, pigs' trotters, pigs' cheek, jars of pork dripping, every variety of cooked pig the mind could imagine or the heart desire, for the succulent pig appeals to the native thriftiness of its eaters since every part of him may be consumed.

All this powerful cityscape of strangeness and unusual harmonies seduces the eye of the romantic southern visitor so much he finds it easy to forget that, thirty years ago, Lewis Mumford defined such places as Bradford as 'insensate industrial towns'. J. B. Priestley's Bradford was a good place to have come from, bearing in mind one would be able to remember it in tranquillity far, far away; and John Braine's postwar Bradford expressed only an appreciation of those affluent parts of the place that might be anywhere else in Britain. But now it is easy to find it charming here.

It is partly so charming because it is so strange; the presence of so many Pakistanis creates not so much the atmosphere of the melting-pot for, at present, the disparate ethnic elements are held in an uneasy suspension, but an added dimension of the remarkable. Signs everywhere in Urdu; young girls with anoraks over their satin trousers; embroidered waistcoats; unfamiliar cooking utensils in hardware shops; and cinemas with even their names up in Urdu. On Sunday afternoons, the man next door spends perhaps three or four hours practising upon some inexpressibly exotic musical instrument which sounds as though it has only a single string. He chants constantly to his own accompaniment and, to this Pakistani threnody, the wuthering of the Brontë winds from the moors

lends a passionate counterpoint.

But thirty years ago would I have found all this charming? Or would I have flinched that human beings should be forced to live and work in these conditions which might well have reminded me of the workers' dwellings in Lang's *Metropolis*; and if, unwillingly, I had found a quaint attraction in the scene, I would probably have identified it as the same attraction/ repulsion the late eighteenth-century intellectual experienced at the spectacle of the Horrid. Just as the uneasy aesthetic of the Horrid modulated into a positive pleasure-reaction to the same spectacle redefined as the Picturesque and thence into that expansion of the sensibility involved in the discovery of the idea of the Sublime, so the Horrid – i.e. the working-class environment, Victorian Gothic architecture, the detritus we now refer to as examples of industrial archaeology – began its modification towards the picturesque twenty years ago, if not before. It is now well on the way to becoming a new type of the Beautiful, although we have not yet found it a fitting name, a type of the beautiful first consciously rendered visually in those British films of the late fifties which featured endless arty shots of gasworks reflected in canals and pit wheels outlined against storm clouds.

A hundred years ago, Daumier found such spectacles perfectly hideous; forty years ago, George Orwell found only a poignant desolation in these industrial cityscapes, marked with the grisly stigmata of poverty. They are probably still seductive principally to the bourgeois romantic intellectual who sees them with the fresh eye of one not born and bred in a back-to-back house or to those afflicted with a sad case of Hoggart nostalgia. (I have a peculiarly rich reaction to Bradford due to a confusion of both kinds of response, plus some piquant memories of an early childhood in a more southerly Yorkshire environment which really looked more like Tolkien's Mordor than anywhere else.) On the other hand, the history of taste may well be that of the obscure and probably warped predilections of the bourgeois romantic intellectual gradually filtering down through the mass media until everybody knows for certain what they ought to like. After all, only a handful of eccentrics were turned on by moun-

tains until one got up and followed Wordsworth across a lake.

Personally, I often feel that Manningham Mills are rolling inexorably after me on ponderous wheels down Oak Lane, intent on swallowing me up and lashing me to a machine inside their black, gigantic belly; no doubt I feel this because I have not yet sufficiently transcended those working-class origins that also make me want to blow up Blenheim Palace, to name another shrine to the oppression of the masses.

Yet Bradford has the virtues of a total environment where work and life goes on side by side, and the hilly streets, following as they do the (indeed) majestic contours of the surrounding hills, retain some kind of organic relation with the countryside in which a chance combination of natural elements, wool and water, produced the city in the first place. It is not a handsome city as Leeds, nearby, is handsome; it does not wear its muck with such conscious, assertive pride. It is more domestic, earthier. The contrast between the splendid front and the squalid asshole are not nearly as great. It is far older than Leeds. At times, it even feels almost medieval, with its windy, winding streets. It is a city with such a markedly individual flavour that even though it will take an aesthetic volte-face of seismic proportions before even the most entrenched preservationists hail it as the Florence of the North, that day might some day come; Bradford will indeed be seen by all to be beautiful if it escapes the fate of the rest of Britain, which is plainly that everywhere will be done over to look like a universal, continuous North Cheam. Then we will wake to a shocked consciousness of the visual pleasures we have lost. [1970]

Flatscape with containers

Reyner Banham

It's amazing how many educated minds' eyes still visualize docks in the imagery of, say, Quentin Hughes's *Seaport* – tall craggy warehouses, masts, cranes and funnels silhouetted against the sky, picturesque Trotskyites in silk mufflers toting that box, lifting that bale, getting a little drunk and landing in Tower magistrates' court. But this is now an iconography of death; all the standard images of rich clutter belong to a world that has had it.

The wealth of nations no longer piles up storeys high, tight under the crutch of Thames. Docks, growing inexorably bigger, slip down round the ankles of estuaries. Thus, Mersey operations no longer pack snugly into Jesse Hartley's Albert Dock, but have slipped down the whole length of the Dock Road and are about to fetch up in a new giant installation in front of the pretty marine terraces of Crosby. The Port of London is growing like crazy down at Tilbury, but Telford's St Katherine Dock is now no more than a candidate for a playport.

And when you get to Tilbury, for instance, you see little to recall the typical imagery of ports. What you see, more than anything else, is acreage of flat tarmac or concrete. Literally acreage; single areas of ten acres, hardly broken by a lamp-post or sign, are chickenfeed in the new world of freight handling that includes not only ports, but also railway freightliner yards, and even parcels depots. It's all part of the 'container revolution' about which we are getting so much PRO-chat; but it is important to realize that the container bit is not an extraordinary and unprecedented event, but simply the most recent stage in a revolutionary process that has been going on since about the time Telford and Hartley built their master docks.

Their monumental warehouses stood tall at the water's edge, with cranes bracketed off their façades for a very good reason.

If you had winched a bale up from the bottom of a ship's hold to deck level, you might as well go on moving it vertically to the umpteenth floor, rather than put it down and start moving it about horizontally, because that was a good deal more difficult before railways and mechanical power. But by the time these heroic schemes were completing, the railway age was already beginning; horizontal movement on land was becoming handy and economical; and the next full generation of docks, like the Royals on the Thames, ceased to look like any part of civil architecture. They started to slip down the estuary, the buildings began to shrink in height and pretension, and were moved back from the waterside to accommodate rail tracks and travelling cranes.

Old Albert and Katherine were thus the first victims of what now appears to be an inexorable law of design for transportation – that by the time you have finally found an architecturally acceptable format for any type of transport, it's obsolete. Bert and Kate finally found the canonical form for a dying medieval concept of goods handling; St Pancras station became obsolete on the day it opened; Idlewild (Kennedy), the perfected propeller-driven airport, is overrun with jets.

And now that the rubber-tyred vehicle can rush about horizontally in all directions without benefit of railway lines, the railway-age dock of two-storey warehouses and luffing cranes has had it too. The most conspicuous, because invisible, victim of this phase of the goods-handling revolution, is architecture. At Tilbury or Rotterdam, or the BR freightliner terminals, buildings are of little consequence, look temporary, survive on sufferance at the margins of the action. And for a very good reason: insofar as buildings existed to keep the weather off the merchandise, they aren't much needed now. The essence of both containerization and roll-on-roll-off techniques is not only that the goods reach the terminal in neat packages, but that the packages provide as much of the right kind of weather protection as the goods need – pork in refrigerated containers, stout in tanks, timber in steel-strapped parcels.

But if buildings are not needed, the one thing that the trailers, straddle cranes and fork-lift trucks must have is vast

areas of more or less ideal flat surface on which to roll around. When No. 34 berth at Tilbury was (rather hurriedly) converted to handle packaged timber, its shed had a 72-foot clearance punched through the middle of it, to connect the dockside with 11½ acres of tarmac hard-standing behind it. This can be used indiscriminately as a surface on which to stack, or a kind of omni-directional roadway on which the fork-lift trucks can whizz around with the packages of timber.

And that is the scale of the new dockscape, dictated by the rubber-tyred vehicle. The same rubber-tyrant fixes the wide flat form of practically everything else around. A roll-on-roll-off terminal, for instance, is effectively a motorway intersection, from which two or more of the roads run straight into large holes in the sterns of ships. Or at the York Way freightliner terminal behind King's Cross station, the thing which strikes the eye is that, in spite of the fact that this is a railway facility, the Drott Travelift (no, I didn't make that up) cranes run up and down the 1000-foot interchange on large-diameter road-wheels, not railway tracks.

At the Stratford terminal in east London, the effect is really spectacular. The given landscape is wide, raw, flat and sandy under an expanse of sky that would make poets rave if it wasn't the southern end of Hackney marshes. Nothing stands more than a truck's height, except where containers have been stacked two deep along the side of the terminal, and beside them the outlines of the two big Morris straddle-cranes dominate the sky. In the first week of August, one was still a bare four-legged skeleton, orange-red in its lead-oxide underpaint; the other fully equipped with its lifting tackle and control cab, in its final livery of yellow, with men busy painting diagonal black fright-stripes on its lower extrimities. (Query: in a scene where nearly every visible thing is covered in yellow and black fright-stripes, how do you know which one to beware of next?)

It's one of the great sights of London (and a pity it's not open to the public, though you get a fair view of it after the kink in Temple Mill Lane). But what are architects going to do with situations like this? As a profession they claim the right and duty to design 'the complete human environment',

but one thing they cannot bear to contemplate is large flat areas of anything at all; they whimper in their campari-soda about airports, supermarkets, 'prairie planning in the new towns' and – above all – car parks. Hence the constant attempts to sweep parked cars up into monumental multi-storey heaps, even where there is no great need. At Cumbernauld, Geoffrey Copcutt tried to make cars disappear by tucking them up under the skirts of his town-centre megastructure, above ground level.

But they have fallen out again, and are beginning to spread over the surrounding ground. And the logic of transportation seems to say Yes. The logic of airport operation says: bus and passengers straight to the plane on the tarmac, and scrap the buildings; and the logic of freight handling – logical enough to compete with Europort/Rotterdam, that is – says: acres of hard-standing with nothing on it that can't be moved out of the way.

This logic is already beginning to make a transitional kind of sense, visually. Where buildings – roofed volumes with side enclosures – persist, they seem to grow naturally as lightweight shells unencumbered by massive masonry or cultural pretensions. In a portscape where corrugated asbestos and ribbed aluminium sheet are not cheap substitutes but the very stuff of building, a brick looks as pompous as rusticated masonry does elsewhere (the passenger hall at Tilbury, with its coats of arms and barrel vaults, would look pompous anywhere, and attains a positively nightmare quality there). And these shed shells, stiff tents almost, can be perfectly adequately designed by engineers without any interference from architects, and usually are. [1967]

Power of Trent and Aire

Reyner Banham

A litany for that late moment when you turn out the bedside light: 'Let not Drax falter nor Cottam pause, for without their like all will be dim in England.' You may not know these names, their location may well be remote from yours, but they affect your life more intimately than you care to believe. They are among the more accessible of Hinton's Heavies: generating stations of 2000-megawatt capacity along the Trent – Cottam, West Burton and Ratcliffe – and the Aire – Drax, Eggborough and Ferrybridge C. And if they go on the blink, TV pictures will shrink and heaters go cool over much of England, for they are all part of the computer-controlled supergrid that supplies the basic power for most of the country.

But if they are so big and important, why do we hear so little about them? For a start they are not glamorous, sabotaged or atomic; they burn old-fashioned coal – though they burn it with a sophistication that makes atomic power look primitive, and with an efficiency that substantiates the too-often-mythical 'economies of scale'. Secondly, they are not visible from Hampstead and Highgate and therefore they all escape the notice of opinion-makers and public mouths – though they are well known to various in-groups such as bird-watchers (because of some accidental amenities they have created for our feathered friends). But chiefly, I think, because the Central Electricity Generating Board secretly hoped no one would notice them, and tried to make them self-effacing. The 2000mw programme was launched at a time when the whole electricity business was under heavy pressure from amenitarians, and it seems almost as if Sir Christopher Hinton and his advisers, aghast at the literal enormity of what they were about to commit, tried to find ways of making the supposed offence less noticeable. Honestly, there was no

offence, but the leap in size from previous generating plant could make anyone nervous.

The statistics don't really tell the layman much – even when you have translated all those megawatts into domestic light-bulbs, the answer is still a number with seven or eight noughts after it. But if you start comparing the physical plant with other large objects you have to realize what league they are playing in, and it's a very Big League indeed. The average sort of chimney for one of these stations is at least the size of the Post Office Tower; the cooling towers are about the height of the spire of Salisbury cathedral or of St Paul's; and Battersea power station would almost go inside one.

To anyone brought up on the standard pious myths about the small-scale delicacy of the English countryside, this must sound like Total Destructo Corp at work. But what does a 700-foot chimney look like at Drax? Answer: not even half that size, because there is nothing at Drax with which to compare it, except other equally over-scale objects, such as the cooling towers. Like the other five, Drax sits in the water meadows of a broad valley-bottom, rising from a flat low horizon without a human habitation or other conventional structure in the same view.

There is, in fact, a little Victorian railway building in the foreground at West Burton, but it hardly registers as part of the picture. The only one where scale comparisons are really revealing is also the only one that is at all well known – namely, Ferrybridge, on the A1 north of Doncaster. From the main road, it is just another scale-less Heavy in a rural setting, but if you leave the A1 and go round to the high ground at the back of the station, the landscape suddenly becomes basic drift-from-the-north stuff, with pigeon lofts and broken pavements and cleared house-sites and shuttered shops – and even the cooling towers of the earlier, smaller Ferrybridge B stand up like mountains behind that lot.

With the others – such as Ratcliffe, just beyond the A6 inter-section on the M1 – it is a quite different optical effect that gives the only clue to scale. Going north on the motorway, for instance, Ratcliffe's 600-foot chimney and eight monster cooling towers come into view over a hill on the right, long

before you reach the intersection. But even after you turn off, and are driving straight towards them, they still don't seem to get any closer. It is this apparent recession alone that tells you that they must be very big – big enough to cause serious misjudgement of distance – because there is simply nothing else against which to measure them.

Ratcliffe, the most accessible of the Trent group, exhibits all the standard features of the 2000mw type – chimney, cooling towers, a boiler-house some 800 feet long to 200 high, switchgear buildings the size of aircraft hangars, office block, dust precipitators, a megaton coalyard, a private railway loop to bring the coal in and haul the dust away: all gathered together in a composition of parts that looks natural and convincing and right, and at home in its riverside landscape, even if its size remains inscrutably vast. But as you actually drive into the station, and get close to the buildings, you become aware that all this natural and industrial grandeur has been fiddled about and meddled with and busied over by some other race of beings whose scale, by comparison, is that of ants. The broad self-confidence of the designing sensibilities that created the hugely elegant forms of the cooling towers and chimneys has been niggled away in the smaller structures and the ground-level parts of the larger ones – and all this is, ultimately, the result of the CEGB over-reacting to the pressures of the amenitarian/conservationist lobbies.

I'm not saying that the board shouldn't react at all – as the body responsible for effluents, for instance, that have raised the temperature of the Trent to a level that threatens unpredictable ecological changes, the CEGB has a manifest duty to take all the relevant advice it can get, and act on it. In fact, the board takes a lot of advice and acts on as much of it as can reasonably be expected. As it happens, the kind of riverside site that gives good communications and handy cooling water, is also the best from the point of view of visual amenity, because of the advantages of these ambiguities of scale. In the valleys of the Trent and Aire, the board could hardly get it wrong, and most of its choices of site are very good.

Choice of site, indeed, solves as much of the amenity

problem as it is within the power of human ingenuity to solve, but in the mental climate of the late fifties it was mandatory to do more. The board had to perform in public certain approved prophylactic rituals of Establishment magic: it had to make a big show of calling in architects. Given the peculiarities of building in remote sites rarely seen by the public, plus the conspicuous irrelevance of the architectural contribution – reputedly responsible for less than 2 per cent of the total investment – the whole operation became a licence to architects to do their nuts in rural privacy.

It was the sight of the extraordinary architectural goings-on at Drax last summer that alerted me to the extent that this new dispensation had turned the clock back to the bad old days of the brick cathedrals. Admittedly, Drax is the most extreme example; but all six of the Trent and Aire Heavies I have now seen exhibit some symptoms of irrelevant architectural overkill.

Brick cathedrals? Ah, there was a heroic episode in the history of technology and taste: the day they killed off the brick cathedrals!

It all happened in the early fifties, lads, when great and good men looked upon this green and pleasant land of ours and noticed that it was being disfigured by architects who were making technology an excuse to do *old-fashioned* architecture, and were dressing up power stations in a monumental style, when they ought to have been coming on crisp, clean and modern. What it really amounted to was that the style that had made Battersea a popular landmark before the war had become unfashionable among the architectural pundits, and too expensive for the nationalized industry to bear. Sensing the changed atmosphere just in time, Farmer and Dark architected Marchwood in a skinny, modern, machine-aesthetic style and even offered to leave some of the equipment out in the open air without benefit of architecture at all. They became the heroes of the hour, and Robert Furneaux Jordan, surveying the battlefield from the safety of the *Architectural Review* in April 1953, exulted: 'The dross, the stylistic cage, has gone; the only major building left is the turbine hall!'

Heigh-ho – with the onset of all Hinton's 2000mw Heavies

that 'major building' was to become so major that men of
goodwill would tremble right down to their cold feet and
call back the dross, rebuild the stylistic cage. The Hinton
regime at CEGB began by calling in Lord Holford (thus
ensuring a good hot-line to the Royal Fine Art Commission),
setting up the board's own in-house Architectural Division
(which has subsequently shown sign of becoming the only
really useful part of the whole exercise) and wading into some
major PR operations.

Now, to be fair, the role of the external architects (many
of them new blood, doing their first power stations), under
this new dispensation, was originally envisaged as far more
radical and comprehensive than it had been in the brick-
cathedrals period. As consultants, they were intended to have
some say in the design of all structures great and small, their
location on the site, the surrounding landscaping and even the
exact line of the sites boundaries. The intention was ambitious
and much was made of it. The catalogue of the 1963 'Archi-
tecture of Power' exhibition in fact singled out for special
emphasis Gordon Graham's model studies for the bulk forms
and grouping of West Burton.

But between ambition and performance there has been a
persistent and widening gap. In the end, there has been very
little that architects could do about the shapes of the main
forms of their grouping, and precious little that landscaping
could do either, when the structures it was supposed to hide
were between twice and 150 times the height of the tallest
deciduous greenery available.

Even if it is not true that 'there is nothing they can do
about the machinery, so they take it out on the human race',
there is manifest truth in: 'They are determined to make a
personal statement somewhere, so the office block gets over-
designed, a bloody jewel!' The architected parts of Hinton's
Heavies are getting very precious and arty indeed.

The board has been quite astonishingly indulgent to the
foibles and fantasies of its external architects, as if by hiring
a big-name Fellow of the RIBA it could excuse itself from
further architectural responsibility. Fortunately for us, if
uncomfortably for the board, its apparent complacency has

been sabotaged from within; the in-house Architectural Division, disenchanted with its unprofitable role as a kind of internal pseudo Fine Arts Commission, trying to vet external architects' work, has been transforming itself into a highly competent design-and-development team.

Along the way it has designed some neat, serious and economical buildings. Not power stations yet, but district offices, training centres and the like. One of them picked up a *Financial Times* industrial architecture award this year, thus pleasing and surprising the board and giving heart to some of its more concerned architectural employees. But surely this award also carries with it a clear duty for the CEGB as a public body. It can no longer pretend that it does not have the talent to design a model 2000mw station itself. Quite clearly it now *has* the capacity to 'set standards', in Lord Holford's phrase, not only by exhortation but by tangible example as well. We could all use a station that stands up to the closest architectural and financial scrutiny – as well as looking like a successor to Stonehenge when you stand too far away to be distracted by detailing. [1970]

Parting Shots

The naked Lawrence

Angela Carter

A piece of comment I once read about that monstrous book, *The Story of O*, suggested that only a woman could have written it, because of some curious metaphor about (I think) curlers somewhere in the book. The commentator, a French intellectual, probably a member of the Académie Française and God knows what else besides, said this sartorial detail was uniquely revelatory of a woman's eye.

Yet *The Story of O* bears all the stigmata of male consciousness, precisely because details about clothes are just the sort of thing a man would put into a book if he wanted the book to read as though it had been written by a woman. Cleland uses much the same device in *Fanny Hill*. Not that it could not have been written by a woman: many women writers themselves pretend to be female impersonators. Look at Jean Rhys and Edna O'Brien, whose scars glorify the sex that wounded them. But the nature of female impersonation in art is a complex business. The man who sets out to do it must be careful not to let his own transvestite slip show; especially if he does not like women, much.

Which brings me, by a roundabout route, to the strange case of D. H. Lawrence. Those who preach phallic superiority usually have an enormous dildo tucked away somewhere in their psychic impedimenta. I should like to make a brief sartorial critique of *Women in Love*, Lawrence's most exuberantly clothed novel – a novel which, furthermore, is supposed to be an exegesis on my sex.

Women in Love is as full of clothes as Biba's; and clothes of the same kind. Lawrence catalogues his heroine's wardrobes with the loving care of a ladies' maid. It is not a simple case of needing to convince the reader the book has been written by a woman; that is far from his intention. It is a device by which D. H. Lawrence attempts to convince the reader that

he, DHL, has a hot-line to a woman's heart by the extra-ordinary sympathy he has for her deepest needs – that is, nice stockings, pretty dresses, and submission.

Lawrence clearly enjoys being a girl. Trust not the teller but the tale. The tale revels in lace and feathers, bags, beads, blouses and hats. Lawrence is seduced by the narcissistic apparatus of femininity. It dazzles him. He is a child with a dressing-up box. Gudrun, witch and whore, is introduced in a fanfare of finery. 'She wore a dress of dark-green, silky stuff, with ruches of blue and green linen lace in the necks and sleeves.' The Brangwen girls habitually come on to the page dragging *Vogue* captions behind them. It is the detail of the 'linen lace' that gives Lawrence away, of course. He is a true aficionado of furbelows. What the hell is linen lace? I'm sure I don't know. It is a delicious feminine secret between Gudrun and her dressmaker.

Gudrun completes her ensemble with emerald-green stockings. Gudrun's stockings run through the book like a leitmotif. Very gaudy stockings. She will keep on drawing attention to the pedestals which support her, her legs, though these legs are rarely mentioned by name. Her stockings become almost a symbol of her contrariness. When she arrives at the Crich mansion wearing thick, yellow, woollen ones, Gerald Crich is a little taken aback. 'Her stockings always disconcerted him,' notes Lawrence, to underline just what a bourgeois cow Gerald is – that he can't take a pair of bohemian stockings with equanimity.

Stockings, stockings, stockings everywhere. Hermione Roddice sports coral-coloured ones, Ursula canary ones. Defiant, brilliant, emphatic stockings. But never the suggestion the fabric masks, upholsters, disguises living, subversive flesh. Lawrence is a stocking man, not a leg man. Stockings have supplanted legs; clothes have supplanted flesh. Fetishism.

The apotheosis of the stockings comes right at the end of the novel, where they acquire at last an acknowledged, positive, sexual significance. 'Gudrun comes to Ursula's bedroom with three pairs of the coloured stockings for which she was notorious and she threw them on the bed. But these were thick, silk stockings, vermilion, cornflower-blue and grey,

bought in Paris.' With sure, feminine intuition, Ursula knows 'Gudrun must be feeling *very* loving, to give away such treasures'.

The excited girls call the stockings 'jewels', or 'lambs', as if the inert silky things were lovers or children. Indeed, the stockings appear to precipitate a condition of extreme erotic arousal in Gudrun; she touches them with 'trembling, excited hands'. The orgasmic nature of the stocking exchange is underlined by a very curious piece of dialogue:

'One gets the greatest joy of all out of really lovely stockings,' said Ursula.

'One does,' replies Gudrun. 'The greatest joy of all.'

What *is* Lawrence playing at? Or, rather, what does he think he's playing at? This sort of camp ecstasy more properly belongs in Firbank, who understood about dandyism and irony, the most extreme defences of the victim. But Firbank, as plucky a little bantamweight as ever bounced off the ropes, had *real* moral strength. I think Lawrence is attempting to put down the women he has created in his own image because of their excessive reaction to the stockings to which he himself has a very excessive reaction indeed.

Of course, at this point in the novel Lawrence must be feeling very full of Woman, as Birkin has just ingested Ursula, swallowed her whole in the manner of a boa constrictor. So he can really deceive himself with his own closet-queen act, and it doesn't seem to him in the least incongruous that his heroines, who were initially scrupulously established as very heavy ladies, are now jabbering away to one another like the worst kind of schoolgirl.

The girls have just met again in Switzerland, after Ursula's marriage and Gudrun's dirty weekend in Paris with the atrocious Gerald. They scuttle off immediately to Gudrun's bedroom to talk 'clothes and experiences', in that order. Curled up with a box of Swiss chox, I dare say.

Cunning old Lawrence can have his cake and eat it, too. Earlier on in Derbyshire, miners' children call names after Gudrun. 'What price the stockings!' they cry. This is realism, of course. The penalty of sartorial eccentricity is always mockery: some kinds of clothes are a self-inflicted martyrdom.

But Lawrence can put all these lovely garments he himself
desires on the girls he has invented, and yet neatly evade the
moral responsibility of having to go out in them himself and
face the rude music of the mob.

He allots Gudrun a sartorial crucifixion by the miners.
Never, they allow, have they seen night soil in such a lovely
bag. But, with Pauline resolution, they never lose sight of the
fact that night soil, nevertheless, she remains. She has com-
mitted the solecism of wearing 'bright rose stockings' for a
walk in the village. 'What price, eh? She'll do, won't she?'
The miners don't look for the price tag on the stockings, as
did the relatively innocent children (one of whom, in fact,
may have been my own mother, we had many family con-
nexions in the coalfields round there at the time). They per-
ceive the flesh beneath the stockings and speculate about the
price tag on *that*. The old miner thinks she'd be worth a week's
wages. Indeed, he would put the money down straight away.
But the younger 'shook his head with fatal misgiving'. 'No,'
he said. 'It's not worth that to me.'

Lawrence hates the miners with the lacerated, guilty passion
of the true class traitor. All the same, he is delighted to use
the frank speech proper to the degraded status he gives my
great-uncle and my cousins and my Uncle Arthur in order
to put Gudrun, sashaying out in her Lunnon clothes, firmly
in her place. 'Not worth a week's wages,' eh? So much for
your subtle little carvings of water wagtails, girlie. Get down
on your back for free.

All the same, Lawrence has given Gudrun a particularly
shocking kind of beauty, for God knows what masochistic
reasons of his own. And it is a perpetual affront to him. Not
'Beauty's self is she when all her clothes are gone', by any
means; never that. There is no sense of the tactile immediacy
of undressing in Lawrence's relation with his unruly heroine.
Rather, it is like strip-tease in reverse. The more clothes he
piles on her, the more desirable she becomes, because the less
real.

Hermione Roddice inevitably gets the full weight of the
sartorial stick. She disappears under layer upon layer of cloth.

Cloth of gold, fur, antique brocade, enormous flat hats of pale yellow velvet 'on which were streaks of ostrich feathers, natural and grey'. What an asset Lawrence would have been to those fashion writers who report the Paris collections where photographers are not allowed so they have to remember everything.

Hermione's clothes are visible alienation. They verge on fancy dress – which is dress as pure decoration, unmodified by function or environment. 'Hermione came down to dinner strange and sepulchral, her eyes heavy and full of sepulchral darkness, strength. She had put on a dress of stiff old greenish brocade, that fitted tight and made her look tall and rather terrible, ghastly.' Lawrence is plainly terrified of her and full of an awed respect. Her exoticism, for Lawrence primarily an exoticism of class, is expressed in a self-conscious strangeness of apparel. Her dress defines the area of abstract power she inhabits. Hermione is a portrait from life. Ottoline Morel did indeed get herself up like that. But she arouses Lawrence to such a heightened awareness of lace and trimming he might almost have spent lots of furtive, happy hours at Garsington, rummaging through her wardrobe.

The house party at Breadalby sees them all going for a swim together. Gerald looks 'white but natural in his nakedness', with a scarlet silk kerchief about his loins. The ladies decorously expose their flesh, but not much; Hermione approaches the water in a 'great mantle of purple silk', ornate, disguised, shrouded in baroque finery. Indeed, her appearance has the gilded formality of an icon. This is probably because she is an aristocrat, and therefore holy.

If Lawrence is making some pseudo-philosophical point about these heavily overdressed women – that they themselves retreat behind their clothes – he never makes it overtly, which is odd, for him. Like a drag queen, but without the tragic heroism that enables a transvestite to test the magic himself, he believes women's clothes are themselves magical objects which define and confine women.

Most of the time in *Women in Love*, Lawrence is like a little boy dressing up in his mother's clothes and thinking, that way, he has become his mother. The con trick, the real

miracle, is that his version of drag has been widely accepted as the real thing, even by young women who ought to know better. In fact, Lawrence probes as deeply into a woman's heart as the bottom of a hat box. [1975]

Sir, Writing by candlelight ...

E. P. Thompson

Let the power workers dim the street lamps, or even plunge whole districts into utter darkness, the lights of righteousness and duty burn all the brighter from 10,000 darkened drawing-rooms in Chelsea or the Surrey hills. 'Sir, May I, writing by candlelight, express my total support for the government in their attempt to halt the unbelievably inflated wage claims now being made?' enquires one correspondent to *The Times* (12 December). Undoubtedly he may and will.

Historians have often paid tribute to this peculiar character of the British. It is in grave adversity, in states of emergency, that they have noted this flaring-up of the British spirit. Only then do those proper guardians of the conscience of the community – the retiring middle classes – shed their usual reticence and openly articulate their values and commitments.

One infallible signal of such a time of bourgeois renaissance is the epistolary *levée en masse* of the readers of *The Times*. Such *levées* are infrequent; when they occur, one senses the presence of History. One such took place in February 1886 after the 'Trafalgar Square Riots', when unorganized unemployed demonstrators – after listening to some exciting rhetoric from John E. Williams, John Burns and H. M. Hyndman of the Social Democratic Federation – broke into a brief rampage through the West End, smashing shop windows, looting and even throwing bricks at select London clubs. Worse riots occurred, in most years, in some parts of the country: but not on such sanctified ground as Pall Mall.

'Sir,' wrote one unfortunate gentleman whose carriage windows were smashed in the rioting: 'I am a subscriber to

various charities and hospitals, which I shall discontinue. I
have always advocated the cause of the people. I shall do so
no more.'

But wounded and long-suffering righteousness, on these
occasions, takes second place to the firm disciplinary mode.
'Sir,' demanded one correspondent in 1886, 'What is the use
of having a highly-paid Commissioner of Police, with pro-
portionately highly-paid deputies, if they are afraid of the
responsibility attaching to their posts? . . . When there is a
kennel riot in any kennel of hounds, the huntsman and whips
do not wait to get the special orders of the master, but
proceed to restore order at once.'

Another correspondent (11 February 1886) produced an
example of the genre so rich that it has to be quoted at length.

'Sir . . . On returning from the Prince's Levée I was walking
through Pall Mall, in uniform. It was gradually filling with
very suspicious-looking "unemployed" at that time, two of
whom, turning towards me, one said, rather significantly,
"Why, who the ―― is this chap?"

'As I passed the War Office entrance, formerly the Duke
of Buckingham's, a blind fiddler, led by a little girl, came by
. . . playing some odd tune or other, when a young guards-
man on sentry stepped out and said, in a commanding tone,
"You stop that noise" . . . I thought, "Now there is a man
of common sense and of action." It was a little thing to stop
at the time, but when the snowball which a child or a blind
fiddler could set rolling on the top of the hill reaches the
bottom it has become in this country an immovable monster,
in other countries a destroying avalanche.

'On the 10 April 1848, I was sworn in a special constable
between Buckingham Palace and the House of Commons. At
the former we had a battery of Horse Artillery hidden in the
stable yard. I asked the officer commanding what he was
going to do? His answer was, "We have our scouts, and if
we hear of any gatherings we could run out and sweep the
Mall or the Birdcage-Walk in two minutes, or command
St James Street and Pall Mall in three." He would not wait
till mischief was done. Are those days quite gone?

'Your obedient servant, Wilbraham Taylor.'

Such high heroics can rarely be repeated, just as the true, physical *levées* of the bourgeoisie against the plebs (the Volunteers against the Jacobins in 1800, the Yeomanry against the poor of Peterloo, the Specials against the Chartist 10 April, the debs and Oxbridge undergraduates against the General Strike) are too few to satiate the desire dramatically to beat the bounds of class. So the epistolary cry goes out for some-one – the government – to discipline *them*, and put them back in kennels.

John E. Williams had been reported, in 1886, as having deplored that the unemployed were not well enough organized – not to riot and destroy property – but to occupy the banks, Stock Exchange and government offices. 'Sir,' wrote one *Timesian*, 'if correctly reported Williams must be an atrocious miscreant, compared with whom Gashford in *Barnaby Rudge* is a virtuous person.'

December 1970 has produced little in this genre of com-parable quality, perhaps because electrical workers' leaders are scarcely typecast as communist or Trotskyist fiends. (Per-haps the nearest was the letter – 14 December – from Nicolas Bentley, suggesting that Robert Morley, who had dared to declare his solidarity with trade unionism, must be a 'callous reprobate'.) But the old theme of 'there ought to be a law against . . .' has been fully orchestrated. This was very evident in another vintage epistolary year, 1926.

One mine-owner addressed himself (5 June 1926) to the subject of the mineworkers' officials: 'Their one object is to squeeze as much money out of the industry as it will stand, to the detriment of the proprietors who have taken all the risk incidental to coalmining.' (A rigorous statistical examina-tion of the number of coal-owners killed in mining disasters might not bear this out.) The Bishop of Durham came baying up behind (22 June): 'Trade unions now include in their ranks a great number of young men whose boyhood was spent during the war, when every kind of discipline was weakened . . . These lawless youths are well fitted to become the janissaries of Communist Revolution.'

Trade unions were 'the mocking caricature of anything . . .

democratic', and their rank-and-file were 'the hopeless tools
of the ruling clique'. They could only be held down by
stronger law. The compulsory secret ballot, then as now, was
one grand recipe for the extirpation of strikes, from correspon-
dents pathetically anxious to believe that if only the workers
expressed their minds in secret they would turn out to be chaps
just like themselves – or, rather, chaps *convenient to* them-
selves, compounded of all bourgeois virtues of prudence, self-
help, and deference to property, but emasculated of the
bourgeois reproductive system – the drive for *money*.

Such themes, announced in 1926, have, if anything, become
more pronounced with the epistolary *posse commitatus* of
1970. Should strikes be forbidden by law? asks Sir H. T.
Smith, from Wallingford (11 December). On the same day
the 'long-suffering public' found a spokesman in H. P.
Rae: deeply perturbed about invalids dependent upon 'con-
tinuously functioning kidney machines' (which they aren't), he
demanded: 'why the hesitation in putting in troops *now*?'
'The vast majority of the public,' he assured *Times* readers
from his Chelsea address, 'are sick to death of the squalid
attempts by the unions to tyrannize', etcetera. Mr Tennet of
Shottermill Ponds, Haslemere, also found (12 December) that
the workers were '(mis)using their monopoly position', and
Richard Hughes, from the United University Club, suggested
'a national one-day token lock-out (by employers) in support
of the . . . Industrial Relations Bill'.

Mr Flamank of Solihull (also 12 December) wanted to see
the formation of 'an emergency service corps', which could,
at the Home Secretary's whistle, 'move in and run the
services'. Those encouraging industrial unrest, 'be they com-
munists, shop stewards or militant students, are just as much
our enemies as were the Nazis'. (Perhaps one can hear an
echo of Wilbraham Taylor and the Horse Artillery over
Birdcage Walk?)

Such situations tend to make the bourgeois feel, with a
sudden flash of insight, their own value in the world: they
bear its weight and (*vide* the coal-owners) its risks upon their
shoulders. 'Think what the feeling would be,' exclaimed Lord
Midleton (28 June 1926), 'if any pit were closed for the day

and all wages lost to the men because the managing and controlling staff required a day off!' A similar thought occurred to Mr Reade (14 December 1970): 'Sir, If manual workers can work to rule, why not wages clerks too?' Aha! The argument is final: what if we, who *have* the money, stopped letting you rotters have it ! ! !

It is not to be thought that, in such national emergencies, the bourgeoisie is solely concerned with such paltry matters as money or comfort or class power. Not at all: the full moral idealism blazes out. Thomas Hughes, the Christian Socialist author of *Tom Brown's Schooldays*, came unhesitatingly to his post in the correspondence column in 1886: these modern socialists he found to be 'notorious ruffians', and 'If Mr Chamberlain will consider whether he cannot be getting Messrs Hyndman & Co. a year or two's oakum picking instead of "receiving their views in writing" he would be doing all honest folk more service, in my judgement.'

At such moments *Timesian* correspondents always know unhesitatingly what are the thoughts and needs of 'all honest folk' or of (see *The Times*, 14 December 1970) 'the welfare of the entire community' (Rose Cottage, Westhumble, Surrey). But it was left to the honest folksman, Sir Alan Lascelles (The Old Stables, Kensington Palace), to come forward as shop steward of 'an immensely larger union — namely, the union of British citizens' (17 December).

In 1926, however, the immediate requirements of the 'entire community' were pointed out to the striking miners in more dulcet tones, since they had made the tragic error of being manœuvred into a bitter, wasting strike during the summer months, and the readers of *The Times* were suffering, not from empty grates, but from an over-full sense of moral outrage. At such a time the clergy select themselves as the proper admonishers. The Dean of Worcester advised the miners (8 June 1926) that if they capitulated to the coal-owners' terms they 'will have won a great victory – a victory of their nobler over the lower self'. The Archdeacon of Chester addressed the same homily with greater fervour: capitulation by the miners 'would be good Christianity . . . an act of personal self-denial . . . of personal self-renunciation for the sake of

others, following the supreme example of the Greatest Figure in history'.

One has yet to notice, in 1970, correspondents congratulating the power workers, who called off their work to rule, on their good Christianity, or likening Frank Chapple to the 'Greatest Figure' in history. (Nor did *The Times* publish such congratulations from rural deans in 1926, when the miners returned to their pits defeated; after all, such letters, if read at the pithead, might have induced moral complacency, and, as events were to show, the nation was to expect a good deal more Christianity from the miners in the coming years.)

But – let us be fair – there has been one change in the genre in recent years: the clergy, generally, do not push themselves forward so obtrusively, nor do they presume so readily to express the conscience of the nation on socially-divisive issues. Their role, as national conscience and admonishers of delinquents, has been passed over, in good part, to David Frost and Malcolm Muggeridge. Some small part, perhaps, has been taken over by that new conscience-bearer, the middle-class housewife, who being out of the hurly-burly and puerility of industrial warfare, can watch all things with a wholly objective eye and instantly detect from her kitchen the national interest. Thus, on 11 December, a correspondent from Prescot, Lancs: '. . . the radio is dead. The television is dead. The electric heaters are dead. The kettle is dead. The fridge is dead. My washing-machine is dead. My iron is dead. All the street lights are dead . . . Goodness knows how many *tragic* deaths may result . . .' It is (she concludes) 'an exhibition of power surely grotesque in its selfishness . . .'

All dark and comfortless: we stalk the drear world of the psalmist or space-fiction writer: all that inanimate world of consumer goods, animated each quarter by the insertion of money, lies inert, disobedient. All flesh is grass, we know; but what (O ultimate of horrors!) if all gadgets turned out to be grass also? It is the Rebellion of the Robots, recorded by the author of Ecclesiastes.

Grotesque and selfish the power workers' action may have been. How can one know? Facts have been scarcer than homilies. Reading the press one learns that one has been

living through little less than cosmic disaster. One had thought that one's neighbours had suffered little more than power cuts for several hours on three or four days, but the mistake is evident. Outside there, in the darkness, the nation had been utterly paralysed for week upon week; invalids dependent upon 'continuously operating' kidney-machines lived two or three to every street; armed robbers prowled the darkness with impunity; not a hospital in the country that was not lit solely by candles, with surgeons operating upon month-old babies by the light of a failing torch.

A comparatively few individuals, wrote a correspondent from Richmond (12 December) were inflicting upon the public 'catastrophic injury'. Why not 'issue an order *withdrawing all legal protection* from the persons and property of the workers concerned', and the officials of their unions? 'Let the community get its own back.' This 'whole community' (another correspondent, 16 December) 'has long been renowned for its patience and forbearance. But surely the time has come,' etcetera. 'We are sick and tired . . .', 'the time has come', 'irresponsible' . . . irresponsible *to us*!

What is, of course, 'grotesque in its selfishness' is the time-worn hypocrisy of the bourgeois response to discomfort. Anyone familiar with the Victorian and Edwardian press cannot fail to detect, in these tones of moral outrage, that old bourgeois theme for moralisms: the 'servant problem'. But the servants now are out of reach; an electric light switch is impervious to the scolding of the mistress; a dustcart cannot be given a week's wages in lieu of notice.

And anyone who has read his E. M. Forster or his Angus Wilson knows the old British bourgeois propensity to moralize his own convenience and to minister to his own comforts under a cloud of altruism. For 95 per cent of the bluster and outrage was the miasma rising from tens of thousands of petty material inconveniences. The electric alarm failed to go off, mummy fell over the dog in the dark, the grill faded with the fillet steak done on one side only, daddy got stuck for half an hour in the lift on the way to a directors' meeting, the children missed *Top of the Pops*, the fridge de-froze all over the soufflé, the bath was lukewarm, there was nothing to do

but to go early to a loveless bourgeois bed. But, wait, there was one alternative: 'Sir, Writing by candlelight . . .'

But to mention the *real* occasions might seem petty. It was necessary to generalize these inconveniences into a 'national interest'. The raw fillet steak became an inert kidney-machine, the dripping fridge an operating theatre, the loveless bed became a threat to the 'whole community'. No matter: now the emergency is over these moral fantasies will shrink back to their proper size. The shivering old-age pensioners (many of whom will continue to shiver all winter through on their inadequate pensions), the imperilled invalids (many of whom will continue in peril from inadequate medical provision), will cease to obtrude themselves in the correspondence columns of *The Times*.

It has been a notable state of national humbug. It was concluded, as in an obligatory ritual, by David Frost, at peak viewing hours on a Saturday night, bullying a few power workers, with a studio audience, handpicked for their utter insensitive self-righteousness, baying at his back.

Occasions were found, not only to express moral disapproval, but also approval; the audience applauded to the echo nurses who, underpaid as they are, would never strike because of the needs of their patients. David Frost who, from what one has heard, does not face the same financial dilemmas – and the withdrawal of whose labour would scarcely induce even this government to declare a state of 'national emergency' – was evidently delighted. The bourgeoisie has always been ready to acknowledge virtue in the servant class when it finds it: pliant, loyal, living patiently in the attic, carrying on dutifully a service to the 'whole community'. Aubrey Leatham, physician at St George's Hospital, Hyde Park Corner, saluted the same virtue among the cardiac technicians at his hospital (*The Times*, 16 December) who, earning 'as little as £415 a year, would like to strike, but they do not, because they are humanitarian'.

And how noble they are, indeed, to pace the hearts of emergency patients in the acute care area for only £8 a week! But, surely, if this is so, this also is an outrage, which we should have heard of before, and insistently, and not only as

a stick to beat the power workers with? Has Mr Leatham taken up his pen before, to press the astonishing case of his cardiac technicians? Or will he, and the other militant correspondents to *The Times* and so many other papers, relapse into silence now that the inconvenience and discomfort are over?

The grand lesson of the 'emergency' was this: the intricate reciprocity of human needs and services – a reciprocity of which we are, every day, the beneficiaries. In our reified mental world, we think we are dependent upon *things*. What other people do for us is mediated by inanimate objects: the switch, the water tap, the lavatory chain, the telephone receiver, the cheque through the post. That cheque is where the duties of the good bourgeois end. But let the switch or the tap, the chain or the receiver fail, and then the bourgeois discovers – at once – enormous 'oughts' within the reciprocal flow.

But these 'oughts' are always the moral obligations of other people: the sewage workers ought not to kill fish, the dustmen ought not to encourage rats, the power workers ought not to imperil invalids, and – this week it will be – the postmen ought not to deny bronchitic old-age pensioners of their Christmas parcels from grandchildren in Australia. Why, all these people owe a duty to the 'community'!

What the duty of the community is to these people is less firmly stated. Certainly, those whose lolly is the theme of the business supplements – those whose salary increases (like those of admirals and university teachers) are awarded quietly and without fuss, and which (it seems) create no national emergency and no dangerous inflationary pressures – have little need to compose letters to *The Times* as to their own moral obligations and duties.

It is the business of the servant class to serve. And it is the logic of this reified bourgeois world that their services are only noticed when they cease. It is only when the dustbins linger in the street, the unsorted post piles up – it is only when the power workers throw across the switches and look out into a darkness of their own making – that the servants know suddenly the great unspoken fact about our society: their own daily power. [1970]

The contributors

REYNER BANHAM is Professor of the History of Architecture, State University of New York at Buffalo. Born in 1922, he went to school in Norwich and worked as an aircraft engineer before going to study at the Courtauld Institute of Art. He was then on the staff of the *Architectural Review*, till he joined the School of Environmental Studies, University College, London. He left his professorship there to go to Buffalo in 1976. His books include *Theory and Design in the First Machine Age* (1960), *the Architecture of the Well-Tempered Environment* (1969), *Los Angeles* (1971) and *Megastructure* (1976).

PAUL BARKER is Editor of *New Society*. Born in 1935 at the Brontë end of the West Riding, he went to Brasenose College, Oxford, where he took a degree in French. He taught at the École Normale Supérieure in Paris before joining *The Times*. He then went to *New Society*, of which he became Editor in 1968. Books he has edited include *A Sociological Portrait* (1972) and *The Social Sciences Today* (1975).

JOHN BERGER, author and art critic, was born in London in 1926 and was trained at art schools there. He began his career as a painter and a teacher and drawing. His books include *The Success and Failure of Picasso* (1965), *A Fortunate Man: the story of a country doctor* (1967), *Ways of Seeing* (1972), *A Seventh Man* (1974), and the novels, *A Painter of Our Time* (1958), *Corker's Freedom* (1964) and *G* (1972).

ANGELA CARTER, novelist, was born in Eastbourne in 1940 and brought up in south London. She was a local newspaper reporter before going on to take a degree in English at the University of Bristol. She lived in Japan from 1969 to 1972 but now lives in London again. Her novels include *Shadow Dance* (1966), *The Magic Toyshop* (1967), *Several Perceptions* (1968), *Heroes and Villains* (1969) and *The Infernal Desire Machines of Doctor Hoffman* (1972). She has also published a collection of short stories, *Fireworks* (1974), and two children's books.

ALBERT HUNT is Senior Lecturer in Community Arts, Bradford College, where he directs his own theatre group. Born in Burnley in 1928, he went to Balliol College, Oxford, to study modern languages. He taught in schools and in adult education, forming a theatre group after he went to Shropshire as adult education tutor in 1960. He was associate director of Peter Brook's *US*. He has published one of the Bradford group's projects as a play text, *John Ford's Cuban Missile Crisis*. Other books are *Arden: a study of his plays* (1974) and *Hopes for Great Happenings: alternatives in education and theatre* (1975).

PAUL MAYERSBERG works in films—most recently on the screenplay of Nicolas Roeg's *The Man who Fell to Earth*. Born in 1941 and educated at Dulwich, he has worked in both Paris and London. He wrote *Hollywood, the Haunted House* (1970).

DENNIS POTTER, playwright, was born (1935) and brought up in the Forest of Dean, before going to New College, Oxford. His first jobs were with BBC TV and with the *Daily Herald*. He stood as a Labour candidate in the 1964 election. His television plays include *Vote, Vote, Vote for Nigel Barton*, *Where the Buffalo Roam*, *Son of Man*, *Casanova*, *Only Make-Believe* and *Joe's Ark*. He has also written *The Glittering Coffin* (social criticism, 1960) and a novel.

E. P. THOMPSON, social historian, was born in 1924. His time at Cambridge, where he read history, was interrupted by war service in Italy. From 1948 to 1965 he was an extramural lecturer at the University of Leeds. He was joint editor of the *New Reasoner*, which became one of the components of the *New Left Review*. He also taught at the University of Warwick before turning to full-time writing. His publications include *William Morris* (1955), *The Making of the English Working Class* (1963) and *Whigs and Hunters: the origins of the Black Act* (1975).

MICHAEL THOMPSON is a research fellow at Massachusetts Institute of Technology. Born (1937) and brought up in Cumberland, he went to Sandhurst before spending six years in the King's Dragoon Guards. He then studied anthropology at University College, London, and Oxford. He has taught at the School of Architecture, Portsmouth Polytechnic, and at the Slade School of Art. He has been on expeditions to both Annapurna (1970) and Everest (1975).

ANDREW WEINER teaches psychology at a community college in Montreal. Born in 1949, he was brought up in the north-west suburbs of London, before taking a degree in social psychology at the University of Sussex. He worked in London as an advertising copywriter, and then as a film and rock music critic, before going to Canada in 1974. He has published science-fiction short stories.

MICHAEL WOOD is Professor of English and Comparative Literature, Columbia University, New York. He was born (1936) and brought up in Lincoln, and went to St John's College, Cambridge, to study modern languages. He taught in schools and at Cambridge before going to Columbia in 1964. He has published *Stendhal* (1971) and *America in the Movies* (1975).

Index

Keywords
Raymond Williams

Alienation, creative, family, media, radical, structural, taste: these are seven of the hundred or so words whose derivation, development and contemporary meaning Raymond Williams explores in this unique study of the language in which we discuss 'culture' and 'Society'.

A series of connecting essays investigating how these 'keywords' have been formed, redefined, confused and reinforced as the historical contexts in which they were applied changed to give us their current meaning and significance.

'This is a book which everyone who is still capable of being educated should read.'　　　　　Christopher Hill, *New Society*

'... for the first time we have some of the materials for constructing a genuinely historical and a genuinely social semantics ... Williams's book is unique in its kind so far and it provides a model as well as a resource for us all.'

Alasdair MacIntyre, *New Statesman*

'... an important book.'　　　　　F. W. Bateson, *Guardian*

'... excellent and penetrating. It must be added to any shelf of reference books about words.'　　　Woodrow Wyatt, *Sunday Times*

Technosphere

Technosphere is an original Fontana series that presents individual studies of particular sciences and technologies in terms of their human repercussions. The series will include original analyses of a wide variety of subjects – transport technology, drugs, computer technology, operational research and systems analysis, photography, urban planning, films, alternative medicine, and so on – with the emphasis on the present state of the science or technology in question, its social significance, and the future direction of its probable and necessary development.

Technosphere is edited by Jonathan Benthall, Director of the Royal Anthropological Institute.

Already published:

Television: Technology and Culutral Form
by Raymond Williams
Through a survey of the development of television and broadcasting institutions in Britain and America, and an analysis of the different programming forms and their scheduling by the BBC, ITV and American networks, Raymond Williams seriously questions current views on television, and maps out a critical approach to programmes as varied as 'Coronation Street' and 'News at Ten'. '. . . a powerful and reasoned attack on technological determinism.' Stuart Hood, *Guardian*

Alternative Technology and the Politics of Technical Change
by David Dickson
David Dickson's searching analysis clearly demonstrates that, as man is forced by increasing scarcity to consume less at a time when he is compelled by economic necessity to produce more, so he must adopt fresh attitudes to technology. The characteristics of these fresh attitudes are outlined in terms that are clear and positive but reflect the tentative and experimental character of all alternative technology.

'. . . entirely convincing . . . Dickson's statement of the case for the non-neutrality of technology is by far the best I have come across.'
New Society

An Open University set book

Illuminations

Walter Benjamin

'From the evidence of this book I would suggest that Benjamin was one of the great European writers of this century.'
Philip Toynbee, *Observer*

Only since his death have Benjamin's works – literary essays, general reflections, aphorisms and probings into cultural phenomena – achieved fame outside his native Germany, where a discerning audience had already recognised him as one of the most acute and original minds of his time.

This aptly named collection includes Benjamin's views on Kafka, Baudelaire and Proust, essays on Leskov and Brecht's Epic Theatre, and discussions on art, technology and mass society, translation as a literary mode, and the philiosophy of history.

In her introduction Hannah Arendt presents the critic's personality and intellectual development as well as placing his life and work in the context of Hitler's Germany.